the BRUSHSTROKES OF Life

the BRUSHSTROKES OF Life

Discovering
How God
Brings Beauty
and Purpose
to Your Story

Anne Neilson

W PUBLISHING GROUP

AN IMPRINT OF THOMAS NELSON

Published in Nashville, Tennessee, by W Publishing, an imprint of Thomas Nelson.

The author is represented by Dupree Miller & Associates.

Thomas Nelson titles may be purchased in bulk for educational, business, fundraising, or sales promotional use. For information, please email SpecialMarkets@ThomasNelson.com.

ISBN 978-0-7852-9240-1 (audiobook)
ISBN 978-0-7852-9239-5 (eBook)
ISBN 978-0-7852-9237-1 (HC)

Library of Congress Control Number: 2022944357

Printed in the United States of America
23 24 25 26 27 LBC 5 4 3 2 1

This book is dedicated to my mom, who taught me the power of praying God's Word through all the seasons of life, and to my dad, who taught me to be adventurous in every area of life.

Honor your father and your mother, so that you may live long in the land the LORD your God is giving you.

EXODUS 20:12

Contents

Foreword ix

Introduction xi

Chapter 1: Beginnings, Brokenness, and Beauty 1
Chapter 2: That Is What I Want to Be 7
Chapter 3: No 15
Chapter 4: Patches and Pieces 23
Chapter 5: Now I'm Found 33
Chapter 6: Anne, Who . . . 41
Chapter 7: Labels, Letting Go, and Leaving an Imprint 49
Chapter 8: Chiseling 55
Chapter 9: Restless Hearts 63
Chapter 10: Great Expectations 73
Chapter 11: There Will Be Time 83
Chapter 12: The Art of Building a Home 91
Chapter 13: Returning, and the Reward of Giving Back 97
Chapter 14: Divine Appointments 107
Chapter 15: Fear Is a Liar 117
Chapter 16: Copycats and Compassion 127
Chapter 17: Angels in Our Midst 133
Chapter 18: Sharpening 139
Chapter 19: Less than Perfect, More than Enough 145
Chapter 20: The Art of Overcoming Disappointment 153

CONTENTS

Chapter 21: Open Hands, Open Hearts 161

Chapter 22: Painting with Purpose 169

Chapter 23: Devotions and Distractions 179

Chapter 24: The Art of Renovation 187

Chapter 25: Remembering Redemptively 197

Epilogue 203

Notes 207

Acknowledgments 211

About the Author 215

Foreword

*M*oments before I was needed on the set of the *Today Show* for the opening of the fourth hour, I noticed that my assistant, Christine, had left a coffee table book on my desk that an artist named Anne Nielson had sent to me. It was January 2013.

Christine routinely went through the thousands of mailed items that I received from wonderful people all over the country. She not only knew what I would be interested in, but she also was tasked with protecting me from potential legal problems that could arise from receiving unsolicited materials. So it was rare that she would leave something like this on my desk.

Just moments before our ten-minute warning I was immediately attracted to the extraordinarily beautiful cover of Anne's book, *Angels in Our Midst*. I remember feeling overwhelmed by the sheer power and beauty of it. So of course, I opened the book and began to get literally lost in the exquisite paintings—so much so that I had to race to the set to take my place beside Hoda just in time for the opening of our show.

Anne's art still has the same effect on me today. It takes my breath away and brings me great peace and joy. I remember all those years ago I would ask Christine where Anne would be appearing locally so I could see her work in person.

That is how I came to be at an art gallery in Connecticut on a dreary, drizzly March morning. The Lord had very powerfully told me to make

the hour and a half trip to meet Anne. *She needs encouragement*, He said. And I could immediately tell that was true as I walked through the door and took her into my arms to hug her.

Well, we have been hugging each other ever since. She has become one of my closest, dearest friends. She is a ferocious prayer warrior that I trust with my deepest secrets and concerns.

You may never know the blessing of personally knowing Anne as I do, but you can certainly come alongside her as she shares her story in this tender and moving memoir, *The Brushstrokes of Life*.

Anne doesn't know how special she is, and that's what makes her so special. She just knows she was born to dream and born to paint what she dreams about. Everything she does she does to be a blessing to everybody she meets.

It is my prayer that her story will encourage you to keep dreaming yours.

Let her humility and kindness touch your heart. Let her in, so she can light a match to your imagination. Her favorite scripture is Ephesians 3:20: "Now to Him who is able to do exceedingly more than you could ever ask or imagine."

Praise His glorious name.

<div style="text-align: right">Kathie Lee Gifford</div>

Introduction

The blank canvas stares at me, its white face stark and bare.

And yet, even now, I sense the promise of life within. God will bring beauty to this canvas; I'm sure of it. I have this confidence because I've painted for more than twenty years. Never once has He failed me.

And so I look at the blank facade in front of me with anticipation and wonder. *What will You do with this one?* I ask the Master Artist.

The familiar, pungent scent of oil paint hits me as I squeeze burnt umber onto my palette. I smile as I think of my oldest daughter's chiding concern, "Mom! You have to get ventilation in here. This stuff has *got* to be bad for you." She's always looking out for me, that one.

I reach for one of my sketching brushes. It's dirty, as all my brushes are. I'll use my one clean tool—my palette knife—later, when I'm layering color to create texture. But for now I focus on the angel who will emerge as I sketch. I turn slightly to make sure my notepad is nearby. I've kept it close for many years, ever since God started giving me ideas for each painting's title while I work. I don't want to miss anything He has for me.

Praise music flows through me from my headphones as I turn my attention back to the canvas. When I first began painting, my home studio provided lots of privacy. I could blast worship songs as loud as I wanted. But I needed more room, and now I paint in a more public space, an old mill shared by many artists. I don't want what inspires me

to disturb others. As Sheila Walsh's *Blue Waters* album plays, I breathe deeply.

It's time to create again.

Like many young children, I loved looking for pictures in the clouds. I'd stare into the heavens, eagerly scanning for a poodle or pony hidden in the fluffy, white expanse. To this day, I'm a cloud watcher. I continue to marvel at the colors of sunrise and sunset, just as I did at six years old.

Though I didn't understand why or how, I *knew* that Someone had painted the skies. I saw His brushstrokes everywhere. I noticed shades and hues before I even had words for those things. Green became one of my favorite colors. I experienced God as the Master Artist even if I couldn't articulate this core belief for a long time. I looked at the world, at the captivating creativity around me, and wanted to join it. By third grade, and only eight years old, I knew I wanted to be an artist.

My story wound through a lot of twists and turns over the years, but my longing to create and to participate in beauty never faded. It's taken different forms and expressed itself in unique ways, but I've always wanted to reflect the brilliance I see in creation. I've always longed to be an apprentice in God's studio.

Though I wasn't a diligent art history student (and my art grades reflected it), I did learn at some point that many young painters acquired their skill through apprenticeship. During the Renaissance, when art experienced a radical rebirth, boys as young as seven would become students of master artisans—painters, goldsmiths, sculptors, and so on. They would be taught craft and technique. They would mimic the style of their masters.

If they were fortunate, they would learn from the best. Eventually, after many years of practice (and, I imagine, a whole lot of failure), an apprentice might become so skilled that his work and his master's appeared almost identical.[1]

I am an apprentice to God, the original creative genius. From Him I have learned—and am still learning—how to mix color, shape form, and express beauty. His brushstrokes are perfect; mine are still in process. But by following His lead and imitating Jesus, I have grown. Truly, I have learned from the best.

When people look at my art, I want them to see more than my ability. I don't want them to see only angels when they look at my most popular series of paintings. I want them to see glimpses of the One who created the angels. I want them to see into the heart of God, whose love never fails.

I felt led to write this book because, in telling my story and in sharing some of what I've learned along the way, I hope to encourage you to see the brushstrokes of God in your own life. Whether you're an engineer or a stay-at-home mom, God teaches all of us to bring beauty out of our daily lives. For me that means painting. It also means being a wife, a mom, a sister and daughter, a friend, and a business owner. For you, life may look quite different.

The Bible uses the word *discipleship* to describe this process of apprenticeship. Please don't get hung up if that word sounds old-fashioned or overly religious. It's really quite simple—and exciting! When you accept God's invitation of love, you embark on a lifelong adventure of learning from Him, growing in Him, becoming more like Him. That's why the Greek word for *disciple* used in the New Testament can also be translated as *apprentice*, *student*, or *follower*.[2] God invites us all to be His apprentices in the studio of life.

Since I've experienced my share of joys, triumphs, trials, and tribulations along the way, this book will not only tell my story but—I

pray—help you understand your own story better. When we focus our attention on the brushstrokes of God, we see His beauty and our own belovedness more clearly. Doesn't that sound good, dear one?

If you're ready to join me on this great adventure, keep a notepad or journal handy. God may impress something on your mind or heart. Writing about it as you go will help you hold on to what you learn. Throughout the book I'll provide short pauses—I call them Brushstroke Moments—for you to process what you're reading. I strongly encourage you to pause at each moment and take the time to journal your thoughts, pray about the questions and ideas posed, and maybe even talk about them with a close friend. This is an immersive experience!

It may be messy too. In that way, our journey together will be a lot like painting. I almost always paint in old jeans and a plain white shirt these days; I learned the hard way that, when one paints in her favorite skirt, bad things happen. I regularly leave my studio with swaths of paint on my face, in my hair, impossibly lodged in the in-between places of my hands that regular washing doesn't seem to reach. Painting—at least for me—is a messy business.

But life is, too, isn't it? Messy. Complicated. Difficult.

And so, so beautiful.

Whether or not you consider yourself a person of faith, I pray you'll be open to tracing the Master Artist's brushstrokes in my life. Jesus has redeemed the hurt in my life; somehow, someway, He's made it beautiful. And maybe—just maybe—as you journey with me, you'll be able to look back on your life and see blessing in your own brokenness too.

In my studio, I bring beauty out of mess. And each and every day, God is creating a masterpiece out of the mess of my life. He's doing this in your life too. And both of us get to join Him in the process. So let's roll up our sleeves, change into comfy clothes, and open our hearts to His work. Together, let's look at the brushstrokes of life.

one

Beginnings, Brokenness, and Beauty

It is hard to render an honest self-portrait if we want to
conceal what is unattractive and hide what's broken. We
want to appear beautiful. But when we do this, we hide what
needs redemption—what we trust Christ to redeem.
And everything redeemed by Christ becomes beautiful.

RUSS RAMSEY, *REMBRANDT IS IN THE WIND: LEARNING*
TO LOVE ART THROUGH THE EYES OF FAITH

How many memories do you have from childhood?

Are they crystal clear, like scenes from a high-definition movie, or are they fuzzy and half-formed, like dreams from which you awaken a bit disoriented?

My memories from childhood are more like the latter. It's almost as if my brain created only a highlight reel of my earliest days. I recall certain times, places, circumstances, and conversations. I can replay those memories as if I'm there right now. A great deal of my childhood, however, feels like a hazy dream to me.

the BRUSHSTROKES OF Life

As an artist, someone who loves beauty and wants to bring more of it into the world, I'd like to paint a picture of a beautiful beginning for my life. It would be easy for me to skip over the unattractive parts of my story. Like most people, I want to appear put together, not fractured. And there *are* lovely parts of my childhood. I am so grateful for those. But if I concealed the brokenness I also experienced, I wouldn't be painting an honest self-portrait for you.

Perhaps you, too, have a story that weaves brokenness and beauty together. Maybe it's easier for you to focus on one aspect than another. I understand. The more of life I experience, the more I see it like the paintings I've worked on for more than twenty years—full of texture and contrast. Perhaps I'm drawn to techniques like layering (which creates rich texture) and contrast (which involves mixing and placing colors that might otherwise never fit together) precisely because my childhood was more textured than flat, full of more contrasts than consistency.

I've learned not to hide or paint over the hard parts of my story, because those are the very things that allow me to see God's transforming brushstrokes most clearly. Without texture and contrast, I can't create a painting with depth and meaning. And without childhood memories that include layers of hope and hurt, I could not offer the world the Angel series or my heart: real, raw, and redeemed.

Brushstroke Moment

Is it easy or difficult for you to look back on your life and see beauty, even in the brokenness? If you are willing, invite God to show you His presence and artistry in a painful moment of your life.

I remember a house and a little bedroom. On the wall next to the bed hung a framed picture of the poem "Footprints in the Sand." My parents

2

were newly divorced, and I was six, maybe seven, years old. My sister, Beth, four-and-a-half years younger than me, was still a baby. She was too young to know that Mom was sick, in and out of the hospital while struggling with mental illness. She was too little to remember Mom and Daddy together.

I was alone in my bedroom one night, a night I'll never forget.

Whether in a dream or a vision, I encountered Jesus. As I lay in bed, the power and presence of God filled my tiny body and I felt as if I had been shot straight into heaven. I don't remember if I had prayed before bed, but likely I had recited the words my mother taught me early in life: "Now I lay me down to sleep, I pray the Lord my soul to keep . . ."

I was too young to understand the meaning of that prayer, but when I encountered Jesus that night, I felt kept, held, safe. To this day, it's difficult for me to explain how, but I knew in that moment that God would care for me. There was quite a lot of instability and uncertainty in my home. That night, when Jesus took me into His heavenly arms, I knew I was not alone.

This precious experience changed me. It did not, however, make everything easy.

My mother remarried and our home life continued to be rocky. We eventually moved out of the little home where I had met Jesus and into a complex with townhomes and apartments. We had a two-bedroom town house at first, so Beth and I shared a bunk bed. This did not make me particularly happy.

Being the older and (in my eyes) wiser sister, I came up with the brilliant plan to draw a line between my space and Beth's. The trouble was, our town house was the size of a shoebox, and our bedroom provided an area for bunk beds and not much else. I told Beth, "My space is the beds. Yours is between the beds and the door." I followed up this statement with the adamant assurance that doom would fall on Beth if she crossed into my space. I actually forced my sister to sleep in a sleeping bag on

the floor in "her space." I can see that quilted sleeping bag clear as day in my mind's eye.

Beth will tell you that this arrangement dragged on for days. I remember only the one night. Whatever the case, I cringe at the memory. I wronged my sister, and I hate that I did that! Looking back, I see myself as a hurting girl trying to establish order in a home where stability was elusive. It certainly didn't occur to me then that my need for control and boundaries arose because our home life tended to be more chaotic than consistent. I only knew that I could get Beth to do what I wanted and somehow that made me feel better, at least for a moment.

Wanting to control things—situations, information, relationships—felt very important to me as a little girl. Back in that tiny town house, I was far too young to express it this way, but I can see how my need for security grew as circumstances continued to spin out of my control. Beth took the brunt of my fear and angst. I exposed "the truth" about Santa to her, stealing some of the magic of Christmas. I woke her up in the middle of the night every time I needed to use the bathroom.

"Beth," I would whisper in the darkness. "Get up."

"Why?" her sleepy voice might respond.

"I have to go."

Night after night, Beth would get up with me. Or she'd allow me to drag her to the bathroom. Whatever the case, I sometimes left Beth asleep on the floor of the bathroom, where she'd lain down while I used the facilities. I was so afraid of the dark but completely powerless over it. I couldn't control the dark or the feelings it produced in me, so I controlled my sister instead.

I'm not proud of these memories. I look back and grieve over them. This is quite an inauspicious beginning to my self-portrait, I realize. But it is a true one, and it is also one that God has redeemed.

It's been almost fifty years since I dragged Beth from her bed to follow me to the bathroom, and it would be understandable if Beth carried bitterness in her heart toward me for that behavior and others. But God

did something else instead. He completed a miraculous work to heal our relationship and moved in her to forgive me.

Back then, I was an awkward, scrawny, confused, and frightened older sister. I wasn't big or wise—at all! I repeatedly hurt Beth. But she has forgiven me, and we now share a priceless sisterly bond.

Perhaps reading about my relationship with Beth brings up painful memories from your past. Maybe you were the "Beth," the one wounded over and over again in the family dynamic. I'm so very sorry if that was your experience.

Or you might have been like me in your earlier days—mean in ways you didn't fully understand and now shudder to remember. Whichever side of the equation describes you, the only path through these types of painful memories involves repentance and forgiveness.

Brushstroke Moment

What does *forgiveness* mean to you?
Have you experienced the beauty of forgiveness?
Is there someone you need to forgive or someone
you hope might forgive you?

Forgiveness brings freedom. Freedom from the pain that keeps us in bondage to bitterness. Freedom to move on and move forward. Freedom not necessarily to forget but to remember differently. Because of God, we can remember redemptively. This means that we look at the past with honest and grace-filled eyes.

I don't paint over the rough patches in my childhood relationship with Beth, because they taught me that I needed God to change me. I was a hurting little girl, yes. But I also hurt others. Forgiveness allows me to see both things as true.

In the past, master artists who disliked a painting on which they had worked might slash or trash the canvas. I don't do this. Instead, I've made it my habit to embrace the mess of my artistic process, layering and mixing, layering and mixing, until beauty emerges. It may take quite a long time, but when the breakthrough happens, and the mess becomes a message, it's nothing short of breathtaking.

In a similar way God uses our circumstances and choices—many of which look like chaos on life's canvas—to alter and even adorn us. The Bible tells us He provides for those who grieve "a crown of beauty instead of ashes, the oil of joy instead of mourning, and a garment of praise instead of a spirit of despair" (Isaiah 61:3). Jesus redeems and restores rather than casting us aside like so much rubbish. Isn't that magnificent?

Like me, you may have had some messy relationships. We can learn a great deal through the challenges of interacting with other people, though, can't we? I've decided to embrace the mess of my relationships like I embrace the mess of my artistic process, always looking for God's message in whatever's before me.

I try to relate to people as they actually are, not how I expect or want them to be. It means being quick to listen, slow to speak, and slow to get angry, like God's Word describes in James 1:19. And it involves seeking, receiving, and granting forgiveness again and again. But please don't misunderstand me. This never means allowing others to abuse or mistreat us. Instead, we honor ourselves and others by taking every messy situation to Jesus, trusting Him to be our defender, helper, and guide.

Dear one, what message might God want to bring from the messes in your life? Some of my childhood memories loudly proclaim that I need God's forgiving love. What about you?

two

That Is What I Want to Be

If I could say it in words there would be no reason to paint.

EDWARD HOPPER, AMERICAN REALIST PAINTER AND PRINTMAKER

One day, my third-grade teacher at St. Mark's Episcopal School, Mrs. Bloom, assigned the class an essay: What I Want to Be When I Grow Up. We each had to write three complete sentences, Mrs. Bloom informed us. After that, I heard nothing else. I already knew exactly what I would write.

I took out a piece of blank, wide-ruled paper and placed my pencil in the center of the first line, scrawling the title in bold letters: An Artist. Underneath this I wrote, with complete confidence, "When I grow up, I want to be an artist."

If memory serves, my second sentence went something like this: "That is what I want to be." The final sentence escapes me entirely, but that sentence didn't matter. I knew what I wanted, and, in my eight-year-old mind, there was no reason to believe that I'd become anything else. I was created to be an artist.

During my elementary school days, I was always creating something or doodling somewhere. I loathed book reports, but given the chance to make a shoebox diorama, I was golden. I'd do it with battery-operated lighting, in fact. I strung puka shells to make brilliantly colored neck-laces. I made papier-mâché piggy banks. I sewed pocketbooks and gave or sold them to people in our housing complex. Anything that had to do with arts or crafts made my little soul happy.

The rest of school, not so much.

I struggled with reading and math. I was shy and self-conscious. Taking a standardized test felt torturous. I would rather draw and create than finish a book. Maybe I had undiagnosed learning challenges; maybe I simply didn't pay attention the way I should have. Most likely a com-bination of a lot of things made me want to escape into a world I could color or craft, not read or multiply, write or calculate.

Looking back I truly believe God gave me art to protect me from so much else going on around me. It was almost as if He had deposited creativity within me as a shield against the storms in my life.

––––––––

My stepfather drank—a lot. We called him Papa G, though I have no idea where that name came from. I have sparse memories of him, but most involve vodka and green spearmint gum. When he wasn't drinking, Papa G chewed that gum. Or smoked. He chewed or smoked or drank, and his ruddy face got redder as he did so.

At some point we moved to a second-floor apartment within the same complex as our townhome, and this was an upgrade. We now had three bedrooms! Beth and I no longer had to share a room. Plus, we were closer to the pool, a definite upside on hot Jacksonville, Florida, days.

I was nine or ten when Mom decided I should start riding the city bus to school. The way I remember it is that one gray, drizzly day, Mom

pointed out the city bus stop across from our housing complex, which was nestled in a shopping strip. She told me how to pull the cord that would make a loud buzzing noise and alert the bus driver I'd be getting off at the next stop. I tried to follow her instructions the next day when I boarded the bus for school. I needed to travel about five miles, and I thought I would recognize the area around my school. Instead, the passing terrain started to look less and less familiar.

I was a timid and confused girl on a city bus, trying to figure out when to pull the cord. My anxious confusion increased with every passing moment. As the bus went over a bridge, I saw we were approaching downtown and knew things had gone terribly wrong. I yanked the cord and jumped off the bus, fighting back tears. I had disembarked in a busy area of town, and the only thing I recognized was a chain restaurant—the Stand and Snack. I bolted through the doors, and the floodgates of my tears burst open. I managed to borrow a dime to call my dad from the pay phone outside. Thank goodness pay phones had not yet become extinct! I honestly don't know how Daddy understood me through the sobs, but he showed up not long after and let me skip school for the day.

This was a huge relief, not only because that bus ride scared me and school wasn't my favorite place but also because I loved spending time with Daddy. In my mind he was the coolest, handsomest dad in the world. He was a fighter pilot in the naval reserve and, as a civilian, belonged to a group of guys who called themselves the "Florida Expedition Men." Daddy recounted their adventures to me—canoeing in piranha-infested waters or climbing where no man had climbed before. He had use of the twin-engine plane his company owned and made the most of it, traveling to exotic places.

Daddy was also—and still is—an extremely meticulous person, ordered and measured and controlled. When it came to temperaments, my parents provided quite contrasting examples for me. In retrospect, it

strikes me that I took after my father in many ways, controlling my world as best I could.

It's fascinating and sometimes difficult to look back on what we have received from our parents, noting how their lives and habits, personalities and problems, shaped our own. If we look at life as if it is a painting, it's clear that our parents sketch a rough outline on the canvas of our lives.

But whatever sketch our parents lay down is ultimately subject to the powerful and purposeful design of the Master Artist. God sketched the outline of a creative spirit within me. Neither trial nor trouble could erase that. As you travel with me through my life, you'll see how many years and events temporarily buried the original design God placed on my life canvas, but His purposes and plans for me never faded.

Brushstroke Moment

If you were to picture your life as a painting, what original design do you think God sketched on the canvas of your life? Consider any ways that your parents supported or undermined God's perfect plans for you. Rest in the presence and power of God to forgive and redeem.

As my school days dragged on, I liked "book learning" less and less. I just couldn't make school work for me. But I could say so much through what I made or doodled. Even in elementary school, I knew I needed to draw or craft to make sense of the world. I did not need Mrs. Bloom's essay assignment to know what I wanted to become.

Daddy must have noticed this, because when I was twelve he enrolled me in a five-week art course with a friend and neighbor of his. I was by far the youngest member of Mel Kline's class, but that didn't matter to me (or apparently to Mel and the rest of the class). Somehow, I fit right in with all the adults learning to use charcoals. Our first subject was a tube of

lipstick. I felt so grown up and so very, very happy sketching that lipstick tube. I also got to spend nights at my dad's so I could be on time to class, which only added to my joy. Suddenly I was surrounded by people who were talented and creative. I felt as if I had come home.

With Mom and Papa G, however, my early adolescence and anger mixed poorly with their alcohol consumption. I remember walking up the stairs to our apartment by the pool one night, hit by the smell of eggs and bacon cooking. It was dinnertime and—for some reason—it bugged me that we were going to eat breakfast for supper. Whatever I said when I walked through the door—probably something resembling "Ew, I don't want that for dinner"—made Mom particularly mad. She didn't appreciate my sass and started to yell.

Pretty soon my stepfather joined in, supposedly in her defense. Alcohol exacerbated his hot temper and bloated his face; he genuinely scared me.

Even though I was terrified, I yelled back, "You're not my father and you can't tell me what to do!" The next thing I remember is crawling out from under my bed long after dinner had finished. I was a study in contrasts during those days, standing up for myself one minute and running in fear the next.

During this time I distracted myself with crafts and babysitting and gymnastics. I didn't attend practice consistently enough to advance as a gymnast, but I did perfect my roundoff back handspring in the courtyard of that apartment complex. I would pretend to be an Olympic competitor—the best gymnast in the world—and backflipped my way through some difficult early adolescent days.

I had moved to St. Johns Country Day School by this point, which was a thirty-to-forty-minute bus ride from my home. Jacksonville was a sprawling city with only a few upper division schools. I would have had an extended commute to any junior high, and my parents chose St. Johns, the sweetest little school in Orange Park, Florida. Picture first through

twelfth grade with a grand total of only 350 students. The school was split into lower and upper campuses, with the library and administrative offices in the center. Behind these buildings was a gathering space where students and staff would stand every morning to say the Pledge of Allegiance and hear school announcements. All 350 of us would form a U-shape around the back of the school, with the snack bar, lunch tables, and tennis courts flanking us.

As a sixth grader, I'd peer over to the "other side," where the ultra-cool seventh through twelfth graders stood. I wanted so badly to grow up. But before I could get there, I had to survive Mrs. Carter, the toughest sixth-grade teacher in the whole world. I thought I'd never forgive her for noticing I couldn't see the chalkboard clearly. I had to get glasses and tried my best never to wear them. How could I possibly be cool or cute wearing those things?

Toward the end of sixth grade, I found out about cheerleading try-outs. Here was my chance to shine. I might not be an Olympic gymnast, but surely my hours of backflipping would pay off as a cheerleader. I remember practicing so hard, determined to make the squad for my seventh-grade year. If only an ID bracelet hadn't gotten in my way.

Was there a cute kid in your sixth-grade class like there was in mine? You know, the "it" boy or girl who everyone liked? In Mrs. Carter's sixth-grade class, the "it" boy stood behind me for flag time and announcements every day. He bugged me to no end, kicking the backs of my knees or tapping me on the shoulder and conspicuously looking away.

I had no idea what flirting was, but this boy's older sister—one of the cool kids who stood on the "other side"—told me at lunch that her brother liked me and wanted me to wear his ID bracelet. She explained that he was flirting with me when he did those annoying things. As you can tell, I was a bit naive when it came to boys. I was excited to wear this cute boy's bracelet, though, and I donned it with pride for the next few days, including the day of cheerleading tryouts.

I can't help but laugh at my thirteen-year-old self, tall and skinny as can be, prancing onto the cheerleading tryout stage with stringy hair pulled into a high ponytail and a little pep in my step, wearing a chunky silver bracelet with a gigantic plate emblazoned with this boy's name in all caps. I may have been chanting the cheers I practiced, but apparently the primary thing the judges heard was the clank of the sixth-grade "it" boy's ID bracelet. I didn't make the squad and ditched the bracelet as quickly as I could without ruining any cool factor that I'd gained by wearing it in the first place.

I definitely wasn't the "it" girl, but I did want to fit in. I still felt shy and awkward, but I *was* growing up and making friends, beginning to stretch my wings. I made a good friend, Sarah Brown, whom I practiced my handwriting with for hours on end. We were intent on having the most beautiful signatures in our class. I had no idea that, decades later, people would comment on my handwriting at book signings. If you ask me, God moves in marvelous and mysterious ways to prepare us for what's in store.

In eighth grade, while I was busy practicing handwriting and trying to fit in, my family moved. Papa G was a contractor, and, in my early teens, he built us a small house not far from the childhood home where I had encountered Jesus at six or seven years old. He designed this three-bedroom house and gave me the job of painting the master bedroom. I so wanted to join a bunch of friends who were getting together that weekend. But my life wasn't like their lives. Everyone else seemed to enjoy their lives. Mine so often felt hard.

Today, almost fifty years later, I see how God has used the hard parts of my life to shape me and help me grow. But at the time it was very difficult. I just wanted things to be easy, to be fun. I wanted to create a world for myself that didn't involve a stepfather who smelled like vodka, cigarettes, or spearmint gum. I wanted to create a world that was beautiful and not broken in any way. I wanted Daddy to be around more,

and I wanted my mom to be healthy, to be married to a good husband. I wanted to be happy. That's what I wanted to be.

Brushstroke Moment

What did you want to be when you were little?
What do your childhood dreams have to
say about who you are today?
In what ways do you think God might have used the hard
things in your childhood to shape and form you?

three

No

Every child is an artist until he's told he's not an artist.

JOHN LENNON, MUSIC ICON

When I'm at art shows or events, people might mistake me for a big-crowds kind of person. This couldn't be further from the truth. I'm definitely a small, intimate-gatherings girl. I love one-on-one coffee dates and close ties. The tiny private school I attended through eleventh grade fit this aspect of my personality perfectly.

My time at St. Johns Country Day School was a mix of highs and lows, probably a lot like your school experience. Though I didn't make the cheerleading squad the first year I tried out, I did land a spot on the team the following year and for the rest of my time at St. Johns. I was so happy. My class—twenty kids in all—felt proud of every one of our sports teams. We cheered our hearts out for each of them.

By my sophomore year I had broken the mold of the shy, awkward little girl and—even though I still didn't like the academic part

of school—I became a somewhat more confident young woman. Wait; that might be too strong. Realistically, I was striving toward greater confidence. At least, I was, before Mr. K's art class.

True, I loved to create more than learn, but I somehow received a D- in that art class. A *D minus*! I have the proof on my old school report card. My memory of Mr. K's class was that I was coloring outside the lines while he instructed me to color within the lines, hindering my creative desires. Whether or not that's actually what happened, that D- came with serious consequences. My dad—my super-cool, adventurous dad—did not see that grade as an adventure in character building. He wanted my grades pulled up pronto.

Daddy told me that if I made another D in any class, he would pull me out of St. Johns (which he had to pay for) and send me to a public school (where he wouldn't have to pay a dime). Sadly for me, that is exactly what happened my senior year. Typing these words right now, I wonder why I didn't fight harder to stay. Why did I not do everything in my power to try to pull my grades up, to pay attention in class? I suspect I could have done it, but I think at the time I just gave up and walked away from my small and intimate school with all my sweet, dear friends.

Brushstroke Moment

Have you ever given up? Walked away from something you love? If so, God understands this. His love for you does not change, whether you are a wild success or struggling with failure. Perhaps you can take a moment—even right now— to thank God for His steadfast love that *never* fails. How might being truly, unconditionally loved change the way you feel about yourself and what you have accomplished or failed to accomplish?

I spent my senior year at our local high school and because I had almost all of the courses necessary for graduation, I had to enroll only in math, English, and some elective classes. I chose art again, and this time it was easy. I also made new friends and headed back to see old friends at St. Johns occasionally.

One friend, however, stayed particularly close to me. Jane and I had met in eighth grade at St. Johns and became virtually inseparable. Though we went to different schools after eleventh grade, I practically lived at Jane's house during my teenage years. Her dad was a surgeon, and their family had a pool—a massive plus on those as-hot-as-it-comes Florida afternoons. Jane was also the funniest girl I had ever known. She giggled her way through life. Jane was—back then and until the day she passed—my very best friend. During high school I loved escaping to Jane's house, especially when things felt crazy elsewhere.

And yet things had also begun to change at my own house. Mom divorced Papa G and found Jesus. She told Beth and me that she had been born again. Apparently, our priest, Father Dearing (who honestly looked a lot like the actor George Burns), had pulled Mom aside and encouraged her to start living differently, in a way more like Jesus. Mom was radically changed, and Beth and I started noticing major differences. Mom went from only praying "grace" at meals to praying for extended periods of time. She interceded for the sick and hurting; she prayed for people she loved and for complete strangers. As she studied the Bible, Scripture informed and empowered her prayers. Beth and I watched all of this, but we were young and immature and a little embarrassed by some of the ways Mom expressed her born-again faith.

Truth be told, I thought I knew everything there was to know about God, the Bible, and all that "church stuff." I remember when Jane and I, eighteen years old and ready to conquer the world in our newfound independence, were asked to teach the sixth-grade Sunday school. On the first day, we told the class to open their Bibles to the book of Job, which

I pronounced /jäb/, like the occupation. The class tittered and one kid sneered, "I think you mean *Job*," which he pronounced accurately.

"Yeah, yeah, I know," I shot back. "Just making sure you're awake."

I did not know how to pronounce Job. There was so much I didn't know.

Jane and I tried creative ways, some more successful than others, to get the sixth graders interested in their Bible lessons. At Christmastime we broke the class into small groups and told them to choose a character from the nativity story. "When we all come back together," Jane explained, "each group will perform a scene from the Christmas story for the rest of the class, told from the perspective of the character they chose."

I'll never forget the rowdy group of kids who stood up and proudly declared, "This is the story from the donkey's point of view." They proceeded to "Hee-haw, hee-haw" on all fours with vocal inflections. Of course everyone—including Jane and I—burst out laughing. We had no idea how to disciple sixth graders. We thought we knew so much, but God was pulling us into a place of humility, reminding us that we weren't all that we thought we were. I didn't yet know how to be myself with God, to be real before Him.

Brushstroke Moment

Sometimes we feel the need to pretend we're
more "together" than we actually are.
We even do this with God. We posture and pose, trying
to make ourselves look a certain way, but God looks at the
heart (1 Samuel 16:7). In what ways do you pretend?
Jesus knows who we really, truly are and—
hallelujah—He loves us right there.
You don't have to pretend with God. Isn't that good news?

I faced a far more humbling and difficult situation than teaching sixth graders when my mom and dad discouraged me from attending art school after high school graduation. I had my heart set on Parsons School of Design, a prestigious fine arts school in New York. My parents didn't want me to even consider it.

"You'll be a starving artist your whole life," they reasoned.

These conversations with Daddy and Mom cast a cloud over my dream. And I listened to the voice of doubt. If I could counsel my younger self, I might say, "Don't let a *no* derail you." If God has called you to be or do something, follow His leading with confidence until He fulfills that calling or changes your course.

John Lennon said that children are natural artists until they're told otherwise. I was told no—in Mr. K's class and by my parents—and I shelved my dreams as a result. I look back and see how God used those noes to shape me. I ultimately developed resilience through disappointment. I learned to push harder and persist longer because I had been told I couldn't or shouldn't pursue my creative passion. Today I'm grateful for all those noes—but it took me a while to gain this perspective and to learn all I did from it. I can't help but wonder what life might have been like if I'd had enough confidence in my calling when I graduated from high school to persevere through the pushback and keep chasing after it.

Instead, I simply applied to the schools my friends were heading to. But my lack of attention in high school—mirrored in my overall GPA—provided me with few choices. Daddy said he'd pay only for an in-state school, a financial benefit for him. At this point I did not think my father was so cool.

I could choose between Florida State University (FSU) and the University of Florida. They were both affordable and extremely large schools. While the sheer size of the classes and campuses overwhelmed my mind, I sucked it up and told myself, *I've got this. I can do it!*

A dear friend from St. Johns decided on FSU, and when I found out

I could be in the same dorm as her, I chose FSU too. We moved in and everything was great—for a few days. Then a station wagon pulled up to the dormitory, packed up my friend's belongings, and took her back home. What? She couldn't be leaving me! But we said our goodbyes and off she went. I wanted to go back home, too, but I rallied and once again convinced myself, *I can do this!*

I pledged a sorority and loved the girls of Alpha Delta Pi. I'm so grateful for the incredible friends I made during that first year and a half at FSU. Halfway through my second year on campus, however, I decided I'd had enough. College life simply wasn't working for me.

Back then, before the days of online classes and digital everything, you had to show up in person to make sense of any class. At the very least, you had to be present for midterms or final exams and to turn in papers (hard copies only at that time). I didn't seem to grasp this concept. Or I was just overwhelmed by the number of people in each class. Or maybe a little bit of both. By the end of the first semester of my second year, I simply hadn't gotten my bottom in the classroom seats nearly often enough. For years afterward I believed I had simply decided to go home. The records my dad stored until a few years ago told me a harder truth: I had failed out of college. This was another hard-stop no that shaped me.

I find it fascinating that I told myself such a different story about this situation for so long. Perhaps it was God's mercy, protecting me from feeling the sting of failure. I really did not want to be at a huge state school any longer, so whether I had done well in school or struggled, I knew I didn't belong there. I packed my things and made my way home. Though I didn't know how, I truly had faith that I would figure out the plans God had for me. I knew He had something in mind. I had just gotten a little lost, especially in the bigness of college life at a gigantic public university. Instead of focusing on what I had lost or failed at, I focused on the verses from Jeremiah 29 that I had learned:

"I know the plans I have for you," declares the LORD, "plans to prosper you and not to harm you, plans to give you hope and a future. Then you will call on me and come and pray to me, and I will listen to you. You will seek me and find me when you seek me with all your heart." (vv. 11–13)

I did find God's plan for me eventually. Before I embraced His good purposes for me, though, I did a whole lot of wandering.

Brushstroke Moment

How has hearing the word *no* changed your life and shaped you as a person?

How did you feel when you first heard those noes?

Do you feel the same now?

How can you trace God's fingerprints in the noes in your life?

four

Patches and Pieces

In the landscape, colors are more neutral than you may think. Pay close attention to this. Small areas of rich color can make the whole painting look colorful.

MATT SMITH, AMERICAN PAINTER

If people know of my artwork, they most often associate me with my Angel series. I love this, as it connects my work and faith in a tangible way. However, I also enjoy painting other things, including landscapes. Capturing God's beauty in nature delights me. Neither kind of painting is better nor worse, simply different.

If I were to paint my early twenties as a landscape, I believe it would be a desert. Though an outside observer may have looked at all the "fun" I was having during this period in my life, my internal experience felt like wandering in a parched and tired place.

King David, who wrote many of the poems collected in the biblical book of Psalms, once described his own experience with these words:

> You, God, are my God,
>
> earnestly I seek you;
>
> I thirst for you,
>
> my whole being longs for you,
>
> in a dry and parched land
>
> where there is no water. . . .
>
> On my bed I remember you;
>
> I think of you through the watches of the night.
>
> Because you are my help,
>
> I sing in the shadow of your wings.
>
> I cling to you;
>
> your right hand upholds me. (63:1, 6–8)

I knew God and had experienced His love to a certain extent. I would think of Him when it was quiet and lonely, at night when the day's work or fun was over. I went to church and read my devotional, but I had not yet surrendered my life to Him. I had not decided to cling to God in the way David described. My loving heavenly Father wanted to uphold me, but it was like I was holding His hand as far away from me as I could. I never let go, but neither did I want Him to get too close. I desperately needed to feel in control—believing I was in control made me safe. The effort left me dry and weary instead.

Brushstroke Moment

Have you been through a season of wandering or dryness? What did this look like in your life? If you have come out of such a season, what insights did you glean? If you are still in a desert, what do you need more than anything else right now?

The decade of my twenties didn't start out as a desert. After a semidisastrous second year in college, I returned to Jacksonville and dived into any and every adventure available to me. I water-skied and mountainclimbed. I jumped out of an airplane not once but twice.

One day a group of old friends and I were hanging out at the beach. A few of the guys started talking about skydiving. They knew of a place about an hour south and were making plans for their jump date. None of my girlfriends seemed too keen on the idea, but I did what the daughter of any nonstop adventurer would do and invited myself along.

Rushing home, confident that Daddy would be the perfect partner for my debut as a skydiver, I shared my plans with him. I'll never forget his response: "Why would you want to jump out of a perfectly working airplane?" Remember, my dad was a pilot as well as an adventurer. He proceeded to tell me I was crazy and advised me *not* to skydive. Like many other twentysomethings, I half listened and did the exact opposite of what my parent encouraged me to do.

My friends and I headed out the next day at first light and arrived at skydiving central in the middle of Nowhere, Florida, as morning broke. Not only were we *nowhere*, we were also surrounded by virtually *nothing*. A few cinder block buildings and scattered parking spaces, some emergency vehicles, and a ragtag crew of dive instructors in a gigantic open field—that was it. This didn't strike me as the best of beginnings, but my adventurous spirit won out nonetheless.

Back then skydiving required a full day of coursework prior to launch. My friends and I learned the extensive routine of packing our chutes, then practiced several times. The experienced crew explained we would pack our own parachutes for the launch, but they would pack the reserve chute, which would have to rescue us if anything went wrong. If any primary chute failed, its owner would owe the crew a six-pack of their favorite beverage. *How often does that happen?* I wondered nonchalantly.

We endured agonizingly detailed accounts of safety protocols until

the moment for our jump. At that time, no one jumped tandem. There were no safety lines. Solo skydivers—whether first-timers or veterans—climbed out on the wing of an airplane and launched themselves headlong into the wind. And that is exactly what I did. From an airplane with a single propeller and a jump door lined with beer bottles. True story.

Adrenaline kicked into high gear as, one by one, I watched my friends climb onto the wing of the plane. Then they were gone. I had told them I wanted to go last, but watching my final friend launch into the unknown unnerved me. Not enough to overcome the adrenaline coursing through my veins, though.

Before I knew it I was inching my way out onto the wing, gripping the small grab bars with clenched fists. I looked back at the pilot, and he nodded, then shouted "Go!" The earth spun below me, a surreal land-scape stretching far beyond my line of sight.

Before I knew it, I was falling . . . falling . . . falling.

The ground below me spread out like a patchwork quilt, orange groves and cattle fields punctuated here and there with farmhouses or family homes. From ten thousand feet everything looked miniature and manicured, like a display you might see in a natural history museum. There must have been wind, but I didn't hear it; I felt neither hot nor cold. After an initial few seconds of free fall, I simply floated downward, euphoria pulsating through my body, erasing any competing sensation.

I listened carefully to the voice pumping through the radio in my helmet, guiding me when to pull the cord that would release my chute. When directed, I tugged and felt a tight jerk upward, followed by the graceful billowing of my parachute. I sailed toward the *X* on the ground and landed relatively gracefully, one foot after the other.

The rush that ran through every bit of me was more exhilarating than anything I had experienced. We all were whooping and high-fiving as the hot-pink sky catapulted toward sunset. Someone threw out the idea of jump-ing again, and I was all in with that. This time, though, I wanted to go first.

Which I did.

Again I launched, and again I listened for ground control through the radio in my helmet. That voice guided me securely and easily toward a second safe landing. Again, the rush. Again, the high fives.

Then the fear.

One of my friends jumped and began floating in the opposite direction. The ground crew quickly identified that his radio had malfunctioned. An inexperienced skydiver, my friend was now falling—completely on his own—toward a potentially tragic end. Ambulances and an emergency crew sped off, attempting to track where he would land.

Unaware of this, another of my friends climbed out onto the wing of the plane and propelled himself into the sky, which was streaked with sunset rays. It would have been a glorious picture if his parachute had deployed, but it didn't. His radio had not failed, but his pack job did. A chaotic frenzy broke out around me, and another set of emergency workers scrambled.

Thank God his reserve chute worked, and he made it safely to the ground.

And, to our relief, so did our friend with the broken helmet radio.

Brushstroke Moment

The helmets my friends and I wore while skydiving were essential, not only to protect our heads from serious injury but also because they were equipped with a radio that enabled us to follow directions from the ground crew—toggle right or toggle left, pull this or do that. Looking back, it strikes me that this experience gave me a picture of how critical it is for me—for each of us!—to listen to the voice of Jesus as He provides direction. When we get disconnected from His voice, we endanger ourselves, similar

to how my friend was in peril when he was cut off from
the communication that could bring him safely home.
What do you think about this idea?
How in tune are you with the voice of God?
Is there static or clarity when you listen for His guidance?
Have you ever experienced a time when
listening to His voice protected you?

We were safe but rattled. We also had no money left, and the crew wanted their promised six-pack. Somehow we finagled our way out of that predicament and got the heck out of Dodge.

I look back on that adventure with a mixture of pride—I did it!—and terror. Things could have gone horribly, horribly wrong. It all turned out okay, and it was quite the adventure, but in retrospect I see that I was living on the edge, almost as if I could stave off feelings of fear and failure by doing "fearless" things. Fun distracted me from the fact that I didn't really know what to do with my life. My dream—being an artist—had been all but sidelined by the no I received when I wanted to attend art school.

So I sought adventure and worked to finance my fun.

Because I had worked as a hospital secretary during high school and college (mostly thanks to Jane's dad, the surgeon), I landed a job in the real estate industry as a file clerk at Alliance Mortgage. This firm specialized in real estate–owned properties (REOs). With my work ethic and commitment to excellence no matter the task, I quickly began to move up the ranks. Being promoted and given a raise motivated me even more. Within short order I had an office and tickets for a business trip. Alliance Mortgage moved premises not long afterward, and I scored an even swankier office, this time overlooking the St. Johns River. I had an office mate during that time, and we were young and carefree.

On January 28, 1986, however, the windows of our office framed utter shock and devastation. My colleague and I watched in real time as the space shuttle *Challenger* disintegrated over the Atlantic Ocean, just off the coast of Cape Canaveral, directly in our line of sight.

Just after 11:30 a.m. on that fateful Tuesday in January, the *Challenger* flew for only seventy-three seconds. We watched in stunned disbelief. This was long before instant news access via cell phones or computers. My coworker and I hoped the ball of fire that morphed into curling streams of smoke spelled anything but disaster. With the rest of our country, we had highly anticipated the exciting launch of America's twenty-fifth space expedition, which for the first time carried a civilian—a teacher.[1] We had eagerly tuned in to the radio broadcast tracking *Challenger*'s dispatch, ready to celebrate the triumph of American engineering. Instead, we viewed a horrifying explosion and watched the wreckage scatter.

I had no clue that my life would disintegrate soon after.

———

During that season I got into my first serious relationship and wondered if he—we'll call him Boyfriend #1—might be "the one." After about six months, however, it became clear that he was most definitely *not* the one.

I knew from my years in church that God created sex and intended for it to be enjoyed in a committed and loving marriage. I wanted that and had promised to save myself until I met the man of my dreams and became his bride. As time moved on and so did my relationships, I didn't keep that promise.

I then turned to one of my best male friends at that time, and we quickly became an item. I loved how carefree Boyfriend #2 was; I didn't want a buttoned-up, nine-to-five kind of guy. I wanted someone spontaneous, and Boyfriend #2 fit the bill. We considered getting married, but

I kept breaking up and getting back together with him. He had his own issues, but my need for control also hurt our relationship. I vacillated between wanting love and wanting my own way.

I desperately wanted to be married, even though I was still quite young (in my early twenties). Truth be told, I wanted to be a wife and mother even more than I wanted to be an artist. Though I looked quite confident and independent on the outside, a nagging fear whispered that I might never find lasting love, the thing I wanted most. After I finally broke up with Boyfriend #2 for the last time, I jumped into another relationship, hoping this time things would turn out better. That didn't happen.

Boyfriend #3 was a really sweet man. He treated me well. We did not honor each other in our relationship, though.

Never did I ever think I'd find myself pregnant at twenty-two. I think the father, Boyfriend #3, would have married me, but I knew—deep down—that we were not right for each other. I was afraid. I was desperate. I never believed I would contemplate an abortion, let alone have one, but this is part of my story.

I told no one beyond Boyfriend #3 about the pregnancy. He spoke to me gently; he also made no attempt to dissuade me from "taking care of things." I felt both terrified and determined. There didn't seem to be another option. I wanted to handle this and get on with my life. Despite a gnawing ache inside me, I hoped moving on would solve everything.

The clinic was in a nice area of town, close to a favorite restaurant where my dad and I ate lunch once a week. I had passed it countless times, never picturing myself walking through its doors. The staff was professional, a little distant and reserved, perhaps, but certainly not unkind. I'm not sure whether I was more startled or relieved to discover that the consultation and procedure would happen the very same day. The first pangs of guilt and shame resounded in my heart, but I quickly quieted them with what I believed was logical reasoning: *You can't have*

*a baby, Anne. You can't even tell your parents. This is the only way for you
to have any kind of real life.*

Oh, how I wish I could have known the agony that would follow me
for years afterward.

A medical assistant guided me into a sterile room with garish,
hospital-grade lighting. I just wanted it to be over. And it was, quicker
than I'd imagined it would be. A haunting sound like a power tool or
vacuum is all I remember—along with being placed in a recliner to recu-
perate for one hour after the procedure.

"Okay, you can go now," the nurse told me after checking to make
sure I had no bleeding or other signs of distress.

I guess she couldn't see the tumult in my heart and mind. I pushed
it so far down that even I couldn't listen to my own emotions; I fixated
on relief and went on with my life.

Some of you reading this will have strong reactions to my choice. I
understand that. It would certainly be easier for me to ignore this part of
my story than to bare my soul to you. But this was a watershed moment
for me, a cataclysmic decision that altered the rest of my life. I share this
with the hope that you will see, as my story unfolds from this point on,
that God can redeem *anything*. His forgiveness and victory over my bro-
kenness and shame became even more real to me after the devastation
of abortion. As I describe the healing brushstrokes Jesus used to restore
me, I hope you'll remember times when He worked even the worst things
together for good in your own life.

From today's vantage point, I clearly see that I had been wandering
for some time before this. I had been living in a wasteland, keeping God
at arm's length, but I couldn't see the reality of the desert around me until
the pain of my choices looked me squarely in the eye. Fun had distracted
me for a time, but its glamour faded as the consequences of my decisions
came crashing down.

I was devastated. I was alone. I didn't know where else to turn. And

in that dry and weary place, God met me with healing. Slowly, almost imperceptibly at first, He began adding color to the landscape of my life. In patches and pieces, He painted me through the desert. The primary way He did this was through prayer.

five

Now I'm Found

O Great Creator,

.

We offer ourselves to you as instruments.
We open ourselves to your creativity in our lives.
We surrender to you our old ideas.
We welcome your new and more expansive ideas.
We trust that you will lead us.
We trust that it is safe to follow you.

.

We ask you to unfold our lives
According to your plan, not our low self-worth.
Help us to believe that it is not too late
And that we are not too small or too flawed
To be healed—

.

Help us to know that we are not alone,
That we are loved and lovable.
Help us to create as an act of worship to you.

JULIA CAMERON, "AN ARTIST'S PRAYER," IN *THE ARTIST'S
WAY: A SPIRITUAL PATH TO HIGHER CREATIVITY*

*C*onsidering my most popular series of paintings involves heavenly beings, it's probably not a shock when people find out that relationship with God is at the core of who I am. Whether I'm being interviewed for a tiny local newspaper or an international event, on television or social media, I'm not what you'd call shy about my faith.

That said, I work with and love lots of people who don't share my beliefs. I showcase artists in my gallery who come from diverse backgrounds with worldviews that diverge from mine in major ways. People who claim no faith at all are often drawn to my angel paintings, regardless of what they believe about God, heaven, or life after death. I love that art stretches beyond religion because I'm not about religion; for me, life's all about a relationship with God.

You may have picked up this book because you're interested in my art or art in general. You may have grabbed a copy because you share my love for God. Whatever your worldview, please allow me to offer this chapter as a window into my soul. You may have prayed every day of your life or never have spoken to God. The words in this chapter may feel as familiar as your favorite cozy blanket or as uncomfortable as a cross-country flight in basic economy. I invite you to journey with me, back in time, only to look at how color and life came back to me after the desert experiences of my early twenties.

Will you open your heart to hear how prayer transformed me?

Brushstroke Moment

What has your experience with prayer been like?

Do you currently feel far from or close to God?

Are there ways you'd like your faith and, far more importantly,

your relationship with the Faithful One to grow or change?

What do you think about inviting Him to meet you now?

I was living the high life in 1980 when Dr. Francis MacNutt and his wife, therapist Judith MacNutt, founded a ministry with one express purpose: make life in families, churches, and medical professions revolve around Christian healing prayer. By 1987 Francis and Judith's work had expanded in such exciting ways that their Christian Healing Ministries (CHM) established a home office in Jacksonville, Florida. I thank God that He brought the MacNutts into my life in the late eighties when I so desperately needed healing. I needed prayer. I needed God. And He met me through my sessions at CHM.

My mother introduced me to the MacNutts. Mom's faith had grown by leaps and bounds during my late teens and early twenties. She was a veritable prayer warrior by 1987, serving in a variety of capacities at CHM. She prayed with anyone and everyone, anytime, anywhere.

Mom may not have known every detail of my wandering, but she could sense that I needed healing and hope. She saw the weight of guilt and shame I carried. She urged me to pursue the blend of counseling and prayer ministry that CHM offered. I wasn't sure that it would work, but I was hopeful. I wanted to be close to God and had never deliberately walked away from Him. I had wandered about as far as I could without letting go of His hand, however. Through CHM, I felt Him drawing me back, gently and kindly. I could no longer rationalize my destructive decisions or keep Jesus at arm's length. It was time for me to decide: Would I follow Him or keep grasping for the control that always seemed to elude me?

I attended some CHM events and conferences. Waves of healing and deliverance from shame would crash over me. But God had more in store. Norma Dearing, daughter-in-law of Father Dearing, the priest who had called my mother to a more intimate walk with God when I was a teenager, led me further into the presence of God through healing prayer.

If you're unfamiliar with the concept of healing prayer, don't be concerned. It's simple and biblical. In short, healing prayer connects the

person praying to God, who longs to heal. The Bible teaches that God is the great Healer (one of His names is Jehovah Rapha, which literally means "God who heals"). Our God who heals desires to restore and reconcile every human to wholeness—body, mind, and spirit (Exodus 15:26; Colossians 1:20). Forgiveness is a central facet of this process, and in that season of life, I very much needed to discover God's forgiveness anew.

Healing prayer for an individual will be as unique as the person praying, and my journey included various steps. I needed to—and quickly developed a passionate hunger to—meet Jesus in every aspect of my life, in every memory. For me, this included knowing that He was present in the darkest moments of my life, whether those moments were dark because of my own choices, the choices of someone else, or circumstances entirely beyond human control.

Here's how it looked for me, step by step.

I started by relearning truths from God's Word. Passages like these came alive to me as never before:

> Praise the LORD, my soul,
> and forget not all his benefits—
> who forgives all your sins
> and heals all your diseases,
> who redeems your life from the pit
> and crowns you with love and compassion. . . .
> The LORD is compassionate and gracious,
> slow to anger, abounding in love.
> He will not always accuse,
> nor will he harbor his anger forever;
> he does not treat us as our sins deserve
> or repay us according to our iniquities.
> For as high as the heavens are above the earth,
> so great is his love for those who fear him;

as far as the east is from the west,

so far has he removed our transgressions from us.

(Psalm 103:2–4, 8–12)

"As far as the east is from the west, so far has he removed" my sin. *Thank You, God!* my heart proclaimed.

It was an important next step for me to look at my choices and acknowledge where I had hurt myself and others through my decisions. The Bible calls this recognition *repentance*. I asked for forgiveness and received it. How wonderful that was! I also needed someone to walk alongside me, praying me through the next steps of my journey of faith. I met Norma Dearing through my prayer group, and she was the precious friend to help me through prayer counseling.

Through CHM, I was encouraged to invite God to meet me in an imaginative way. This was so healing and important for me as a visual person, as an artist. And my place with God was as clear to me as the noonday sun. In vivid detail I saw a field of bright yellow flowers. Dear one, it was so, so beautiful. In the middle of the field, God showed me a stone bench, and on that bench sat Jesus. No matter what I was praying about on any given day, He always held me there, safe in His arms. Sometimes, in prayer, Jesus would hold me as a young child. Other times I was a teenager. And then I would be an adult, held there in the arms of the One who forgave me and cleansed me of all shame. I didn't have to hide any part of me or any memory from God. He knew who I was, what I had done. And all was forgiven because of Jesus' sacrificial love. He died so I could live.

In my memory I was different ages when Jesus met me in prayer, but one thing never changed. The colors were always the same—the vibrant yellow of the flowers and the brilliant white of Jesus' clothes. The work of visualization in prayer was a major component of my healing in the late 1980s. It has continued to carry me through more storms than I could recount.

My experience with healing prayer was intensely personal. Apart from the woman guiding me during different sessions, I didn't talk to people about my special place with God. Perhaps that's why an experience I had years later impacted me so powerfully.

I had driven to a church in the middle of nowhere for a prayer session. The building was small and old, yet somehow inviting. A sweet-faced secretary ushered me into a prayer room, a square space made comfortable with a well-cushioned, if worn, couch and recliner. Muted lighting bathed the room in hues of gold. The faint smell of musty upholstery reminded me of the tiny Sunday school rooms from my childhood days at church.

Two precious women were already in the room, ready to soak me in prayer. Basically, this meant what it sounds like; I seated myself in the comfy chair, and they prayed over me silently, soaking me in God's loving presence. Before I arrived I had been feeling particularly unsettled about a person I loved very much. He did not have the kind of faith that expressed itself in churchy ways. But the words God kept bringing to my mind in prayer were *release* and *receive*.

After about thirty minutes one of the women asked if she could share a picture that the Lord had given her while she was praying. She told me she saw a man, my father, walking with Jesus in a narrow stream. Black and white pebbles littered the streambed, and Jesus would periodically reach down, extract a black pebble, and throw it away. After a while Jesus took Daddy's hand and led him onto the bank and into a field.

"You were there, Anne, greeting them in the field of bright yellow flowers."

It would be difficult for me to adequately express how seen, how cherished, I felt in that moment. My concern and fear evaporated. Jesus loved me so much that He gave this woman—a complete stranger at a random church—a prayer picture of my healing place. I knew God loved Daddy and was with him always.

I'm not sure how you feel about prayer. But I know how I feel. To

borrow the lines of a beloved hymn, "I once was lost, but now am found, was blind, but now I see." God healed me through prayer, and I have never been the same.

That's why I trust Him to lead me. He led me then, and He leads me now. I know that it's safe to follow Him. I pray you'll join me in inviting God to unfold your life according to His plan. I pray you'll not believe the lie that you're too far gone, that you're too *this* or not enough *that*. Despite what the hiss of the Enemy might be, the truth is that *you are not alone, ever*. You are loved and cherished. God is near, awaiting your prayer. You have only to open the dialogue to begin.

Brushstroke Moment

If you could design a prayer place, what would it look like?
If you are willing, take a moment and ask God
to show you His special place for you.
Notice where Jesus is in your prayer place. He's there.
Don't stop looking until you find Him.

six

Anne, Who . . .

Come into the mountains, dear friend
Leave society and take no one with you
But your true self
Get close to nature
Your everyday games will be insignificant
Notice the clouds spontaneously forming patterns
And try to do that with your life

Susan Polis Schutz, in *Come into the Mountains, Dear Friend*

My mother saw the grief and guilt of my wandering twenties and urged me to pray. Daddy saw my hurt and sent me on a different transformative journey, through the Blue Ridge Mountains of North Carolina with an outdoor school called Outward Bound.

My father knew of Outward Bound because my stepmother—a partner on many of Daddy's exotic expeditions—had attended one of their ten-day courses a few years prior. My dad liked Outward Bound's mission: "to change lives through adventure, challenge, and discovery; their

aim to cultivate resilience and compassion; and their value of lifelong learning."[1] He offered to pay for me to go.

Part of me just wanted to escape, and adrenaline-pumping adventure sounded like an excellent diversion. Dad wanted me to grow, though. He saw that my resilience was wavering, and my love of learning was all but extinguished. I was wrestling with a monumental question: What should I do with my life? I didn't know how or if retreating to the mountains might answer that, but I hoped that something might shift in me, that some clarity might emerge.

Spending nine days close to nature—as in sleeping-under-a-tarp-and-the-stars close to nature—did change me in profound ways. Looking back I see how the Master Artist used this journey of adventure and discovery as a perfect complement to the colors He'd used to heal my heart through prayer.

On day one of my Outward Bound course in July 1987, two hundred people, myself included, gathered at the Asheville, North Carolina, airport awaiting bus assignments with anticipation and—at least in my case—a healthy amount of trepidation. I was an adventurous and spontaneous girl, but I knew not one soul on this trip. We were allowed one piece of small luggage, one bathing suit, one pair of shorts, one pair of pants . . . you get the idea. To join Outward Bound's intensive course, we truly left society and took very little; I took no one and didn't yet know that I would encounter my true self. I also encountered the God who made stars and mountains, streams and forests.

After a pretty miserable bus ride that first day, all two hundred of us arrived at Table Rock Mountain, otherwise known as base camp. After hours of exaggerated bumps and precipitous inclines, everyone happily piled out of the buses and devoured the fresh, cold apples offered to us. Instructors began separating us into groups of twelve, our teams for the next nine days. I waited. Then I waited. And then I waited some more. The Outward Bound staff placed me in the very last crew, a team of only

eleven, as that's how many of us were left. Bob and Natasha, our Outward Bound instructors, introduced themselves, then told our team to make its way up a steep hill.

I remember walking with my tiny piece of luggage, feeling unsure yet excited about what lay in store. It seemed as if I were leaving behind not only most of my possessions but also a lot of emotional baggage as well. I breathed deeper and freer as mountain air filled my lungs, already sensing that *something* was coming.

In a clearing at the top, Bob and Natasha led us in "name games" designed to help us get to know one another. As an organization, Outward Bound (which still runs intensive outdoor adventures like the one I experienced) wants participants to connect on a relational rather than professional level, so we were asked—respectfully—not to speak about our careers. Accordingly, team members began with simple statements about themselves, then made a game out of repeating the quick facts about one another. *John who likes to cycle, Linda who likes horses, Gena who also likes horses*, and so on.

When my turn came, I identified myself with one of my favorite pastimes. "I'm Anne, who likes to ski."

At the time it seemed simplistic, but meeting one another on this level rather than being impressed (or not so impressed) by one another's jobs allowed us to connect as collaborators, not competitors. This became incredibly important as we learned the rope-tying, belaying, and rappelling that would consume most of our next few days.

Bob and Natasha led us through practice exercises, including the Spider—a mass of strings hung between two trees that formed geometric shapes of all sizes. We had to get each group member through the maze without touching a string or reusing one of the openings. We also had to get all eleven of us over a towering wall—no ropes allowed. The final practice exercise involved our team forming two lines facing each other and linking arms to create a "catch." We took turns trusting our

teammates as we fell backward into their arms. Bob and Natasha called it the Trust Block. I got the sense that I'd have to let go of some of my controlling tendencies on this trip. A lot of this seemed to be about trust, communication, and working together. While I was far outside my comfort zone, I welcomed the chance to learn these things and dived in eagerly.

After the first few obstacles, we faced a different challenge—leaving even more behind. We were heading to our bivouac shelter (affectionately called the bivy) and took only the compass, whistle, raincoat, water bottle, and blue stuff sack Bob and Natasha had issued to us. In the stuff sack we could place a sweater, our bathing suit, and running gear. I surrendered everything else, almost relieved to leave it all at base camp. I didn't realize it at the time, but I was learning the joy of living lightly and freely.

We hiked to "Dangle Rock," where we set up camp and had our dinner—stone-ground wheat crackers, a huge block of cheese, oranges, and what Bob and Natasha identified as the world-famous GORP, otherwise known as good ol' raisins and peanuts. Around 8:00 p.m. the July sun slowly descended to the horizon in breathtaking glory.

As night fell we gathered around and shared why we had come to Outward Bound and what we hoped to get out of the experience. A few of us started the evening reserved, but as time passed, we opened up more and more. One man shared that his son had recently died by suicide. He came to heal and find new life. With intimate revelations like this, we drew together, no longer eleven strangers (or, rather, thirteen with our instructors) but now friends who would journey together.

Still I was young and unsure. People of all ages enroll in Outward Bound's intensive programs, and I was younger than all the others. I didn't know how to articulate what I wanted from the experience. Was I supposed to share with perfect strangers that I didn't know what to do with my life and hoped I might find it by being close to nature? I

wanted to learn and change and grow. And I had already been drawn in by the surrender, trust, communication, and collaboration lessons that organically arose from working through the team-building obstacles and leaving material things behind.

I didn't share much that evening. I was caught up in absorbing everything, listening to and observing the people I'd be adventuring with, while pondering my own journey. What I hoped to gain from Outward Bound was forming in real time. I felt tentative but hopeful.

Like most discoveries, things simply unfolded, sometimes imperceptibly, sometimes with force. The days that followed overflowed with opportunities for me to face my fears and support others as they overcame their own. I left the pressures of time behind (we weren't allowed watches on the trip), and let me tell you, that was a real killer for some.

Former director and Outward Bound legend Derek Pritchard created a recipe that describes the Outward Bound intensive quite well:

SELECT eleven strangers.

REMOVE social dependencies—spouses, friends, alcohol, tobacco, watches.

PLACE ON THE EDGE OF A PAN filled with unusual and stressful circumstances.

GIVE A SLIGHT PUSH and watch to see that all are fully immersed.

ADD the opportunity to learn and master skills.

STIR IN a sprinkling of natural grandeur and a spoonful of skilled instructors.

SIMMER carefully for nine days.[2]

Bob and Natasha followed this recipe to a T, and the results were remarkable.

Each day our team faced a set of challenges and obstacles crafted to help us take the previous day's lessons of letting go, trusting, and

communicating with a team to the next level. One night when I was the last to descend during a rock-climbing exercise, I rappelled perpendicular to Hawksbill Mountain at midnight. As I hung there, feeling *anything* but safe, the stars seemed to explode across the inky sky. It was scary. It was awesome. It was simultaneously exhilarating, a rush, horrendous, and mind-bogglingly beautiful. Out there, trusting a rope and people I barely knew to hold me, I experienced the reality that I wasn't in control. And somehow that was okay. It was risky and rewarding. I felt my soul expanding as I incrementally loosened my tight grip on life and embraced the freedom of trust.

We ate a lot of dried fruit and got pretty sick of bagels and GORP. We canoed down rapids that tipped most of us and ran a seven-mile Outward Bound marathon up a mountain. Sometimes we'd pile into the van that Bob drove to each new location and sit silently, in awe of what we'd encountered in nature or what we'd just accomplished. We'd sometimes offer one another words of encouragement, but often we just sat, deep in thought and physically exhausted.

I learned the term *sewing-machine legs* on a rock formation known as the Chimneys. Experiencing uncontrollable shaking while ascending a nearly vertical incline is not a fun feeling, my friend. But this, too, I overcame. I breathed deeply and continued up the rock, cheered on by my teammates and instructors.

Periodically we'd gather to discuss the components of a good crew—patience, strength, alertness, trust, communication, and compassion. Outward Bound teaches the importance of remaining fully present with yourself and the team, patience as people face their fears or dig deep to overcome, and compassionate care for one another and the earth. One day we spent several hours picking up trash around the river, caring for nature, which had given us so much.

We also spent time evaluating our strategies and performance. The goal was always to improve, never to condemn. We learned when to

communicate and when to be quiet. We smelled the sweet, crisp air at summits, and one afternoon we got lost, overheated, and beyond irritable as we attempted to navigate without Bob and Natasha.

Each of us also faced a solo night toward the end of our journey. As I lay there alone, I had space to think about the past few days, about the past few years, and about the life that lay ahead of me. I was alone and yet not alone, in the presence of the Master Artist who painted every sunset and sunrise, the very natural phenomena I had so often taken for granted during my days of wandering. I reawakened to childlike wonder.

After Outward Bound, I'd never look at the world the same way.

Brushstroke Moment

Have you ever had the experience of being alone and yet not alone? If so, what was that like for you? If not, what do you imagine that would be like? What thoughts or feelings does being alone bring up in you? Consider how being alone might sharpen your awareness of God's presence within you.

For many of us in the group, the nine days of Outward Bound marked a turning point. Some of us had come to challenge ourselves, to see what we were made of, if we still had "it." Others needed to get away, to escape society and be in the *now*, not stuck in the guilt of the past or worries about the future. Some of us needed to know that we were part of something bigger—a team, the earth, the Divine. For me, it was a mixture of all of this and more.

At the end of the trip, we placed our last names and professions in a hat. We took turns guessing which belonged to each of our friends and,

of course, there were some surprises and a whole lot of "Of course! That totally makes sense" comments.

Linda, who had bandaged her own wound after we all crossed a river barefoot, was a nurse. Of course she was! And Gena, whom I had just spent hours talking and picking wild blueberries and flowers with, told us she was a third-grade teacher.

I admired Gena and loved being around her. *That's it*, I thought. *That's what I need to do! If Gena is happy as a teacher, maybe I can be too.* My mom and dad may have said no to art school, but surely they'd be behind my getting a degree in education.

I started Outward Bound as "Anne, who likes to ski," but I left as a transformed young woman, returning home to enroll in college once again and start my training as a teacher. I thought this was it—I was going to be "Anne, who is a teacher," but I had no idea that the next chapter in my life would lead me back to the dream God had painted on the canvas of my heart all those years before.

Labels, Letting Go, and Leaving an Imprint

*It is impossible to walk on the beach without making an imprint in
the sand and taking some of it with us. Life is very much the same.
If we noticed this, we might be more
aware of our actions and words.*

ANONYMOUS

I returned home with fresh vision and vigor. Gena, who walked
along steep, rocky paths with me; crossed rushing creeks; gobbled
wild blackberries; and had a laugh that made you feel like everything
was going to be okay, inspired me to finish my higher education and
pursue teaching. I graduated from Jacksonville University the following
year, in 1988.

After landing a job as a third-grade teacher in one of the poorest
areas of Atlanta, Georgia, I moved so I could begin the next great adventure. The precious little faces that filled my classroom made my heart

simultaneously soar and ache. These kids struggled to read and write; some could hardly stay awake during lessons. One little guy cried and cried all day long. I soon discovered that his entire set of upper teeth had rotted. No wonder he couldn't stop crying! I wanted to pack him up right then and there and take him straight to a dentist. But I wasn't his mama; I was his teacher.

Midway through the year, leaders of the Georgia public school system identified an imbalance in the number of young, inexperienced teachers (like me) in struggling schools. Administrators decided to move me a few hours north to Decatur, where I took over the third-grade class of an experienced educator who would transition into the more difficult teaching situation in Atlanta. The second I set foot on Ashford Park Elementary's campus, I knew things would be radically different. That more seasoned teacher had swapped her well-nourished students with incredible family support for my impoverished and neglected pupils. I'd hated leaving them but had no choice. And so I embraced my new third graders with a heart full of love.

I decked out our classroom bulletin boards for every season—hand-cut three-dimensional flowers for spring and full-sized snowmen (with accompanying math problems!) in the winter. I made every inch of wall space in my classroom creative, festive, and fun. I adored the children in my classroom and, today, I often wonder where they are. (If you went to Ashford Park in the late 1980s and had Miss Herring for your teacher, send me a direct message on social media! I would love to hear from you.)

Every chance I got I would include an elaborate art project with our lessons. With one science unit on the ocean, I decided to teach the students how to make an imprint. So off I went, in the dead of the winter, to the local fish market, cooler in hand, packed with ice. I chose several interesting looking fish with everything from brilliant scales to beady eyes intact. I selected fish of different sizes and with unique tails, excited to bring them into class the next day.

When I described this ingenious art project to the students, a few dubious expressions greeted me. Most of the kids were eager to do anything other than multiplication, though, so together we lined a large central table with gleaming white butcher paper. I showed the class how to use paint to completely cover the fish, then roll the body onto paper and make an imprint. After breaking the kids into groups of four or six students, we started our printmaking adventure. The fish imprints were every bit as beautiful as I imagined they would be!

But there was a problem. These fish were dead (duh), and our classroom was heated. Like middle-of-winter heated. It didn't take long before a not-too-pleasant aroma began wafting from the central table. The smell of cooked fish may be appetizing, but the putrid stench of rotting fish progressively warmed by a classroom with central heat is, let's just say, less than appealing. Add to that the slimy, slippery sensation of picking up, painting, and imprinting the fish, and you've got quite the recipe for third-grade disgust.

A lot of ew-ing and ugh-ing followed before I came up with the brilliant plan to open the windows and get some air circulating. Remember, though, this was the middle of winter. Pretty soon all of us had donned our heavy coats. The kids who had finished imprinting their fish wore gloves. *Who cares about the stray flies drifting in to find the fish corpses reposing next to increasingly frigid eight-year-olds? Everyone needs a chance to complete their masterpiece*, I reasoned.

It was a mess—literally and metaphorically—but it was also a fun moment for our class. We proudly hung the gorgeous fish prints around the room.

That day I taught the class how to make an imprint. I wasn't trying to communicate a lofty life lesson about leaving an imprint wherever you go—with the words you speak and the choices you make. But as a growing and changing adult, that lesson didn't escape me. I felt so grateful that I could leave an imprint on those third graders and wanted to do that as well as I possibly could.

Oh, I loved that class and made a point to get to know each and every child. My predecessor had given me a rundown on the students, but I found so much of what she said unhelpful, possibly even hurtful. She had labeled every kid: this one's a troublemaker, this one's studious, this one can't be trusted. It took deliberate effort on my part to overcome the labels she'd placed on each child. I asked God to help me to see each little one as He created them, with incredible potential and for glorious purposes.

Brushstroke Moment

Have you ever felt labeled by someone else?
What labels have you given yourself?
When I was young, I identified myself as shy and awkward.
The labels I affixed to myself impacted me,
and the same is true of each of us.
What labels might you want to leave behind today?
The Great Artist is making you into a masterpiece, no matter
how much mess has characterized your life. His plans for you
are good; He has "plans to prosper you and not to harm you,
plans to give you hope and a future" (Jeremiah 29:11).

Creating art projects and three-dimensional bulletin boards for my third-grade classroom scratched a bit of the creative itch inside me, but still I wanted more. Sometime later I stumbled upon a local craft store where you could create a piece of pottery from the greenware stage. In the greenware stage, clay that has been slightly dried and molded can be sawed, sanded, or shaped, then fired, painted, and glazed to a spectacular finish. I spent after-school hours and weekends painting bowls, platters, and plates, diving deep into the creative spirit God had given me. I loved

my class so much, but artistic expression made me feel alive in a way teaching didn't.

One day a friend asked if she could buy one of my pieces. *Wow*, I thought. *This could actually be a business. Could I leave an imprint on the world through art?* I began to wonder. I was too busy with lesson planning and teaching to entertain these thoughts seriously, but by the end of the school year, I had quite the pottery inventory stored up.

Before heading home for the summer, I stopped in Charlotte, North Carolina. Several friends had moved there and invited me to crash at their place and explore the Queen City with them. Being a spontaneous and adventurous girl, I thought, *Why not?*

I arrived in Charlotte in the summer of 1990, a trunk full of pottery in my car. I'll never forget turning onto Queens Road West, my jaw dropping in delighted wonder. Wide, expansive lanes lined with huge oak trees drew my eyes to the sky. Stunning homes wrestled my gaze back to earth. And at the same time, I still had to look at that darn map. This was before navigation devices allowed a driver to look at the road *and* enjoy the scenery. I tried my best to balance a paper map on my lap or the dash while taking in the beauty of Charlotte.

The quaint, well-kept neighborhoods made me nostalgic for the kind of childhood I had missed. *I could raise a family here*, I thought with excitement. *I* want *to raise a family here.* After the hustle and bustle of a huge metropolis like Atlanta, the more intimate feel of Charlotte's uptown felt like a cold drink to a parched soul.

It was only day one of my trip and, while I *know* it sounds completely crazy to say, I was ready to go back to Atlanta, pack up my life, and make my home in the Queen City. And that's exactly what I did, one month later. What I had intended to be a weekend stay turned into a month-long journey of falling in love. When I returned to Atlanta and handed in my resignation, the principal actually asked me, "Who is he?"

"Oh no," I replied. "I didn't meet a guy. I fell in love with a city."

I didn't have a teaching job in Charlotte, and I didn't want one. I wasn't sure exactly how or if it would work, but I wanted to try building a business around my pottery. I wanted to be an artist again, and this time no one told me no.

eight

Chiseling

The sculpture is already complete within the marble block before I start my work. It is already there; I just have to chisel away the superfluous material.

ATTRIBUTED TO ITALIAN SCULPTOR AND PAINTER MICHELANGELO

When I first traveled to Rome, Italy, in 2008, I knew I couldn't leave without seeing the Sistine Chapel ceiling. As a painter I was captivated by the stories of Michelangelo adding brilliant color, detail, and depth to the ceiling of the Vatican chapel while standing on a scaffold forty feet high. He painted, lying prone, for *four years*. Between 1508 and 1512, Michelangelo transformed the flattened barrel-vault ceiling of the Sistine Chapel into what modern historians identify as the premier example of High Renaissance art.[1] Its beauty defies description.

When I stood beneath the Sistine Chapel ceiling, I felt awed by the masterpiece Michelangelo created. It's also impossible not to think of the Master Artist when you're there, looking at the famous *Creation of Adam*

panel in which God stretches a finger toward man, giving him life. One can't help but reflect on life and death viewing the fresco covering an entire wall of the chapel—in this, Michelangelo depicted the apocalyptic judgment day. It's a breathtakingly beautiful and completely terrifying look at the end of the world. Taken as a whole the chapel inspires awe and prompts contemplation.

Brushstroke Moment

When was the last time you experienced a masterpiece? Perhaps it was a moving piece of music. Maybe you encountered awe in the masterpiece of nature. You may think of a work of visual art, a poem, or a book. What makes that particular thing a masterpiece in your opinion? The Bible tells us that God created each of us as a stunning work of art. Ephesians 2:10 calls us God's *poiema*, a Greek word that can be translated as "masterpiece."[2] Is it easy or difficult for you to see yourself this way? Why?

When I began shaping, painting, firing, and glazing pottery in the late 1980s and early 1990s, I wasn't aiming to create timeless masterpieces like the Sistine Chapel ceiling. But I did want to create excellent work. I wanted to contribute to beauty in the world. And I loved making art my daily work.

After arriving in Charlotte I stayed with my dear hometown friend Anne Jones, who had moved to North Carolina before me, taking a job as an investment banker. To this day Anne is one of the most dependable, consistent women I've ever known. She got up early, exercised, worked hard at the bank, and made dinner every night. Our friend group always chose Anne as host for the "main course" in our progressive dinners. That girl could—and still can—*cook*! Everything that comes from Anne's

kitchen ends up delectable and devoured. I knew I couldn't stay in her little guest room forever, but I sure felt grateful for Anne's openhearted hospitality during my first month in Charlotte.

In the meantime my parents were completely baffled by my choice to give up teaching and move to North Carolina. "You're going to do what?" they asked after I told them about my plans to start a business selling the artistic pottery I created. They thought I was crazy, but I assured them that I knew what I was doing (even though I didn't, at least not really). I just had faith that somehow, someway, with enough time and chutzpah, I'd make it.

Back then Charlotte boasted an amazing creative community. In fact it still does. I discovered a craft store nestled in a teeny house not far from Anne's. It specialized in greenware and pottery. For me, BJ Crafts became a second home of sorts. I'd purchase the delicate greenware and drive it carefully back to Anne's house. Greenware, before it's fired to the bisque stage, is incredibly brittle and fragile. You take one speed bump too fast or at the wrong angle and *crack*, your piece is pot shards, not pottery.

So I would cautiously pack and unpack the greenware, setting up shop on the metal stairs in the backyard to begin my business. I can't help but laugh as I look back at that version of myself, so eager and excited, painting designs on bowls, platters, and plates.

Perhaps inspired by my maiden name, Herring (though I truthfully cannot remember my thought process from that time), I created my product line around intricate fish patterns. I called it Herring Designs. I had always loved water—the ocean, rivers, lakes—so that probably contributed to my choice. From rolling fish on butcher paper with eight-year-olds to creating fish-patterned pottery, I definitely wanted to leave an impression!

Using a clay saw I worked meticulously to carve a mouth and detailed tail on each piece of pottery. It was slow and deliberate work, but I loved

it. I'd turn the TV on in the background or listen to music, but mostly I immersed myself in the creative world inside me. I chiseled away at and painted the greenware until each little work felt like my own masterpiece, then carefully packed it back into my car and took it to the kiln at BJ Crafts, where it would be fired. I'd return a couple of days later, glaze the pieces, then fire them again.

There's no way I could estimate the number of trips I made back and forth between Anne's house and BJ Crafts. Let's just say it was *a lot*. It was also worth every minute. I adored designing my fish with stripes or cross-hatched patterns, painting details, and choosing colors. I tucked tiny, intricate flowers into the squares formed by intersecting lines. I experimented and created on the back porch's metal stairs, all while my friend Anne lived in the real world of banking.

I loved Anne, and she graciously allowed me to stay (and perhaps outstay my welcome) in her home. Eventually I found a little place of my own to rent, right across the street from another Jacksonville friend of Anne's and mine, Lee Cooney. Lee seemed so grown up to me (she was already married!), and I loved growing closer to her, popping over to chat, to suggest that we break for lunch, or to take a walk together.

My schedule included carving and chiseling, painting, and transporting pottery in various stages of finish. I'd often create into the wee hours of the morning and sleep in the next day. After all, I didn't have to bend to anyone else's schedule. It was a dream job for me.

I regularly hosted home shows where I'd sell enough pieces to cover my basic expenses while still having some fun. I marketed a bit, focusing mainly on our friend group, who were marrying off like crazy and attending weddings virtually every other weekend. I wrote a creative PR piece and mailed it to everyone I knew.

I wasn't making much money, but it was fun. My rent, bills, and entertainment were covered. Single and relatively carefree, that's all I needed.

THE HERRING COMPANY
• A SPLASH OF ENTERTAINING •

HAND PAINTED DINNERWARE

PLATES • BOWLS • PLATTERS

JOY ANNE HERRING 1042 CODDINGTON PLACE
(704) 365-8280 CHARLOTTE, NC 28211

Greetings all you single gents!

Caught in a net of friends tying the knot?

Tired of brass candlesticks?

Let me make your gift giving needs a breeze!

The Herring Co. is starting a service just for you!

You'll be hooked on these fish!

So catch this new wave and send in your stack of wedding invitations or just call... 365-8289.

The Herring Co. will do the rest!

My friends and I lived in community, spending multiple nights together every week. Back then we weren't glued to phones and computers or any of the technological distractions I see consuming lives today. Back then we lived in the moment, and, for me, most of those moments included joy and laughter.

Years later when my second daughter looked at the scrapbook of photos and memorabilia I had made of my early adulthood, she mentioned that she wished she had grown up and come of age "back then," when life seemed simple. In many ways she was right. Things were simpler; at least they seem simpler when I remember them. I didn't face the trap of constant comparison presented by social media, which can be so daunting, so discouraging, and downright depressing if you ask me.

Back in late 1990 or early 1991, someone contacted me and asked if

she could represent Herring Designs, selling my work in gift stores up and down the East Coast. I was thrilled! Every piece I created was a labor of love; perhaps you can imagine the number of hours it took to carve detailed mouths and tails, paint intricate designs, and schlep the pieces back and forth for firing and glazing. I was so thankful someone else would do the selling part.

Hopeful that I could reduce my overhead and spend far less time going back and forth between BJs and my home, I called my dad and asked him to invest with me in a kiln. "I could be far more profitable, Daddy, and I've already checked; I can get the basement of my place rewired to accommodate the kiln." My father listened, then responded kindly yet firmly.

"Honey, we're in the middle of a recession. I'm sorry, but I just can't help you right now."

I hung up, devastated. I knew Daddy loved me; his response had nothing to do with that. There was the nagging question in my mind, though. Did he actually believe I could make it as an artist? I wasn't sure, but thankfully, my dad settled this matter not too long after. On a trip to visit his friend, a successful judge in Alexandria, Virginia, Daddy walked into a little gift store. A brightly colored and creatively designed platter shaped like a fish caught his eye, and he turned it over to read the information on the back. The carefully painted words *Herring Designs* greeted him. Later that day my phone rang, and Daddy didn't waste any time with pleasantries.

"Do you still need that kiln?"

Did I ever!

Before stumbling into that little store in Alexandria, my father had no idea what I was creating. Remember, this was long before the days of instant images and digital accessibility. He needed to see—with his own two eyes—what his daughter was capable of making. And when he did, Daddy went all in with me. With a sales rep, a kiln installed, and the wind of my dad's support filling my sails, I took Herring Designs to the next level.

I continued the careful, slow process of carving and painting. I hardly noticed the time passing. There were some crumbles and breaks along the way, but I learned that I could overcome so much. It was almost as if I were being chiseled and shaped as I did those very things to my pottery. I was being changed from a woman who took someone else's vision—a dream to teach and imprint lives through education—into a woman who embraced again the dream of her own third-grade self. I wanted to be an artist back then, and here I was, twenty years later: an artist.

Brushstroke Moment

Michelangelo claimed his sculptures were already
inside the blocks of marble he chiseled.
He simply released the captives in stone.
When I look back at my life journey, I see how the Master Artist
chiseled me through high times and hard ones. God already knew the
design He had created. He simply chiseled and shaped me until I was
released from the captivity of my fears, from all that held me back.
What's holding you captive today?
In what ways have you been or are you being
chiseled and shaped? How does that feel?

nine

Restless Hearts

Our hearts are restless until they rest in you.

AUGUSTINE OF HIPPO, FROM *CONFESSIONS*

By April 1993, Herring Designs was a thriving business. I had an amazing group of friends and a solid church community. I had a close walk with God and had even worn out more than one copy of the devotional *God Calling* by A. J. Russell. What I did not have was a husband or family. And I wanted to be married and have children so badly. This longing had too often distracted me from God in my dating relationships.

I have visceral memories of falling to my knees one spring day and crying out to God. I don't mean this in a metaphorical way. I literally fell on my knees under the weight of my desire. I was thirty, successful, and still felt empty. The afternoon sun cascaded in beams around me as I told God that I was ready to surrender.

I'm sick of trying to control everything, Lord. Please forgive me for not letting go, for not trusting, for walking away so many times. I surrender everything to You.

Peace flooded my mind and heart, a peace that defied explanation; it could only be experienced. I had been waiting for marriage and family to bring me peace and settle me down. In that spring surrender, God reminded me that only He is the sure and safe source of peace. Like Augustine, I came to know, "You have made us for yourself, and our hearts are restless until they rest in you." Things or people, accomplishments or accolades, might bring me temporary peace and joy—and these were things to enjoy and celebrate! But God alone delivers eternal peace and unquenchable joy. I wanted this; I needed this. My heart was restless until I surrendered to Him that sunny April afternoon in 1993.

Brushstroke Moment

On a scale of one to ten, how peaceful is your life right now?
Is the level of your peace dependent on
circumstances or something else?
What do you think about the Bible identifying
Jesus as the Prince of Peace (Isaiah 9:6)?

Peace carried me into a lovely summer in Charlotte, and while everything wasn't perfect after I surrendered to God, everything did feel new. My relationship with God had grown so close, and I wouldn't have traded that intimacy for anything. In my case this meant choosing to set sex aside for marriage. I promised God that this area of my life belonged to Him, that I would trust Him with the journey. He knew my heart's desire—I wanted to have lots of children, a loving husband, and the proverbial white picket fence around us. If and when that would happen was now up to God; I had released the reins of my life.

God painted a fun friend into my life during that season, a spunky gal named Arlene. Arlene was a real estate broker by trade, but that summer

she vowed to become my marriage broker as well. Let me just say, Arlene wasn't kidding! That girl set me up on so many blind dates, my head spun. None of them went beyond one dinner, though. I wanted to marry a man who loved Jesus, and I knew I needed someone who made me laugh and loved adventures, so I didn't waste any time with guys who didn't fit that bill. I weeded through the blind-date options pretty quickly.

Sometime later Arlene's husband hosted an event for the University of Virginia basketball team. Before the festivities started, a tall stranger walked in, and Arlene gave him the once-over. Noticing no ring on his left hand, my friend found out his name was Clark and asked if he was married. Clark replied that he had been—for five years—but had divorced.

"And children?" Arlene asked.

None.

Bingo, she thought.

Here's the catch: I wasn't the only gal Arlene was playing marriage broker for that summer. She told Clark about three girls she wanted to introduce to him. Clark replied that he had three questions to go with Arlene's three girls. Before he agreed to meet any of us, Clark wanted to know the following:

1. Does she smoke? (Remember, this was the early nineties. A lot of people still smoked, so Clark's question was on point.)
2. Is she a member of the Y? (His discreet way of asking if these girls worked out.)
3. What does she do for a living? (Translation: Does she have vision and passion?)

To someone who doesn't know Clark, that second question might have sounded a bit odd, maybe even shallow. But this wasn't about finding a girl with a hot bod. At least it wasn't *primarily* about that. Clark was an athlete through and through—a veritable basketball stud—and

having a girlfriend (or future wife) who enjoyed being active with him was nonnegotiable. If a girl belonged to the Y, she most likely enjoyed exercising.

Arlene described me as a talented artist who owned her own business. Yes, I did work out at the Y, even taking shifts in the family center caring for kids so I could exercise for free. No, Anne doesn't smoke anymore, she promised. I had at one time, and, ugh, I still have nightmares about that smell. Clark said he'd take my number.

He decided to take the other two numbers, too, though both of those women smoked, at least according to Arlene. He opted to call me first, but I was in the Bahamas for ten days, and this was the pre–cell phone era. We had answering machines with actual tape that recorded people's messages.

Clark didn't wait around to hear back from me. He took each of the other two girls Arlene had introduced him to out to lunch. Nothing came of either of those dates, however, and by the time I got back from my trip, Clark had left another message (just in case I hadn't gotten his first one).

Arlene had told me a bit about Clark—basically that he fit the tall, dark, and handsome profile. Plus, she gushed, he was super smart; Clark had gone to UVA and graduated as a nuclear engineer. *Huh*, I thought, *this guy might be interesting.*

On Tuesday, June 29, 1993, life as I'd previously known it changed forever. Of course I didn't know when I returned Clark's call that day that I would never be the same, but life is usually like that, isn't it? We often don't see what the Master Artist is painting until that portion of the canvas is complete. I simply returned Clark's call, left a rather rambling message, and hung up, wondering if I'd ever hear from him again.

I did, around nine that night. I answered the phone, and Clark introduced himself. We talked and talked, then Clark told me he had just gotten home from playing basketball.

"I'm starving," he confessed.

Short pause.

"What are you doing right now?" he continued.

"Not much," I replied.

"Want to join me for a late dinner?" he asked.

"Sure."

"Really?"

Clark didn't yet know how flexible and spontaneous my life was. This wasn't an exception to my rule, more like the pattern. Maybe he felt encouraged by how willing I was to drop whatever I was doing, which—that night—really wasn't much of anything. Regardless of what was going on, God was in it all.

About thirty minutes later Clark arrived, and off we went to a well-known Charlotte establishment, the Roasting Company. I had just been there earlier that day, I explained to Clark. The manager had wanted to know if I would paint vegetable murals over the Roasting Company bar. I didn't take that job, but it sounded impressive to be asked. And I kind of wanted him to be impressed.

We sat in a booth talking and laughing and drinking cold beer while the restaurant wound down. Clark was tall, dark, handsome, and smart, just like Arlene had said. He was also funny and talked about his faith and work, serving at church as a deacon, and working for his ex-father-in-law, even after the divorce. Clark was clearly serious about God and passionate about his work.

After dinner he wanted to take me to see his office at R. B. Pharr & Associates, a land surveying company founded by Robert Baxter Pharr in 1957.[1] A little more than thirty years later, R. B. Pharr was the most successful business of its kind in Charlotte, and Clark was its most successful employee. With his nuclear engineering degree and a business degree from the University of North Carolina to boot, Clark dreamed of owning and running his ex-father-in-law's business once Robert Pharr felt ready to sell it.

I didn't have to be anywhere early the next day, so we capped off our first date by sharing life stories at a little joint across from his office. Clark eventually dropped me off at my doorstep, said goodnight, and that was that. My life had changed forever.

Over the next two months, Clark and I went on ten dates. I know the exact number. I left at some point during those eight weeks to spend time at the coast with my mom and her third husband, Bronson, one of the gentlest, most amazing men I've ever known. Before his death in 2011, Mom and Bronson enjoyed thirty amazing years of marriage together.

By the summer of 1993, when I was dating Clark, both my sister, Beth, and I embraced Bronson and his kids like our very own family; that's what they were! Bronson's family loved the water and boating; they owned—and still own—Lamb's Yacht Center in Jacksonville, Florida. We spent at least one week every summer on vacation with the Lamb family.

On one of those summer 1993 evenings, at the Florida Keys where my family and Bronson's had gathered to fish and grill and laze in the sun, the phone rang. Someone—I think it was my sister—answered and said, "Anne, it's for you. It's someone named Clark." She mouthed the words, *Who's Clark?* while I grabbed the receiver and stretched the cord to its farthest, and considerable, reach. This, my friend, was back in the day when phones attached to walls and good ones had cords that could stretch twenty feet or more.

I didn't remember giving Clark this number, but I must have. And I was glad that he called, so I didn't bother to ask him how he knew where I was. He wanted to know if I'd be interested in meeting his family the following week at Duck, part of North Carolina's famous Outer Banks. That sounded fun, I thought, not comprehending what this might mean for our relationship. We were just dating, I thought. Little did I know that Clark had already told his mom that he thought I was the one. I think we had kissed only once!

On the phone that night, I agreed to meet his family, and Clark

told me he would pay for my flight to Norfolk the following weekend. We could drive back to Charlotte together, he suggested. Okay. Good. I was ready to get back to my family vacation now. Clark seemed to need reassurance, though.

"You're sure?" he kept asking.

"Yes, yes," I promised. "See you soon," I said, hanging up the phone.

When I returned to Charlotte after my time away with Mom, Beth, Bronson, and our blended family, I found an overwhelming stack of mail. One envelope contained a check made out to me by Clark, fulfillment of his promise to pay for my flight to Norfolk. I just didn't see how to make that trip work, though. I couldn't believe how much I had left undone and how many other tasks had piled up while I had been living it up on our family vacation. I felt bad but called Clark to break the news that I wouldn't be coming to Outer Banks after all.

"I just have so much to do, Clark. I don't think I can get away."

My words were met with silence.

"You told me that you would come."

His voice was abrupt. Tense. Not like him at all. I could hear the disappointment in his tone and even in the silent spaces between his words. I melted a little inside.

"I'll think about it, okay?" I promised. "Really. I'll see what I can do."

Across the street I scurried to my dear friend Lee's house. I told her about Clark's invitation and about a confusing dynamic that had recently arisen. A boyfriend I had cut ties with back in April when I surrendered my life to God had initiated contact again. I wasn't sure what to do.

Lee didn't hesitate. "If you don't go on this trip, I will personally drag you to the airport."

Lee apparently recognized that Clark was a guy to treasure, not set aside.

Friday came quickly and I boarded the flight to Norfolk, curious what the next seventy-two hours might bring. Clark's parents were lovely

people and his dad an impeccable chef who plated fresh flounder and hand-cut vegetables for our first dinner together. Clark's parents and I talked for hours and got to know one another, making plans before bed to spend the next day at the beach.

Back then (and today!), if you gave me a beach chair, feet in the sand, and the sound of waves crashing on the shore, I was set for hours on end. When we arrived at the beach, around 10 a.m. the next day, my whole body melted in relaxation. The scorching summer sand threatened to burn my feet, but I didn't care. I love the feeling of the summer sun beating down on me.

I inhaled the briny coastal air in deep, expansive breaths and placed my collapsible beach chair at the point where the white-capped waves finished their long roll to shore. With every break of the surf, my chair would sink just a bit lower toward the salty water. Within twenty minutes the entire base of my chair—my bottom along with it—dipped into the ocean's exhilarating cool. I buried my feet deeper and deeper into the wet sand at the shore's edge, relishing how it squished and squelched around every toe. I think you get the picture: I *love* the beach.

I had positioned myself at the edge of the surf for a quiet time of prayer. Clark respectfully gave me room. I didn't do this to impress him; I had simply promised to pray for people in a group my mom had formed. Though we were all strangers, we prayed for one another's most intimate needs. I didn't know all the details of any situation, but I prayed Scripture over each person, trusting that God knew every particular and would act with power.

I had been praying for some time when I heard a voice ask, "What do you want?"

I turned to look at Clark, sitting some distance away but still close enough to have spoken to me. He was lounging on his beach towel, consumed with his newspaper. He clearly hadn't said anything. Passing it off

as the sound of surf crashing or the conversation of passing strangers, I returned to my prayers.

Then I heard the question again, this time in a loud voice.

"What do you want?"

I sat in silence, leaning in, asking God in prayer if He really was speaking to me. The Holy Spirit nudged my heart with a yes, so I began to tell Him how very much I wanted to be married and to have a family. *I want to follow You more than anything, though*, I told God.

Clear as day I heard, "Are you ready to trust Me?"

I was. And I did.

I looked back at Clark, chill as could be, reading his paper. I had no idea if trusting God included a future as Clark's wife, but I did feel that day the same peace that had come over me when I surrendered on that sunny April afternoon a couple of months prior. That day at North Carolina's Outer Banks, my beach chair was so close to the shore that, as the tide crashed in and rolled out, I felt the water like the presence of God washing over me. I settled into that peace while the rest of our trip evaporated in a whirlwind of fun and great food. Before I knew it Clark and I were saying goodbye to his family and heading home.

The drive back to Charlotte felt interminable. It's an eight-hour trek at the best of times, and this summer Sunday was particularly hot and humid. Clark, who really enjoys talking, kept asking me questions that amounted to the same thing: What do you want in life? I thought I was giving him clear enough answers. I had work I enjoyed, a nice business without the nine-to-five grind that allowed me to pay the bills and enjoy my freedom. I loved painting and creative expression, I explained. This didn't seem to satisfy Clark, though.

Eventually I caught on that he was asking me what I wanted in terms of family life.

Oh. Yes, I absolutely wanted to be married. And yes, I wanted kids. Yeah, probably four.

"Four is a good number," he replied.

Clark rambled on for the next six hours and finally blurted out something like, "Well, how am I stacking up?"

Truth be told, at that moment I was trying to figure out how in the world to tell him that some of his clothes smelled like old basketball sweat. This was not a particularly pleasing smell, and we had been in a hot car for hours. He was beading with sweat, and I wasn't sure how to get past the smell factor. He was courting me in his black BMW with red leather interior, and I was wondering if he knew how to operate his washing machine correctly. I guess we were both a little clueless.

Clark later confessed that he came very close to asking me to marry him on that sweltering road trip. But a professor of psychology back at UVA had taught him that if a person is in love, their pupils will look huge, almost saucer-like. After a quick glance at me and having the disheartening realization that my pupils were tiny, tiny dots, Clark abandoned his plan momentarily and dropped me off at the Charlotte airport, where I had parked my car before flying to Norfolk. He drove off chiding himself—*Anne's no more in love with me than with the man in the moon.*

But Clark, incredibly intelligent nuclear engineer that he was, didn't factor in the sun being in my eyes and how my pupils would contract in response.

ten

Great Expectations

There's a lot of fantasy about what Scotland is, and
the shortbread tins and that sort of thing.

Sean Connery, film icon and Scotsman

I was falling in love with Clark, and I was in love with the idea of love, marriage, and children.

When I invited him over to sample the mahi mahi fish I'd frozen and brought home from our Lamb family vacation, Clark chitchatted with me about this and that. All of a sudden, he announced, "I'm madly in love with you and I want to take care of you for the rest of your life. Will you marry me?"

Apparently my pupils were sufficiently dilated that night.

Though I truly wasn't expecting a proposal that night or anytime soon, I said an enthusiastic, "*Yes!*"

I remembered my conversation with God on the beach just a few days before and marveled at His timing. I could hardly believe things were happening so fast. We had gone on exactly ten dates, one of them the weekend to visit his family.

We hadn't been together very long, so I explained to Clark that I did not want to be intimate with him until we got married. "Let's get married tomorrow, then," he suggested. He was joking.

Sort of.

After Clark left that night, I called my mom and shared the news.

"I'm getting married!" I exclaimed.

Dead silence.

Then two words: "To who?"

Okay, so we had a little ground to cover with my family. Neither Mom nor Bronson had met Clark. He hadn't asked for my father's blessing. We decided to travel down to Jacksonville over Labor Day weekend to introduce Clark to both sides of my family.

I lost count at some point, but I estimate that Clark and I had gone on about fifteen dates by then. We had spent a lot of intentional time talking and getting to know each other—we were thirtysomethings, not teenagers!—but there were still so many things to share and explain.

On our drive to Jacksonville, we stopped for gas, and at the checkout Clark noticed a package of temporary tattoos. With a sneaky grin and a gleam in his eye, he proposed covering ourselves in tats for our boating date with Mom and Bronson.

"Oh no, no, *nooo*," I replied, then spent a *long* while explaining to Clark why that would not be a good idea. Mom had some very specific opinions about tattoos and other things she considered taboo—fortune-telling, horoscopes, and the like. Clark listened dutifully, nodding at all the appropriate times. *Good. He gets it*, I remember thinking.

Over an elegant dinner for four, replete with candlelight, fine wine, and a scrumptious meal, Mom and Bronson asked Clark about himself. Everything was going great until Mom asked, "So, Clark, how do you know that you love my daughter?"

My fiancé paused for less than a second, a thoughtful expression playing on his handsome features.

"Well, Mrs. Lamb, a few weeks ago I went to have my fortune read and the medium told me that I had found the girl of my dreams. But I didn't trust her, so I went to a tarot card reader. When she said the same thing, I knew Anne was the one."

If I thought "dead silence" characterized Mom's response to my engagement, this was deader than dead silence. Tension hung in thick ropes of quiet.

Clark burst out laughing before things got out of hand (and teased Mom the rest of the night). He then switched gears and told Mom and Bronson how sincerely he loved me and wanted to marry me.

Bronson had figured out that Clark was kidding halfway into his practical joke, but it took Mom years to trust that no fortune teller or tarot card reader had played a role in our courtship. To this day I'm not certain if Mom fully believes that Clark was kidding.

We spent the following morning and afternoon with my dad. Clark walked into Daddy's condo as a complete stranger. My father treated him like a friend of mine, not my fiancé, regaling Clark with details from a book he had read and memories of his time as a fighter pilot. Honestly, I don't think Clark heard one word coming out of Daddy's mouth. After a while I realized nothing was coming out of Clark's mouth either. This was *highly* unusual. He later confessed that all he wanted to declare was, "I'm in love with you daughter and may I please have her hand in marriage?" but there never seemed to be a good time to break in with this information.

Daddy chattered on and finally Clark could stand it no longer. He told Daddy he loved me and wanted to marry me and would be honored to have my hand. I kid you not; my father looked at him, slightly per-plexed, then asked, "Who are you? And how long have you been dating?" Clark explained our whirlwind courtship and our plan to get married. It was Labor Day weekend, and we had settled the wedding date for November 6, just two months away. Fortunately, Daddy was game for our wild ride.

Clark knew I wanted an adventurous destination wedding. When he had proposed, I told Clark my first choice—Paris—but that didn't fly for him.

I laughed and agreed. "What about Scotland?" I suggested. Mom and Bronson had friends whose daughter had gotten married there a year ago, I explained. They even knew a great Presbyterian preacher across the pond, Reverend Guthrie.

With Daddy's permission secured after that somewhat awkward but ultimately happy first meeting, Clark and I began another two-month whirlwind, this time planning our wedding rather than our next movie date. We called Reverend Guthrie, and he gave us all the details, then helped us with the particulars. He booked everything from the reception site to the florist. He even connected us with Mrs. Woods, the local baker. My aunt, who documented the entire wedding adventure in a journal she later gifted to me on Clark's and my third wedding anniversary, described Mrs. Woods as "a very nice roly-poly lady who obviously enjoyed her own cooking. Her house smelled like butter (one of my favorite fragrances)."

I expected that everything for my destination wedding in Scotland would be as charming as Mrs. Woods was to my aunt. My expectations were greater than reality, however. Ten of us had agreed to arrive a few days early to finalize plans, a bride squad ready to get the party started. We arrived at Malin Court—which I had pictured like a castle (or at least a manor house), nestled in verdant rolling hills with stunning vistas out every ornately detailed window—to discover it was actually a nursing facility.

The hotel portion occupied the upper floors, but the ground level, which included the reception site for my dream wedding, was a Scottish retirement home. The restaurant did have a beautiful oak bar, but that's not where Malin Court had scheduled my reception to be. The hostess took me to a room that wasn't too bad, if you like linoleum floors and metal ceiling fans.

Both Mom and I burst into tears.

We cried for a minute, then rallied and agreed that we'd make this a dream wedding no matter what. We worked with Reverend Guthrie, Mrs. Woods, and the local florist, and things really did seem to be looking up. But that was before our meal at Malin Court.

All ten of us, East Coast Americans who grew up believing that any month that ends in *R* is a good month to eat oysters, ordered them for dinner that November evening, two nights before Clark and the rest of our guests planned to arrive. Every single one of us got violently ill in the night. All ten of us stayed in bed the entire next day, food poisoning wracking our bodies and sending us, with chills, under the heavy Scottish covers in our hotel room beds. I called Clark, begging him to bring me some saltine crackers. I couldn't stand to look at another beef stew. Seafood was out of the question.

Bronson got out of bed before anyone else the following day and drove our rental car a mile up the road to Turnberry, famous for its stunning landscapes and home to the British Open golf tournament. My amazing stepfather booked the entire wedding party into new rooms at Turnberry, then arranged to have the wedding reception moved there on November 6. I had no idea he had even left Malin Court until Bronson returned and said, "Pack your bags, Anne. We are outta here."

Thank God for Bronson!

Clark arrived, and I felt better. We rushed around, securing a marriage license and meeting with Reverend Guthrie for a bit of premarital counseling, which basically amounted to him asking us, "What do you expect out of marriage?" I don't think I replied, "Sheer bliss," but that's the reality of what I expected. I imagine the good reverend tried to give us some sort of crash course on matrimony, but I was too excited and nervous to hear much of anything. When it came right down to it, I believed that because Clark and I both loved Jesus, things would just kind of work out for us. Clearly I was quite naive about marriage.

Our rehearsal dinner at Turnberry the night of November 5 felt magical; except for the haggis, it was everything I had wanted in a destination wedding. (What possesses otherwise normal people to stuff a sheep's stomach with various ingredients and eat the entire mess? I will never understand.) Haggis aside, our hosts at Turnberry pulled out all the stops, with a seven-course gourmet meal and expert bagpipers circling our table. We hadn't planned to have our rehearsal dinner on a British national holiday, but we discovered that November 5 is Guy Fawkes Night, which the Scots also call Bonfire Night. Originally begun to celebrate the failure of the Gunpowder Plot of 1605, Guy Fawkes Night now includes ball gowns and traditional kilts for the high society, colorful fireworks displays for the common crowd, and a whole lot of Scotch whiskey for everyone and their brother.

I went to bed before Clark, eager to get a good night's sleep for the big day. What I didn't know was that every Scotsman at Turnberry wanted to toast Clark's good fortune as a husband with a shot of local scotch. Not one to refuse gracious hospitality, Clark drank more that night than his body could handle. *Far more.* He didn't mean to get dead drunk the night before our wedding; he was a Christian man, a deacon for goodness' sake. But the next day when Clark's dad knocked and asked if his son needed help with his bow tie, the terrible truth emerged: Clark lay completely passed out on his bed, with the clock ticking its way mercilessly toward our 11 a.m. wedding.

I'm not even sure how she heard what was going on—someone must have told her—but my mom got wind of the situation and barged into her future son-in-law's room, anointing oil in hand. She gathered a group of family members around Clark and prayed that he'd revive. To this day Clark's dad swears it was like watching Lazarus rise from the dead. All the while I was oblivious.

Daddy picked me up in the Turnberry Rolls-Royce and accompanied me to the tiny Scottish church with the red door where Reverend Guthrie

presided, and the pews were fuller than I had anticipated. Apparently the local townspeople considered themselves invited to this foreigner's destination wedding. When the good reverend offered us the Communion cup, I looked at Clark and saw tears in his eyes. Emotion welled up within me. I had no idea that he was actually crying because the tiniest hint of alcohol made him feel deathly ill and, being a good Scottish church, there was fully leaded wine in the chalice.

Clueless and happy, I exchanged vows and rings with my beloved. Then Reverend Guthrie pronounced us man and wife. As Mr. and Mrs. Clifford Clark Neilson, we headed back to Turnberry, where melt-in-your-mouth caviar and sparkling champagne greeted us on the estate's sprawling lawn. Though November in Scotland usually dawns cold and gray, God gave this elated bride a glorious day, with streaming sunlight, verdant vistas, and temperatures in the seventies.

The sun's early afternoon rays gave the impression that God had scattered thousands of diamonds on the North Sea. A crystal-clear view of the isle of Ailsa Craig, a sanctuary for birds like gannets and puffins, completed a stunning backdrop for our wedding photos. We were an intimate party—less than twenty people—but we were quite the lively bunch. I can still hear the echoes of joyful laughter and bagpipe music. *So much* bagpipe music.

In my opinion, the traditional instrument of Scotland is captivating in measured quantities. I love that we got to experience a classic element of Scottish weddings. After a couple of hours of consistent bagpiping, however, I was ready to say thank you and goodbye. In writing this book, I went back through our wedding album. Along with the wistful tears I shed, I also laughed at how many photos feature that bagpiper. I could almost have made a *Where's Waldo?* game of spotting him in various shots.

We dined at antique cherrywood tables inside the reception hall, surrounded by the best Scotland had to offer—langoustine (a local scampi

fished along the Scottish coast), petite quiches, massive aged-cheese wheels, and mounds of fresh fruit. A swan ice sculpture glistened next to pristine silver serving pieces. Our butter-loving Scottish baker, Mrs. Woods, delivered the most gloriously moist white cake with pearly bright frosting. Bedecked with local freesia, heather, and baby roses, the cake stood on a pedestal in front of Turnberry's ornate fireplace. The sheer ivory window hangings flanking each French door fluttered in the breeze as afternoon unfurled lazily. It really was a dream reception.

At around 4 p.m., Clark and I said goodbye to our guests and climbed the historic winding stairwell to the honeymoon suite.

If you had asked me what I expected from my wedding night, I probably would have responded demurely. I certainly would not have told you that I anticipated my brand-new husband falling asleep before dark and leaving me twiddling my thumbs until bedtime. Clark had done his absolute best to stay awake and present for the day's festivities, but Guy Fawkes Night and an overabundance of scotch had gotten the best of him by nightfall. This was not how I had pictured our married life beginning.

Brushstroke Moment

Have you ever experienced an important relationship or event that fell short of your expectations? How does your perception of that experience stay the same over time? How does your perception change? Reflect on a time when things turned out worse than you expected. Then recall a time when things turned out better than you expected. In each case, how did God demonstrate His presence, love, and sovereignty to you? If you can't see it, ask Him to show you.

Thankfully the rest of our honeymoon turned out far better than our wedding night did. We toured Scotland in our fun-sized rental car,

blaring the music of Dire Straits from the one cassette tape we purchased somewhere along the way. We sped into married life with "Money for Nothing" and "Sultans of Swing" as our soundtrack. I now had the handsome husband who loved Jesus and made me laugh. Kids were all I needed to complete the picture.

eleven

There Will Be Time

The art of motherhood involves much silent, unobtrusive self-denial, an hourly devotion which finds no detail too minute.

Honoré de Balzac, French novelist, from
his "Letters of Two Brides"

Clark and I didn't waste any time starting a family. Within three months of our Scottish dream wedding, we were pregnant with our first child. Our baby girl, Blakely, came into the world with ruby-red lips and blue eyes as big as saucers. She was an ideal newborn, hardly ever crying. Until her sister made a dramatic entrance eighteen months later, that is. In a simultaneously endearing and maddening toddler way, Blakely made it quite clear that she did not want to share Clark's and my attention with this infant interloper, her sister Catherine.

Catherine was every bit as beautiful as her older sister. Not nearly as quiet, though. She cried—boisterously and frequently—through her early days. Despite the wails and the tantrums, I loved being a mama to these precious little girls. Almost before I could catch my new-mom

breath, only sixteen months after Catherine's birth, our third daughter, Taylor, bounded into our lives. For reasons known only to her and God, Taylor decided to be born breech, so we had a scheduled C-section with her. That was different for me, but it ended with another healthy, beautiful baby, and that's all that ultimately mattered.

My girls were beyond adorable (I'm sure I'm in no way biased), and I'd doll them up for Sunday services in matching smocked dresses and bows bigger than their sweet little heads. I bought a three-seater jogger (purplish-pink, in the height of nineties fashion) and pranced around the neighborhood, hands and heart overflowing.

Clark and I had agreed that four children was a good number, and here we were, three years into marriage with three of the most gorgeous, precious, and healthy babies on earth. Yes, life was a bit chaotic, but we had started our family in our thirties. We thought we were ready for baby number four.

I had no trouble getting pregnant again, but shortly after my test came back positive for new life, our doctor informed us that the pregnancy was not viable. *This cannot be*, I thought. "Check again. The ultrasound machine must not be working," I said. But there truly was no heartbeat, and I listened in stunned devastation as the doctor explained I needed to schedule a D&C.

The day of my procedure happened to fall on an election day, and Clark asked me if I wanted to vote "on our way." What? Are you kidding me? I cried—a lot—and pleaded with God to tell me why. I'm certainly not the only woman to go through miscarriage and D&C, but I felt so alone and sad.

With kindness and grace, God held me during that time. I trusted Him and surrendered the heartache.

My ob-gyn assured me that I was healthy and could try again. I needed time to restore my courage, though, to trust that I could carry another baby full-term. Several months later Clark and I discovered that

we were pregnant for a fifth time. I prayed and prayed that this baby would be as healthy and strong as Blakely, Catherine, and Taylor. I did all the "right things" a newly pregnant mama is supposed to do and not do during the early stages. Clark and I eagerly anticipated the appointment when we would hear the baby's heartbeat, and pretty soon there we were, in the doctor's office, the cold wand-shaped device of the ultrasound machine rolling over my little belly, searching. Searching. Searching.

Searching and finding nothing.

The doctor who had delivered my girls, the doctor who had prayed with me and treated me like a daughter more than a patient, had retired prior to this appointment. I was in the cold, sterile office of a new ob-gyn who practiced with a team of doctors. This was the first time I had seen him, and his gruff manner was beyond straightforward; it bordered on unfeeling.

"There's no heartbeat," he stated with zero emotion, washing his hands with disinfecting precision.

"There will be," I insisted. "Have some faith."

Perhaps the doctor was annoyed at my suggestion that God had anything to do with this. He virtually sneered, repeating, "There *is no* heartbeat" with far more emphasis on the "is no" than any empathic person would include.

Only the humming drone of medical machinery and fluorescent lighting broke the ensuing silence.

I looked at the screen and willed there to be a thumping heartbeat. I wanted to know a little life was growing inside me. But the sonogram revealed only a small blob of white. I had the bizarre thought that it looked like an undigested bean in my tummy. *Maybe it's just too soon,* I hoped. *Maybe our dates are off, and they just can't detect the heartbeat yet.* The pregnancy test had been positive; I was having symptoms of morning sickness. Or at least I thought I was having symptoms. But no, the doctor insisted. This pregnancy, too, would end in miscarriage. And another D&C.

Clark and I left without another word. Thank God he didn't say anything about running an errand or voting. My heart felt crushed, and I desperately wanted my husband to hold me and tell me everything would be okay. But I didn't know how to ask for that, and I don't think Clark knew how to console me. We had sort of figured out what *not* to do last time around, but that didn't mean we knew what *would* help to alleviate the agony of this second miscarriage. So I held in my hurt and soldiered on; I had three beautiful little girls after all, and I wanted—indeed, I needed—to care for them.

God mercifully met me through an incredible group of women from my Bible study who gathered around me to pray. After that second miscarriage, the women I had studied God's Word with and prayed with rallied around me in amazing ways. Their support and prayers helped me reach out to God, to begin the journey of acceptance. *Do You want me to have only three children?* I asked my heavenly Father. *If so, they are enough. They are precious, Lord. Thank You for my wonderful girls. Help me to know if You want me to try again or be at peace with the family You've given me.*

A bit of a tug-of-war went on inside me. I had learned to trust God and I wanted to surrender my future completely to Him. I even felt a tad greedy wanting another baby when I had three healthy kiddos already. Some women who miscarry never have what I had already been given. I felt guilt and confusion when I evaluated how the choices of my past might be influencing my experience.

I wrestled with my thoughts. *Have I grabbed hold of control again?* I wondered in prayer. *Have I pushed You out again, Jesus, placed You on the outskirts of my life?* The answer to that wasn't entirely clear, but the journey of dialoguing with God led me to a new depth of surrender and trust. God met me in that small group of praying women who sought Jesus together. They interceded for me, and we also spent time in silent, personal prayer together. It was exactly what I needed to get through the valley of sorrow miscarriage had brought into my life.

Brushstroke Moment

What gets you through the hardest moments in your life?
You have read that, for me, it's dialoguing with God in prayer.
What has your journey with God through
heartache and suffering been like?
In my experience, pain makes people bitter or better.
It's not easy to surrender, to become stronger through rather than
soured by our heartaches, but I've discovered that *is* the better path.
Do you agree or disagree?
Dialogue with a friend about this and consider praying together.

I cannot remember why, on Valentine's Day in 2000, I took a pregnancy test, but something prompted me to just check. When a hot pink cross formed on the stick, my reluctance and fear of disappointment changed instantaneously. I called Jane—yes, the very Jane I'd taught Sunday school with in high school—and told her I was pregnant. We had both grown in our faith since the days when sixth graders performed the Christmas story for us from the donkey's perspective. Jane was now a prayer warrior. And she wasn't a bit surprised.

"You may not believe this, Anne, but I was just in the chapel praying for you, asking God to give you a clear sign about having another baby."

Wow. God made Himself clear that day, with a literal pink cross showing me the way.

Though I felt cautious over the following months, I also felt at peace. I didn't want to endure another loss, but I also didn't want to expect the worst. I prayed and trusted as best I could, knowing that God would be with me no matter what. God showed me during this pregnancy that prayer could push fear out whenever it tried to creep back in.

The little baby in me grew, and the day arrived when we could

determine our little one's gender. Clark and I had never found out with our girls. There was just something about going through brutal, excruciating labor and then hearing the joyful words "It's a . . ." as a celebratory reward. With Clark and my sixth pregnancy, though, I wasn't sure I cared whether it was a surprise or not. My husband remained adamant.

"I don't want to know," Clark insisted.

"Yes, you're right," I agreed.

And I did agree, at the time.

Then came the one appointment in all six pregnancies that Clark had to miss. In a moment of weakness or insatiable curiosity or who knows what, I asked the nurse to tell me if our baby would be a girl or a boy.

"Are you sure?" she asked.

I was sure.

And I sure was surprised when she announced, "It's a boy."

I had to keep a tight wrap on that secret for a couple of months, but oh, was it worth every moment of self-control!

While I kept our little-boy-surprise tucked away, the pregnancy continued in health and strength. Every Friday morning I would waddle with my expanding belly into a prayer time expectant and grateful. My prayer group—we called ourselves the Butterflies—rotated meeting in one of our homes each week.

One Friday at my dear friend Anne Cochran's house, God met me in a powerful way. We had scattered around the living room for a period of silent personal prayer and worship. I stood (on totally swollen feet) with eyes closed and hands lifted, praising and praying with my protuberant belly. I felt hands on my womb and assumed one of the Butterflies must have been praying over my baby. I felt comfort and peace through the touch of those hands, and I was so thankful.

I opened my eyes to connect with whoever of my friends was there, but everyone was lost in their own moment of worship. I believe I

experienced a physical touch of God that day. The Lord's hands have literally been on my son since before his birth.

Because God brought our third daughter, Taylor, via C-section, there was some question as to how I would deliver our fourth child. I wanted to deliver naturally—no surgery, no drugs. Though it wasn't common practice back then for mothers who had previously delivered C-section, my doctor approved my all-natural plan. Baby and I were healthy enough to try, he affirmed. So six weeks after God's hands rested on me during prayer, and armed with an extra-large portable CD player, I was admitted to the labor and delivery unit at our local hospital.

The Butterflies and I had recently discovered Sheila Walsh, an amazing worship artist who just happened to be Scottish. Her album *Blue Waters* instantly became one of my favorites. I blared Sheila's music on repeat for twelve hours of labor. I was spent. "Give me the darn epidural and let's move on," I moaned.

Not too long afterward, Clifford Clark Neilson III made his debut. We called him Ford, and his birth blew the winds of pain, sadness, and disappointment out of my mind.

The girls were wonderful older sisters (mostly . . . haha!), and the following days were a blur of mothering. Let me rephrase that. The following *years* were a blur. I went from changing countless diapers to feeding countless Cheerios to picking up countless toys, driving countless carpools, and arranging countless playdates. And I loved being Mom to my boisterous brood.

I had placed a pause on my pottery business shortly after Blakely, our oldest, was born, and I didn't consider that choice a sacrifice. I *wanted* to be a mom, and it felt right and good to set my art aside for a time. I was painting with different brushstrokes during those years, learning the art of motherhood. I so wanted to master that important role.

Several years later when I attended a friend's art show, the reality of what I had given up hit me. This friend, along with some other women I

knew, had recently begun to paint. I came home the night of the art show and sobbed to Clark, "I need to create; I need to paint." I tried to explain the void I felt, the empty place where art had always been inside me.

Clark was so gentle and loving. He held me, and I will never forget his words. "Anne, there will be time for that again. Be with the kids while they are young."

My heart immediately resonated with the wisdom in what Clark encouraged me to consider. The artistic expression in me was silent then, in the midst of all the details a mother must manage, but it hadn't gone away. I sensed that the desires of my heart to create and add beauty to the world would reemerge at some point. I felt God affirm to me that I needed to wait and trust rather than force the timing. It was simple, but—like many simple things—it wasn't exactly easy. I knew it was right, though, and God carried me through the early years of motherhood with a beautiful mix of faith, surrender, joy, and tears.

Brushstroke Moment

When was the last time you set your own desires aside for someone else?
Have you seen God's beautiful brushstrokes in your own
seasons of self-denial—perhaps through caring for an aging
parent, taking care of children, or your profession?
It's not wise to subvert our own needs constantly, but at
times choosing self-denial can be the best decision, not
only for others but even for ourselves. This has become
especially clear to me through motherhood.
Do you agree or disagree with my discovery?

twelve

The Art of Building a Home

Unless the LORD builds the house,
the builders labor in vain.
Unless the LORD watches over the city,
the guards stand watch in vain.

KING SOLOMON, A SONG OF ASCENTS, PSALM 127:1

With four kids and a busy life, our family home started to feel pretty small pretty quickly. Clark and I prayed and decided we'd begin the process of looking for a plot of land; we wanted to build our family a forever home.

In early 2001 I had been praying and journaling after reading the Old Testament. God led me to meditate on 1 Kings 3:10–15, which explains how Solomon asked God for wisdom rather than any other gift. Solomon was granted the privilege of building God's temple, and I came away from prayer one morning with an intense desire to honor God with building our family home in His way, in His time, with His wisdom.

We worked with Gordon Hunter, a builder friend and former in-law

of Clark's. He showed us a lot he owned, and I was astonished and delighted to discover it backed up to a street ten houses away from my sister. Beth and I had become close through the early years of motherhood. Considering how I treated her during childhood, I felt incredibly grateful for our relationship and the relationships our kids enjoyed. They were more like siblings than cousins. In a veritable stair-step fashion, our children were born one after another, all of Beth's kids arriving between when I delivered Blakely and Ford. The lot Gordon showed us seemed the perfect place to build; our kids could run back and forth between our houses.

To draw up the blueprints, we hired a man who ended up being a cookie-cutter home designer. In our first few meetings, he showed us plans that he considered fully executed, but I didn't want a cookie-cutter house.

"I'd like this window here," I'd suggest, or "I want to knock out this wall here."

"You're fired," he said. Well, he didn't use those exact words. But that's what he meant.

Clark and I left his office, stunned.

"Maybe we aren't supposed to do this. Maybe we made the wrong decision," I told Clark as the elevator doors closed.

That meeting with the unyielding home designer happened on a Wednesday morning. We went directly back to Clark's office for the Bible study he hosted every week during Wednesday lunch. By this point Clark had purchased the land surveying and mapping company R. B. Pharr from his ex-father-in-law, and Clark honored Robert Pharr by keeping the company's name and continuing the great work Robert had begun many years prior. One way my husband did this was by investing in his employees, not just as workers but as people. He brought in a pastor every Wednesday to encourage the team and speak words of life, even to those who might not have a relationship with God.

That particular Wednesday Pastor Gene led the weekly Bible study,

and we chatted in Clark's office about what had happened that morning. "I know a great architect," Gene told us. "Allison Pell is an amazing man and loves God," he continued. Could it be that the rejection we received that morning was actually God's protection, leading us toward something better than we could know to ask for? The Bible explains God's above-and-beyond abilities in Ephesians 3:20–21: "Now to him who is able to do immeasurably more than all we ask or imagine, according to his power that is at work within us, to him be glory in the church and in Christ Jesus throughout all generations, for ever and ever! Amen." Isn't it wonderful that our God can do "immeasurably more than all we ask or imagine"?

Brushstroke Moment

A dear prayer-warrior friend once told me that
rejection can be God's protection.
That wisdom stuck!
Indeed, I frequently remind my kids of this, especially
in conversations that involve dating.
Can you think of a time when rejection turned out to be a protection?
Trace the brushstrokes of your life and consider how
God might have moved to protect you through a
situation that seemed really terrible at the time.

Two days later Allison Pell strolled into Clark's office. He opened our meeting in prayer, and we immediately sensed God's presence. I got the impression this would be a completely different experience than we'd had before, and it was. I met with Allison every few weeks and we pored over options and details. With every decision Allison and I would pray Psalm 127:1, "Unless the LORD builds the house, the builders labor in vain." We covered the entire process in prayer, start to finish.

By the time our builder, Gordon, came to review the plans, Clark's and my forever home had grown larger than we had initially expected. Allison and I had worked for nearly a year and a half to execute the plans; we were almost ready to release the finalized drawings. When Gordon said, "I can't build this house for the amount I quoted you," I was devastated. But I had to trust the process. I had to surrender to what God was doing, even if I didn't like it or understand.

"Please, Gordon," I replied. "Please just run the numbers before you make a decision."

Clark and I had not entered into this lightly; Allison and I had prayed over every detail. There had even been a time, somewhere around the middle, when I sensed a nudge from the Holy Spirit telling me to surrender the plans to Him once again. I hadn't even realized that, over the months, I had begun to cling too tightly to my plans. That night after Gordon's announcement, I rolled up the working blueprints and told Allison that I needed to get my priorities straight before we looked at the drawings again. They stayed tucked under my bed for weeks while I reoriented myself to God's plans. Though Gordon told me the plans wouldn't work—at least not within our budget—I trusted that God would build this house. I didn't know how, but I was willing to wait and trust.

Three or four weeks of waiting later, Gordon delivered a quote. I sat down with him and the rather ominous-looking black notebook he carried. What was inside was anything but ominous, though. It held the best possible news.

"I honestly don't know how it worked out. I've added and re-added the numbers multiple times. I can build this house to your specifications for one dollar less per square foot than my lowest quote."

Precisely one dollar less.

I had known God as the Master Artist in nature. I had seen His creativity in my work, my children, my marriage. Now I had a front row

seat to watch as He painted a family home into our lives. It was so faith-building, so stretching, so marvelous.

The day finally came to dig and pour the foundation, and I asked my prayer group, the Butterflies, and our pastor, Steve Eason from Myers Park Presbyterian Church, to join me before construction began. Steve brought the Presbyterian denomination's liturgy for blessing a home, and my Butterflies showed up overflowing with the power of God, the Holy Spirit. One by one, my sister-warriors prayed Scripture over our home-to-be, asking God to be the light in this house, that every detail and every worker would remain in His care. They praised, prayed, and worshiped. The Holy Spirit broke out in Pentecost-like ways. Afterward, Pastor Steve and Gordon both confessed that they'd never experienced anything quite like it. God was truly building this house and building the faith of everyone involved.

The enemy of God likes to throw down discouraging obstacles, though, and it wasn't long before the digging crew let me know that we had "bad dirt" on one entire side of the property. Whereas a typical footing requires a team to dig a few feet down, this project would require a ten-foot dig on one side.

"We won't have enough concrete to pour the foundation, Mrs. Neilson," the contractor reported.

Whether or not it was strictly accurate, it felt as if the whole house of cards would collapse if the foundation couldn't be finished that day. We had timelines and deadlines. We had a strict budget, and paying the crew for an additional day of work—plus more material—would have been a genuine stretch for us. I initially felt deflated, but I refused to stay discouraged. I wasn't sure that day's concrete would be enough, but it didn't matter; I was going to trust the process, however long God took to reconcile this "bad dirt" issue. The kids and I even decided to plant silver crosses where the wet concrete would eventually dry into our home's foundation.

When Clark and I returned that night to check on the construction team's progress, we discovered that, despite the extra digging, there was *just enough* concrete to finish the foundation.

Brushstroke Moment

There have been times God revealed a whole lot of
"bad dirt" in the foundation of my heart.
His purposes include digging that out. Not just some but *all.*
As we allow Him to do this excavating work in our hearts,
He pours the firm foundation of His promises and truth inside us.
That's when we can stand firm and unmovable,
no matter what storms rage.
Is there any "bad dirt" hanging around in your heart and mind?
If so, take a moment to chat with God about it.
He's ready to move in power on your behalf, digging it
up and replacing it with His firm foundation.

As God built our home, He taught me so very much. If the excavation team had ignored the "bad dirt" and dug only the standard footing around our home, one entire side would have been weak, vulnerable to collapse. Over time the stresses of weight and weather might have caused the house to cave in.

Our God is too good to allow that to happen to us on a soul level. If we invite Him to, He will build His home in our hearts on the firmest of foundations. I praise God that He is not just the Master Artist but the Master Builder as well.

thirteen

Returning, and the Reward of Giving Back

For everything there is a season,
a time for every activity under heaven.

ECCLESIASTES 3:1 NLT

Life was beautiful. Life was crazy. And our four little ones grew, delighted us, and made their way through every stage, with Clark and I perpetually running to keep up.

During their elementary school days I hosted neighborhood classes I called Art and Soul. I would lead the kids who came to our home—sometimes twenty at a time—in an art project and correlating Bible lesson. One of my favorites involved a beautiful hand-painted bowl. I'd show the children how lovely and complicated the inner pattern of the bowl looked, how full it seemed even though it was empty. Then I asked them to tell me ugly things that people do.

"Lying," someone might say.

"Being mean to my sisters."

Hold on. Was that my son, Ford?

"Cheating on a spelling test," someone else might pipe in.

"Hating people," another would suggest.

We'd write each of the ugly things on pieces of paper, crumple them up, and put them in the beautiful bowl. After a while I asked the children to notice how much of the bowl's beauty was covered up by the ugly things, the things I told them were called *sin*.

"You can't see the flowers anymore," one of the observant kiddos might offer.

"That's right, honey," I responded. "The ugly things we do and the ugly things people do to us make it hard to see the good things in life."

Insert adorable nodding and sounds of affirmation from small children here.

"But God made a way to help us," I promised.

Then I would take the bowl to the trash can and dump out all of the ugly things written on crumpled pieces of paper.

"He calls it *repentance*," I explained. "It means you tell God that you see those ugly things, you don't want them anymore, and you need His help to get rid of them. And guess what? Jesus came to earth to get rid of all that bad stuff. You can talk to Him just like you talk to your best friend, only He listens better and knows best. He will help you throw away all the ugly stuff—every day—if you ask Him."

Then we'd dive in to an art project, make a gorgeous mess, and send all the kids home with a craft to show their families. I loved planting truth in little lives—not just my own children but also their friends and our neighbors—in ways like this.

Clark and I also loved our home. Our kids thrived and they did indeed run back and forth between my sister's home and ours. It was a fulfilling and busy season, but a part of me remained on pause. I trusted that God would make clear when to create my own artwork again. I

waited as patiently as I could. I remembered the conversation Clark and I had years ago after a friend's art show, the time I told him—through tears—"I need to create; I need to paint." I recalled my husband's gentle, loving words: "Anne, there will be time for that again. Be with the kids while they are young." I had done that; our children had all started school, and I now had several hours alone each weekday. I was excited to begin exploring creatively once again.

During my hiatus from professional art, I had decided to give up pottery—too messy!—and try my hand at painting. Allison and I had included a studio in the plans for our family's forever home, and the sunny studio just off the kitchen in our family home was ready to be filled with canvases and color. After we settled into our home and the kids settled into the rhythm of school, I felt the green light from God: it was time to return to the creative passion He had given me.

My first forays into painting were—how do I say this nicely?—a complete disaster. At least that's how they felt to me. I didn't know what to paint and stared at quite a few blank canvases, believe you me. When I got an idea, I didn't feel able to bring it to life in a way that satisfied my creative spirit. To spark inspiration I decided to rummage through old photos from Mom's travels with Bronson, my beloved stepfather. The two of them were jet-setters, always traveling to incredible locations and bringing home the pictures to prove it. I did a simple oil painting based on their trip to Normandy, France, and Omaha Beach.

Huh. That's not too bad, I thought, turning to look at the canvas with a mix of pride, astonishment, and excitement.

Inspiration struck again: Fruit! That's what I need! Determined to try a still life, I hurried into the kitchen to retrieve some pears.

Hurrying back to my studio, I placed two perfect pears in the makeshift light box, delighting in the placement of shadow and shape. Praise music played while I went to town with my palette full of colors. I mixed and experimented and scraped off the bits that didn't work. Oils are quite

forgiving when wet, and they take a long time to dry; I found them the perfect medium for a messy artist like me, who loves to play.

In those days I had as many tubes of paint as colors in a max pack of crayons. The more the merrier, I assumed. I happily squeezed Prussian blue, viridine green, or Vandyke brown from brand-new tubes. Once I matured as a painter, I discovered that I could mix and blend primary colors to create my own hues. That fascinated and thrilled me. Today I paint with a very limited palette at one time—usually four colors or fewer—and enjoy bringing a subject to life with less, not more. The tones I select change from painting to painting, but I've never returned to the "come one, come all" approach to my color lineup. Back then, however, I was squeezing every possible option onto my palette, eager to make my pears as perfect as God had designed them to be.

Afternoon arrived way too fast and, before I knew it, the school bus dropped my kids back at home. Catherine, my middle daughter, walked by the canvas I had been working on all day and said, "Mom, I think you need art lessons."

Not gonna lie, I was crushed. I loved my little pear painting. I loved the colors. I loved the composition, even if it was quite simple. I loved that I had been able to create depth by mixing everything on my palette.

Instead of letting my daughter's words wound me, I put them to work for me. I enrolled in classes with a local art legend, Andy Braitman, whose studio in Charlotte originally opened with two classes—one for teens and one for adults. By the time I joined, Andy's roster topped one hundred students. He had a full support staff and a number of exhibiting artists who fought to display their work at Braitman Studio.

It's not an exaggeration to say that Andy is a man of many geniuses, including the masterful ability to bring out each student's unique artistic voice. He worked with people at every level, from absolute beginners to already accomplished artists, and to each one Andy offered encouragement and support.

When I think of Andy's gifts and all that he helped me to discover within my own creative spirit, I'm reminded of how masterfully the Master Artist operates within us. Andy never forced his methods on his students, and God doesn't create us alike or force us into boxes. In fact I think we actually put our *very big* God into a *very small* box all too often. God wants to cultivate our unique gifts, whether those be in fine arts or the art of parenting, building bridges, settling accounts, or any number of things. He offers us support and encouragement as He draws our true selves out, enabling us to be and express all that He's made us to be.

Brushstroke Moment

Do you think of God as the Master Artist who wants to bring out your unique gifts and voice? If so, how has He done this in your life?
If not, what do you believe God wants to do in and through you?
How did you form those ideas?
I've noticed that, as we learn more about Him, God reveals that His brushstrokes in our lives are *always* for our good, even if things periodically look like a mess on our life-canvases. I invite you to consider that where we see a mess, God is actually painting a message.
What do you think?

At home in my sunny studio, I continued to experiment with the tools, tips, and nuggets of wisdom I had gleaned from lessons with Andy and my own journey as an artist thus far. I always painted with praise music playing and decided one day to try a painting that would reflect my faith. I experimented with some abstract crosses but didn't connect with what I had created. So I mixed and layered, and mixed and layered some more, until a figure emerged.

An angel.

The canvas was tiny, a five-by-seven frame. I sent an image to my sister via email (even though she lived ten houses away) and asked what she thought. Beth's response was almost immediate.

"Wow, I love this. I think you've found your voice."

I painted another little angel, then another. I sketched angels on pieces of paper, practicing form and composition. I'd work with my palette knife on canvases, trying different strokes and layers. It was absolutely exhilarating.

Eventually I was ready for my first little exhibition. I didn't want to be the sole artist, and I knew a lot of talented friends, so I put together a plan for a pop-up art show involving several of us. We all agreed to donate part of the proceeds to support a ministry to teens called Young Life. I loved pairing my art with a purpose—giving back to God in gratitude for all He'd given me.

For two days that fall, my home transformed into an art boutique. Every nook and cranny, from entryway to back porch, boasted space for a different local creator's wares. A gal who crafted handmade belts—fabulously thick, quilted belts with sass—brought her goods and set up shop. My friend who painted watercolors arranged both canvases and notecards in a lovely display. I had become acquainted with a man who traveled to the Middle East and personally selected rugs to sell in the United States; I rolled out the luxuriously woven carpets in the den and living room to the general *oohs* and *aahs* of those who came to buy. My sweet friend who sewed blankets and other adorable items for babies daintily draped her petite products on furniture and tables. I made countless cookies and brewed more coffee than I imagined possible. The house was hopping, the energy contagious. It was so, so fun for me.

And in my kitchen, perched on the countertop, I lovingly placed my first canvases. When that first home show occurred, I had not yet begun to paint angels for purchase. The tiny five-by-seven original oils I sold at my first home show were still lifes and nature scenes. With every

piece that sold, God grew my confidence and joy. I thought back to my little-girl self gleefully hawking my puka shell necklaces and handcrafted pocketbooks. How happy she would have been to know that one day she'd be hosting a pop-up art show bustling with shoppers who snapped up her oil paintings.

By the end of the second day, I was simultaneously exhausted and exhilarated. My kids leaned heavily toward the exhausted side of that equation. They probably thought I had gone a bit crazy; when had I ever missed snack time before? Clark was an amazing support, though, and everything did return to normal at our house after a few days of cleanup and counting.

The final tallies came in and, as a group of artists, we had raised $2,000 for Young Life. It's no exaggeration to say that few things delighted me more than writing the check to give that two grand away. We knew that Young Life would use every dollar to reach kids with the hope of Jesus.

Way back when I first started earning money as an elementary entre-preneur, Mom had taught me about giving back, which she told me is called tithing. Both my parents taught me about hard work and doing everything with excellence too. If I were babysitting, you can bet those parents came home to a spick-and-span house. If I earned twenty dollars, I gave two dollars away. I gave 10 percent back to God no matter what. That's just how it was. Now that my artwork was generating income, I could return to giving from what I had made. Clark and I tithed for our family, of course; selling artwork was simply one more way that I could return to God a piece of what He'd given me.

Brushstroke Moment

What is your current view of giving?
Do you practice tithing or donating to charity? Why or why not?

When I trace the brushstrokes of God on the canvas of my life, I see His stunningly generous artistry. I'm simply trying to follow His example by giving back generously. In what areas or ways has God been generous to you?

Our team of local artists hosted three more home shows. We gave thousands of dollars to a variety of organizations focused on helping children. Clark and I also established a tradition of inviting my artist community and his business community, plus all of our church friends and their families, to one massive Christmas party each year. We requested that every individual or family bring a top-quality toy to donate to a local children's charity. We regularly welcomed more than a hundred adults at those parties; I'll leave you to imagine how many kiddos were running underfoot!

We set up cookie-decorating stations, where kids frosted cute cutouts of Christmas trees, stockings, and snowmen. Sprinkles and colored sugar crystals seemed to proliferate, finding their way into the most unexpected locations. And I loved watching the happy faces of the children (some of whom had equal amounts of frosting on their faces and their cookies) as Santa Claus made his appearance.

I had met a gentleman—at a movie theater of all places—who looked just like the traditional image of Saint Nick. No joke, I asked him on the spot if he was for hire. He agreed to come to one of our parties and enjoyed it so much that I engaged him for a second year.

Nothing—not the catered Christmas feast or the laughter of many friends or the delight on kids' faces when Santa arrived—compared to the stunning generosity of our friends and colleagues. They went beyond above and beyond! Our house busted at the seams with bicycles, clothes, and every type of toy imaginable. I remember one year in particular when my kids had grown up enough to help Clark and me load the Suburban

and deliver the donations. I thought back to what my mom and dad had taught me. I was now passing the joy of giving back to my own family.

Whether I was delivering checks or clothes or children's toys to the local chapters of charities, I never questioned the why of donating time, money, and artwork. It made sense to me. I had so much—so many blessings, so many privileges. How could I not give back to Him? Plus I felt so happy and fulfilled when I gave. Some people who haven't practiced sharing their resources don't know yet the joy that comes when you give back. I'm glad Mom taught me about tithing way back when, because it would come to play a significant role in my journey as an adult artist. Stay tuned, because we'll return to the joy of giving back in chapters to come.

fourteen

Divine Appointments

God is setting up divine appointments all the time. . . .
We can't create divine appointments.
All we can do is keep them.
We can't plan God-ordained opportunities.
All we can do is seize them.[1]

PASTOR MARK BATTERSON, *DRAW THE CIRCLE:*
THE 40 DAY PRAYER CHALLENGE

Sometime after that first art show, I heard Pastor Barbara Brewton speak about her work with people experiencing homelessness. Barbara's husband had been murdered walking home from work one night in the Fairview Homes / Double Oaks community in Charlotte, leaving her to raise three young children as a single mom. She might have become bitter, but she allowed God to do a better work instead.

"The Lord told me to go back and help that neighborhood," Barbara informed my Sunday school class. "So I did."

Barbara, along with her sister, Rosa, opened a food pantry and

ministry called Harvest Center. Barbara refused to sit idly by, watching violence destroy more lives. She went straight to the top of Charlotte's leadership ladder, to then-mayor Richard Vinroot.

"Barbara Brewton was a lady you had to respect," Vinroot once told me at an event. "You had to listen because she would come up and almost grab you by the collar and say, 'Let me tell you something we need to do.'"

I laughed. That was Barbara all right.

Early in Harvest Center's ministry journey, after another brutal murder, Barbara called Vinroot and demanded, "I want police officers here. I want this place patrolled. This has got to change, and you're responsible for it."

He respected her enough, Vinroot told me, that he needed to respond.

By the time I became a volunteer at Harvest Center, God had already done so many amazing things through Barbara and Rosa. It was Rosa who greeted me on my first day as a volunteer, a bitter cold Tuesday morning. I started in the kitchen, helping to prepare a meal that would serve around two hundred people experiencing homelessness that winter.

Rosa grabbed me from my kitchen job, though, and asked me to find a coat for a man who had come in with no winter clothing. His dirty, baggy pants hung on a body diminished by hunger. I noticed his stained shirt, pockmarked with a variety of holes, and a pair of shoes clearly too small for his feet. I tried not to stare, hoping I hadn't made him uncomfortable in any way. Thankfully Rosa gave me a practical way to help, pointing me toward the coat closet, the place where donated clothes were stored. I couldn't do everything for this man, but I *could* find him some winter items. I opened the coat closet with a determined attitude.

Almost immediately I felt shocked and sad. I could not believe the condition of some of the items that had been donated. Many were torn or stained; some were in absolute tatters. I felt almost ill. Was this what people were "generously giving" to the men and women patiently waiting for food in the other room? I wasn't exactly angry with people who had

dropped off crummy clothes at Harvest Center, but I sure felt frustrated. I also felt so sad for and defensive of my brothers and sisters experiencing homelessness.

After bringing some items for the gentleman with no winter clothes, I asked Rosa if I could come and organize the donations—not just the clothes but also the toys, many of which were in as poor a shape as the clothing I'd riffled through. I roped my sister into the project and together we sorted and sifted, sorted and sifted. Beth has a beautiful heart for giving back, and between the two of us and the friends we lovingly corralled into joining us, we organized an amazing clothing and toy distribution area for Harvest Center. We even had racks separated by size—small, medium, you get the picture. We brought our kids and enlisted them in helping. We purchased fifty coats at a time and set up stock for each winter. Our little volunteer team threw Christmas parties for kids experiencing homelessness or poverty.

Back on my very first day at Harvest Center, however, none of that had happened. I just felt sad. Then I felt guilty for having so much when others had so little. It was a confusing feeling, thinking about myself in the midst of volunteering to help others.

It was on that first day of volunteering, as I was finishing up my shift, when a pastor and worship band led the men and women in an amazing time of prayer and praise. People lifted their hands in surrender and worship. Despite their circumstances, so many of these brothers and sisters exhibited the joy of the Lord and the power of His presence. I watched in awe as Rosa prayed with and ministered to so many that day; she was the hands and feet of Jesus Himself, walking around that gymnasium, a force with which hell itself had to reckon.

I left weeping. I drove away—in my brand-new Suburban, to my brand-new house—asking God to help me. I felt so much guilt and confusion. "I want to keep painting, Lord," I cried out, "but how can I not work here every single day? The need is so great."

Paint and give back, I heard the still, small voice reply.

I wasn't sure if I had heard correctly, but I told God that I would follow Him no matter what He asked me to do with my time, whatever He asked me to keep or give up. I arrived home and noticed a blinking light on my answering machine. I rewound the tape and listened as a friend of mine who owned a gift shop told me about a "divine appointment" she'd had.

"A lady from out of town bought *all three* of your angel paintings, Anne," my friend gushed.

This was one hour after I heard the whisper to paint and give back. And this is exactly what I decided to do: paint and give back.

Brushstroke Moment

Are you familiar with the phrase *divine appointment*?
What does it mean to you? What might it mean?
Can you trace the hand of the Master Artist painting
people or opportunities into your life in ways you
couldn't have planned on your own?

I continued to serve at Harvest Center, and my heart to help the homeless expanded. I also continued to paint with passion, increasing the percentage I gave back with every purchased piece of art. My paintings went from selling off my kitchen countertop for $200 to catching the eye of the Charlotte Symphony.

Artistic directors there asked if they could use one of my original oils—a grouping of three angels, one playing the violin—as the official image of their upcoming season. They planned to use my work on all of their marketing materials, then auction off the original work at their gala benefit. I was so honored and encouraged.

I began experimenting with far larger canvases than the five-by-sevens on which I had started, and God inspired me to create an entire series of abstract, ethereal beings. Every image arose from my times of worship.

A few months later, after being asked to donate a piece for Charlotte's Art With Heart, a fundraiser to help women affected by domestic violence, I watched in awe—you'll notice I say this a lot, but I really was in awe—as that angel painting racked up bid after bid in the silent auction. There was a little yellow pad of paper next to the canvas, and not one but *several* pages filled with bids. When the final call for bidding came, I was shocked to discover my work had sold for nearly $2,000, every dollar of which would help women who had suffered violence at the hands of people who should have loved them.

Not long afterward I donated an angel painting to benefit the Allegro Foundation, an incredible organization for children with disabilities. The Allegro Foundation "combines movement instruction with education and medical expertise, creating new techniques to teach children with disabilities and enhance their quality of life."[2] When I observed a class, watching as the skilled instructors guided families in using new techniques, tears of joy streamed down my face. I didn't need to drum up inspiration for this painting. I saw it live and in action!

Allegro put on a swanky event with ball gowns and black ties. Five items would complete the live auction, including my angel painting. At the end of the evening, that angel outsold a Mercedes-Benz lease, a trip to somewhere tropical, and tickets to the Super Bowl. Allegro received more than $18,000 from that one painting, and I couldn't have been happier.

God continued to bring organizations and people into my life. And with each divine appointment, I felt the exhilaration of painting with purpose. I was very busy with commissions and donations by the time 2010 rolled around—so busy that I declined the invitation of a friend to a fundraising luncheon with an art dealer who had recently coauthored a

book. My friend had agreed to host both authors at her home for dinner, but I opted to paint at my studio instead. A few weeks later this friend showed up on my doorstep with a copy of Ron Hall (the art dealer) and Denver Moore's book, *Same Kind of Different as Me*.

That's an interesting title, I thought.

"Ron noticed your painting, Anne," my friend began.

I was intrigued by this, as this friend had a beautiful home with several pieces of very fine art in it.

"He just stared at it," she continued. "And when he finally said something, it was, 'Wow. That moves me.'"

Huh.

That weekend my husband and I attended a wedding in Charlottesville, Virginia. I packed the book but had absolutely no time to read amid the celebratory festivities. I cracked open *Same Kind of Different as Me* on the drive home and immediately fell headlong into the fascinating details of Ron's and Denver's lives.

"Are you not going to talk to me?" Clark asked.

"Honey, this is a really great book," I answered distractedly.

"And this is a really long drive, Anne. What if you read it out loud?"

For the next five hours, I read—like a human audiobook—the story of Ron Hall, famous art dealer, and Denver Moore, the homeless man who changed Ron's life. I don't want to spoil this amazing book for anyone who's not yet read it (and you really must put down my book and buy one—or ten—of theirs to read and share with others). I won't give any details except to say that Ron and Denver were a power team for the kingdom of God and Jesus' fight against homelessness. Denver has since gone home to be with Jesus; Ron continues to do great things for God here on earth.

I couldn't escape the thought that repeated itself in my mind while Clark and I finished the book later that night, back home and after the kids had gone to sleep:

Ron needs an angel.

The very next morning, I painted an angel I titled *Good and Faithful Servant*. While the painting dried on its easel, I wrote a note to Ron about how his and Denver's book had changed my life and encouraged my purpose in painting. I told Ron how much his commitment to sell art and give back inspired me. I expressed that I, too, had been called to bless others through art and that I shared Ron's passion for coming alongside those experiencing homelessness. I packed up the painting and letter, then shipped it off to Dallas, where Ron and Denver lived.

In the days that followed, I reflected on how Ron and Denver ministered to each other. Their friendship made me think about my own relationships and my desire to honor God in them. Forgiveness played a huge role in Ron and Denver's journey, and reading about their triumphs and troubles helped me better understand the power and necessity of forgiveness in my own life and relationships. *Same Kind of Different as Me* further ignited my fire to paint with purpose. Ron and Denver's book truly made a huge impact in my life.

A week later my cell phone lit up and the caller ID flashed, "Ron Hall." My heart skipped a beat, but I answered and instantly made a new friend. We chatted for what seemed like hours, and Ron invited Clark and me to join him and Denver at a fundraising event in Knoxville, Tennessee, that would benefit a ministry to those experiencing homelessness there. I agreed and created an original work that would hang in the organization's office. Ron urged me to learn how to make a fine art print so that we could sell not one but many angels to benefit the ministry.

That's precisely what I did. I learned a new skill—making a fine art print—and watched as every single angel print sold. One hundred percent of the proceeds went to Knoxville's Volunteer Ministry Center, and I had the immense joy and privilege of watching Ron Hall, my esteemed new friend, hang the original oil painting in the Ministry Center offices.

On a high after the auction and en route to another event in that

weekend's exciting lineup, I asked Ron about the last painting he sold. Note: This is a man who sells Monets, Picassos, and Warhols. My little angels were just that—*little*—at least by worldly comparison.

"It was about this big." Ron gestured, indicating a painting about two feet across. "It was a Remington that sold for $7.5 million."

I don't know what I had expected, but what he said completely floored me.

I couldn't help myself, and the words "Oh my gosh, we could change the *world* if I sold a painting like that" tumbled out of my mouth.

Clark didn't skip a beat and quipped, "Honey, that artist is deceased, and I'd like for you to stick around for a while."

We all laughed at my exuberance and Clark's humor.

My paintings may never sell for millions, but the eternal value of giving back has made me a very rich woman on the inside. I never could have set up the divine appointments that I began experiencing as the influence of God's angel paintings expanded. I did have a responsibility to *keep* the appointments God made, however. I could have missed *so much* if I had been too afraid to step out in faith—to say yes to nonprofits that asked for donations, to paint and send that angel to Ron Hall. God ordains opportunities for us, and our job is to seize those opportunities.

Brushstroke Moment

Is it easy or difficult for you to seize opportunities that come your way?

How do you feel about taking risks?

Where do faith, trust, and courage fit in with your experience?

I don't want you to miss *one moment* of God's

divine appointments for your life.

And, far more importantly,

God doesn't want you to miss one moment

of what He has prepared for you.
How might you commit now to saying yes to the next
divine appointment God presents to you?

As the days flew by, the angels got bigger and bigger. God expanded my influence and impact. I outgrew my little home studio and landed in the perfect space—an old mill building with two stories filled with artists' lofts and studios. My family rejoiced that they no longer had to navigate wet oil paint in unexpected places and the ensuing stains on their favorite things. I rejoiced at all God had done through every divine appointment. I climbed the rickety stairs to the second floor of that old mill and painted with abandon.

Then, right smack-dab in the middle of all of this success, fear crept in the back door of my mind and heart, calling my very security into question.

fifteen

Fear Is a Liar

When he told you you're not good enough
When he told you you're not right
When he told you you're not strong enough
To put up a good fight
When he told you you're not worthy
When he told you you're not loved
When he told you you're not beautiful
That you'll never be enough
Fear, he is a liar

ZACH WILLIAMS, CONTEMPORARY
WORSHIP ARTIST, "FEAR IS A LIAR"

At one of the charity auction events for which I had donated a painting, Clark and I won a bid on a trip. Our four children were still young at the time, and time alone with Clark was in short supply. We so looked forward to jumping on a plane and enjoying the crystal clear waters of Turks and Caicos.

About two weeks before our departure, though, a terrible fear of flying gripped me. *What in the world?* I thought. *I've* jumped *out of planes. What is wrong with me?*

I tried reasoning with myself. I talked it out (or attempted to). Of course I prayed. But fear continued to slither in my ears.

I remember breaking down at a swim meet, grabbing my brother-in-law and explaining to him where Clark and I kept our wills. I told him what to do "when we're gone." I also wrote my sister a long letter, giving specific instructions for how to raise Blakely, Catherine, Taylor, and Ford. I really, truly believed I might die on the getaway my husband and I had won. I was deathly afraid that I'd board the plane and never return, leaving my four incredible, beautiful children behind, with no mommy or daddy to care for them.

Fear-stricken for several days, I finally called my prayer-warrior friend, Anne Cochran. I desperately needed prayer support.

"I don't understand. Why is the fear so heavy?" I asked my friend.

Anne listened as I unloaded. Then she prayed powerfully. I was driving while she prayed, and as she closed with an "amen," I looked closely at a car that had stopped ahead of me at a red light. A worn bumper sticker on its rear fender contained only one word in all-capital letters: *PEACE*.

Message received, Lord, was my immediate response. *Thank You. Thank You, Jesus.*

It wasn't easy to get on that plane, but I did it. On that flight I also started something that has since become a habit of mine. I made the sign of the cross on the left side of the plane, declaring with my hands and my faith what my mind had trouble believing: Jesus was in control. I travel frequently now and continue this practice; it's one way I remind fear that I trust in God.

When we landed safely in Turks and Caicos, Clark and I rendezvoused with our assigned driver. I let out a sigh of relief when I noticed the sticker plastered on the side of his van:

Step by step, keep following Me.

—Jesus

We discovered our driver also worked as a pastor, and God's peace flooded me! I felt cared for by my heavenly Father. And I knew He would care for my kids too.

Clark and I had a wonderful trip, reveling in the masterpiece of creation that Turks and Caicos was—charming and, in many places, unspoiled. With powdery white sand beaches stretching into turquoise waters that kiss the horizon, these islands proclaimed peace and glory. It was just what my husband and I needed.

What we did *not* need was a ridiculous fight about God-only-knows-what the night before our scheduled return home. Not only was the fight silly—truly, I cannot remember what prompted the argument—it was also needlessly big. Perhaps you've been in a situation where a relatively small issue quickly escalates and, suddenly, you're in the middle of the relational equivalent to a nuclear war. Not good.

I was fuming and emotionally taxed. It's not surprising, then, that fear crept right back into my mind and heart, ready to take up residence for good. This is when I discovered that, even when one is fear-stricken and fighting with a loved one, one still has to eat. So the next morning Clark and I went down to the beachside restaurant for our last meal (on the island, that is, not existentially, though I feared it could be the final meal of my life).

Virtually every restaurant in Turks and Caicos sported outdoor tables, and this breakfast spot was no exception. Just as the waitress took our finished plates away, a white dove swooped down and sat, peering at me, right next to our table. I almost laughed out loud. A white dove. Seriously? An international symbol of peace and the symbol, in my faith, of God the Holy Spirit?

From this I sensed the message, *Make peace with your husband, Anne.*

Receive My peace about your flight. Return to Me every time the grip of fear tightens. I will never leave you or forsake you.

Once again I prayed, *Message received, Lord. Thank You, Lord. Thank You.*

I melted into God's peace, which the Bible describes as a peace that transcends understanding. You may or may not be familiar with the verses to which I'm referring. They don't just describe peace; they also impart wisdom about how we can deal with anxiety.

> Don't worry about anything; instead, pray about everything. Tell God what you need, and thank him for all he has done. Then you will experience God's peace, which exceeds anything we can understand. His peace will guard your hearts and minds as you live in Christ Jesus (Philippians 4:6–7 NLT).

Brushstroke Moment

When I was gripped with fear, I needed prayer. My friend Anne supported me in a major way. I also needed to turn my mind to something other than fear. Fighting fear by focusing on it is a pretty ineffective strategy, I've found.

Do you agree or disagree?

I've chosen to follow God's wisdom tucked in the passage you just read from Philippians: I practice gratitude.

What's amazing is that within the last decades, scientists have discovered that fear and gratitude are pathways in the brain that *cannot* fire simultaneously. This means you physiologically can't be thankful and fear-stricken at the same moment.[1]

Next time you feel anxious or afraid, why not grab a notepad or open the Notes app on your smartphone? Start listing anything and everything

you are thankful for and don't stop until the peace comes. You may need to list only five things, or you may not want to stop until you have fifty, but you can trust that God's Word—proven by the evidence of modern science—is true and will help you. Fear is a liar. God is not.

Clark and I reconciled. (How could we not after the dove God sent?) We also returned home safely, and this experience gave me the opportunity to reflect on the role fear played in my life.

I started life as a rather fearful child. Perhaps you remember me telling you that I would wake up my sister to go to the bathroom with me in the middle of the night. As I grew up, though, I became what many people saw as fearless. I skydived. I rappelled and climbed vertical slants. I left a sure thing—teaching—to sell pottery. And I succeeded at so much in life. I'm sure there were people who looked at my life and thought, *She probably never feels afraid.*

But fear lies to us all.

When songwriter Zach Williams released "Fear Is a Liar" and I first heard it on the worship playlists I stream while painting, I immediately resonated with the lyrics. You read some of Zach's words at the opening of this chapter. Let me bring them back to our minds now.

> *When he told you you're not good enough*
> *When he told you you're not right*
> *When he told you you're not strong enough*
> *To put up a good fight*
> *When he told you you're not worthy*
> *When he told you you're not loved*
> *When he told you you're not beautiful*
> *That you'll never be enough*
> *Fear, he is a liar*

Fear lies to us about circumstances—this is how my fear of flying developed. Becoming a mom and knowing what I could lose and who I would leave behind changed my entire perspective on the adventure of travel. I needed to trust God, not just with the actual process of flight but also with what I risked every time I left my family, whether I was driving to the grocery store or boarding a plane for a marriage getaway. You may never have experienced a fear of flying, but you probably have had anxiety surrounding situations in your life. Fear lies to us about what has happened, is happening, and will happen.

But fear lies to us about more than that too. It lies to us about *who we are*. And this is where shame can grip us. Fear tells us we're not good enough and never will be. It lies to us about our strength and ability to fight through the tough trials we face. Fear lies to us about whether we're loved, worthy, or beautiful. Fear, he *is* a liar.

In case you were wondering, Zach Williams didn't write "he" in the lyrics because he hates men. He wrote that because the Bible tells us that we have an actual enemy who lies to us. Jesus identified him as "a liar and the father of lies" in John 8:44. Whether or not you believe in an incarnate evil—an evil that exists and actively opposes light, goodness, and truth—you likely have experienced the effects of lies about your identity.

Fear lies to us all.

That's why, years after I wrestled with God about flying to and from Turks and Caicos, I took the time to write my family and speak truth into their minds and hearts. I wanted to be part of God's work to dismantle the lies fear tried to breathe into them. Ironically enough, after God had delivered me from the fear of flying, I wrote these mini letters to Clark and my children while airline techs de-iced the plane I had boarded during a snowstorm in New York City.

If something should ever happen to me, know that each of you were my life! I love you all more than you will ever know. Please find God

in all of this. I know there are times it seems hard to believe, but we do have a living God.

Clark, I should have responded to your text and said, "I love you too." These past months, I've been so mad about all the baggage we bring to our marriage, but I am so grateful that through it all we can be a beacon of God's light not only for our children but also for others. I *do* love you and *always* will.

Kids, I pray that you would be tenderhearted toward your dad. He is a good man and I know he loves each of you dearly. Give him grace. Love him unconditionally.

Clark, I pray that you would continue the healing process and that your relationship with our kids would continue to grow into a deep, compassionate, unconditional love for each of them. They are amazing kids, but they so need to connect with and know their earthly father intimately before knowing that they can trust a heavenly Father who loves them even more.

Blakely, you are an amazing, talented girl. Believe in yourself and know that God loves you no matter what. Keep your head high. Let go of anxiety—any and all! Live in the river of peace no matter what. It is much better to be at peace than to struggle and fight your way, living in constant anxiety. Know that there is a perfect mate for you and only you. He will love you so much! And please hear me: It's time for all the drama in life and between you and your siblings to stop. Love them unconditionally and accept them for who they are. I love you.

Catherine, stay true to who you are. You are a rock. It's okay, though, to break down and grieve. Your sweet nature and loyalty to family and friends will carry you a long way. Remember to forgive. You have got to keep that word close to your heart—always. Forgive your sister. Forgive me. Forgive others. You are a beautiful young lady and I love you. You have such a bright future ahead of you. Know that God is carrying you in the palm of His hands. Love and love big! Take risks.

Be adventurous (this goes for all of you kids!). See the world. Whatever happens, carry on my dream to travel all over the world. Never forget, God so loved the world that He gave His only Son (John 3:16). Continue to be a beacon of His light! No insecurities. No doubts. No regrets. Live life. Love others well. Believe in yourselves! I pray that you would be the best that God has created you to be.

Taylor, I love you just the way you are. I love your still, quiet ways and I pray that you will forgive me for every time I got in the way of God's design in your life. You are an amazing young lady, inside and out. I pray that you, too, would be able to forgive. And that through all this an unbreakable bond would form between you and your siblings. You will be a quiet force of love that will be evident at all times and especially when needed the most. I love you so much.

Ford, you are a gift from God. After I lost two babies, I thought our family was complete, but God gifted me you. You know that the living Lord's hands have been on you since before you were born. His hand will continue to be on you always. Believe in Him. Believe in you. Set dreams and goals and reach for the stars. Trust in the loving and living God who goes before you in all things! Know that, no matter what, I am proud of you and I love you. Dream bigger than ever. Love your family well! Love and serve others well. You are an amazing young man. Keep your eyes fixed and focused on Jesus, always and forever!

I love each of you to the moon and back, a million, trillion times! Don't ever, ever lose faith!

Brushstroke Moment

I have just traced for you the brushstrokes of love and truth
that I want to paint onto the canvas of my family's lives.

To whom can you speak truth and life today?

Why not take this moment to write a paragraph to someone you love,

affirming their identity and encouraging them to live beyond fear?

Now, dear friend, why don't you spend a moment reading the truth

God wants to paint onto the canvas of your heart and mind today?

You can start with these verses from the book of Isaiah:

But now, this is what the LORD says . . .

"Do not fear, for I have redeemed you;

I have summoned you by name; you are mine.

When you pass through the waters,

I will be with you;

and when you pass through the rivers,

they will not sweep over you.

When you walk through the fire,

you will not be burned;

the flames will not set you ablaze.

For I am the LORD your God,

the Holy One of Israel, your Savior . . .

Since you are precious and honored in my sight,

and because I love you,

I will give people in exchange for you,

nations in exchange for your life. . . .

Though the mountains be shaken

and the hills be removed,

yet my unfailing love for you will not be shaken

nor my covenant of peace be removed,"

says the LORD, who has compassion on you.

(43:1–4; 54:10)

We counteract fear not only with courage but also with *truth*. Fear is a liar, and we need to speak words of encouragement and hope into one another's lives. That's why I took the time to write these truths to my children and husband. I wanted to fill their minds with God's truths that empower and encourage. Fear keeps us in bondage; it holds us back.

The Bible also reveals that the purpose of the Father of Lies is to "steal and kill and destroy" (John 10:10). Don't let fear steal your joy, kill your hope, and destroy your identity.

Fear is a liar, but God is the way, *the truth*, and the life you crave. I've chosen to reject fear and follow Jesus' way. What about you?

sixteen

Copycats and Compassion

Imitation is the sincerest form of flattery.

OSCAR WILDE, POET, PLAYWRIGHT, AND HUMORIST

Over the years God continued to expand the reach of my artwork, especially the angels, exponentially. I received commissions and was invited to donate paintings to fundraisers. I made fine art prints that enabled people who could not afford an original to enjoy the art God inspired me to create. And I also noticed that people began to imitate my style and subjects.

At first I took the "imitation is the sincerest form of flattery" approach. *It's an honor*, I told myself. Throughout art history all of the masters were copied. *This must be a sign that I've made it*, I reasoned. But then the copycatting got more direct. This didn't feel like flattery. It felt like stealing.

I wrestled with competing thoughts about what to do and how to do it. I never used reference images when painting my angels (the series copied most often to date). Those paintings came out of my personal times of worshiping God in the studio. When someone copied an angel painting that I had created, it felt distinctly like a personal assault on something precious: my relationship with God.

127

When people ask me how to differentiate between a painting that's "inspired by" versus "copied from" one of my originals, I don't have a precise answer. There's not always a neat line of demarcation between the two, which makes the whole issue complex and confounding. Because I struggled to know where inspiration leaves off and direct copying of my work begins, I enlisted other professionals—artistic and legal—to help determine parameters.

In the United States, "to qualify for copyright protection, a work must be original to the author . . . independently created . . . [and] possess 'at least some minimal degree of creativity.'"[1] These standards sometimes need to be judged by a court, but there are other instances in which it's blatantly obvious that copying, not creativity, has occurred.

Early on someone alerted me to one young artist who had begun to imitate my work. In looking at what she had done, it really was copyright infringement. I decided to just pick up the phone and call this gal. I have no idea what she thought when she saw the caller ID—Anne Neilson— but I do know she picked up the phone. I thought that was pretty brave.

God laid it on my heart to be compassionate in my approach. I didn't want to—and had chosen not to—launch a counter to what I felt was an attack. Her work didn't imitate mine alone. She had copied other artists as well. I had prayed about how I could encourage her while holding my ground. God told me to speak life to her, to tell her to find her own voice.

We talked for a while, and I think it went well. I encouraged her to express her own unique vision. I affirmed that she was a talented artist and that she didn't need to copy anyone. I did this compassionately, I believe. And then I hung up the phone. Her part of the journey—her response—wasn't up to me. I had followed God's leading to be compassionate and simultaneously defended my intellectual property. That was an important step for me as an artist.

Unfortunately, this wasn't the only time I had to deal with copycatting. I hired a lawyer—a big-city art lawyer—to send cease and desist

letters. That nipped certain things in the bud. But eventually I retained a lawyer that we knew instead, a friend of Clark's and mine. The day I discovered yet another copycat artist was the very day Clark and I got on a plane with this lawyer friend, Bob, and a group of other pals headed to the West Coast for Clark's birthday. Bob looked me square in the eye and said, "Anne, I've got this." I breathed a sigh of relief and enjoyed my husband's birthday celebration immensely.

On my behalf, Bob called the young artist who had copied my work. A month later Bob's legal staff sent me a bill. Suffice to say, the total was higher than I expected. But his expertise was invaluable, so I planned to pay the invoice. A few weeks later we hosted a reunion for the group who had gone on Clark's birthday trip. The first night at dinner, after our friends had feasted, Bob got everyone's attention by standing up and clearing his throat.

Let me pause right here and tell you one thing about Bob. Apart from being an incredibly smart, high-powered lawyer, Bob is hilarious. As in "could have his own Comedy Central stand-up special" hilarious.

That evening in my kitchen, Bob ceremoniously announced, "As we all know, Anne created the angels. I've made us all a memento of her accomplishments." I had no idea where he was going with this.

Bob then reached into a bag he had stowed under the table, pulling from it several bottles that looked like they contained shampoo. Instead of a brand label, however, Bob had superimposed some of my angel images with bold, all-caps lettering: DO NOT COPY. As he passed them to each of the ladies, everyone started cracking up. Bob then proceeded to hand beer steins with the same design to each of the gents. Laughing about something that had been so stressful for me was like letting air out of an overly inflated balloon.

Because Bob had such a great sense of humor, I planned my own practical joke in return. I got one of those gigantic checks—the kind charities receive and take photos with—and made it out to Bob for

exorbitant legal fees. I printed images of Raphael's cherubs, photoshopping Bob's face where the angels' should have been. After mailing him the jumbo check, I only wished I could have been there when he received it. A few months later when Bob could invite only one client couple to share his UVA basketball box, he chose Clark and me, the ones who had written him "the biggest check."

I'm glad we could laugh together about it. Because, honestly, the whole copycat thing is really distressing. It makes me feel vulnerable and angry at the same time.

Though it was difficult, having to navigate the line between imitation and copying presented an opportunity for me. It gave me a reason to reflect on what it means to be real, to be myself. It also gave me pause to consider what it means to be fake, to counterfeit. If you ask me, our modern world encourages more of the latter than the former. Social media, especially, urges us to curate and present our lives through a very particular lens, a lens that's (more often than not) filtered to flatter.

I remember feeling—and giving in to—the temptation to pretend I had it more "together" than I actually did back when Jane and I taught Sunday school. I did *not* want those sixth graders to know they had more Bible knowledge about Job than I did. I postured and posed with them back then, and guess what? There are times I'm still tempted to pretend, to be fake. I'll feel a tug to copy someone else who seems more together. Have you ever felt a similar pull?

Pretending and copying, posing and imitation, are all part of the struggle humans face to be authentic, to be real. We've acknowledged before that it's tempting to make ourselves look better to God. We may want Him to see us a certain way, thinking that will make us more lovable or acceptable, but that's flat-out untrue. Jesus knows who we really, truly are and loves us with no filters, no matter what the angle or lighting. Isn't that the most incredible truth?

> ### *Brushstroke Moment*
>
> Do you agree or disagree with the assertion that our world encourages people to be fake more than unashamedly real? How are the world's values the same or different from what God values? In what ways are you personally tempted to copy someone else—how they dress, what they do, how they speak? How do you know what's really, truly *you*?

Copyright-infringement laws protect artists like me from the theft of their intellectual property. Lawyers issue cease and desist letters or make phone calls to copycats in artistic fields—whether visual art, music, or literature—warning counterfeiters of impending legal action should they continue imitating to the point of plagiarism. Other laws exist to protect people with regard to personal finances, identification cards, and other information. But there are no laws that protect your identity on a soul level. This can be done—and *is done*—only by Jesus, the one who designed your identity and did it perfectly.

At this point I've raised four children and launched them into adult life. Hands down one of the biggest challenges I've observed them face is the need for "identity protection." Our world—with all its distractions—competes for their time, attention, and resources. And I'm not immune to the influences attempting to steal my own identity—media messages, conspicuous consumption, accolades and accomplishments, the praise of others that goes with success. These things tempt me to copy my identity from someone or something other than myself. Look like *her*, sell like *him*, own this, get that . . . it's all quite overwhelming, isn't it?

I'm actually glad that I've had to face copycatting in my profession, as it's made me more aware of the pull to copy someone else's identity rather than cultivate the unique identity Jesus placed in me. I spoke compassionately to

that first copycat artist, not only because God told me to affirm her and to guide her toward finding her own voice but also because I myself need compassion. I need to be reminded that my identity is in God, not in what I do or own or produce. I need to embrace—every day—the truth that I am a new creation in and fully accepted by Christ (Romans 15:7; 2 Corinthians 5:17).

People may mistakenly believe that, because my artwork has been successful, I don't ever feel tempted to fake it. My friend, that's just not true. No matter how successful someone is—and I'm proof of this rule, not an exception—every human must decide whether they will align with what's true and real. It takes deliberate effort to align our thoughts, feelings, and actions with the truth that we are created on purpose, for a purpose, by our living, loving God.

I have personally discovered that the surest way to activate "identity protection" is to know and firmly plant myself in the Word of God. God, the Master Artist, has prepared the canvas of your life. He has already painted with many brushstrokes, using colors and contrasts, some of which have delighted you, others of which have confounded you. I share my journey with copycats and compassion with you in the hopes that you'll activate your identity protection too. Rather than look to the world for guidance on what your life should be, trust what God brings to you in gifts, skills, opportunities, and circumstances. He's got you.

Brushstroke Moment

I shared with you that my identity is rooted firmly in Jesus and His Word.
What is the source of your identity?
Do you need to rethink any ideas you hold about
who you are and what that means?
How do you protect your identity from the daily assaults of the
media—ads, feeds, news, and so on—and unkind words from others?

seventeen

Angels in Our Midst

*This book provides a double blessing, not only for those who
read this book, but also those who benefit from its success.*

RON HALL, *NEW YORK TIMES* BESTSELLING AUTHOR,
FROM HIS FOREWORD TO *ANGELS IN OUR MIDST*

At a certain point I didn't know how I could keep up with the
increasing demand for angel paintings. I was honored and thrilled
that so many people wanted an original, but I was just one person. I
couldn't give everyone an angel.

Or could I?

After the Angel series started selling, becoming popular, and growing
in value, people would comment that they wished they had bought an
original "back then" (when I first started painting). I most often heard
this when people toured my studio, where I had a stack of hundreds of
images of angels I had painted, then sold, donated, or gifted. I also had
matching stories to share with visitors, an inspirational story for almost
every single piece of art God had created through me. It dawned on me

one day that I could create a beautiful coffee table book that would be affordable so that everyone could enjoy the Angel series.

It's perfect, I thought. With a high-quality art book, someone could carefully extract a page and frame it. *Everyone* can *have an angel!* Maybe it wouldn't be an original, but I wanted the angels to be accessible to as many people as possible. Pairing them with the stories of all God had done—in people's lives, through the charities I partnered with—would make an art book even more special. The project started to take shape in my mind, page by page.

But I had to get the book out of my mind and onto people's coffee tables, so I opened my computer at the kitchen table one day, determined yet unsure. How can I write *a book*? I'm an artist with oil paints, not words.

All I can tell you is that my experience writing *Angels in Our Midst* affirmed that when God calls you to do something, He will be faithful to equip you for it. The words flowed out of my heart and onto the pages. God brought memories back to me, things I had forgotten but that He wanted me to share in the book. My friends and colleagues wrote reflections for me to include, their sides of the stories of how God worked, using the angels to benefit charities and individuals. An amazing project editor joined my team, and both my sister and my dear friend Ron Hall wrote wonderful forewords. I collaborated with a remarkable designer who translated the angel paintings into art-book form so beautifully.

Brushstroke Moment

Can you remember a time when things just flowed,
almost like you were a vessel rather than the instigator?
This is what happened for me while writing *Angels in Our Midst*.
I truly felt God's words flowing through me and onto each page.

> Do you believe that God can and *wants to* move
> in you and through you in powerful ways?
> Why or why not?
> What do you think about inviting Him to do something
> new and amazing in and through you today?

The designer I worked with on *Angels in Our Midst* navigated an avalanche of details with me. I remember one conversation about ink. She began with a very dark black ink for the text. It felt *too* black to me. "Can we soften it up a bit?" I asked. It's probably a good thing that I couldn't see her face every time I called or emailed to ask her for yet another change. But I am nothing if not a detailed person. And very visual. If I know the details, I can even see in my mind a creative work a friend has planned long before it's brought to life. I urged the designer to stick with me, knowing that—together—we were creating a beautiful book.

And we did.

After countless hours of discussing, designing, editing, and tweaking, *Angels in Our Midst* entered the world. It was early October 2012 when I heard a knock on my studio door. A delivery man stood on the threshold, and my breath caught momentarily. It almost felt like I was bringing another child into the world. I had planned and prayed and prayed and planned for many, many months. So many people had worked hard on this project, and it was finally here, in real life!

But where were the books?

There was the delivery guy but with not one book in sight. I had ordered an initial print run of 1,500 copies, so I expected boxes upon boxes on pallets stacked high. Dan the delivery guy was standing there, empty-handed.

Dan explained that his semitruck was too large for the driveway;

he'd had to leave it on the main road. That was unexpected but I was eager and determined to get the books into my studio, not only because this was "my baby" but also because I had hundreds of preorders to fill. I couldn't wait for a smaller truck!

Delivery Dan and I walked to the main road, where I immediately saw the dilemma he faced. His semitruck was large . . . I mean *extra large*. There was no way he could maneuver it through my studio's small drive and parking lot. We had a loading dock at the studio, but a loading dock is useless if you can't pull a truck up close enough.

I wasn't exactly angry with Delivery Dan when he told me that he would not—and I repeat *would not*—touch the books. It's a union issue, he offered. For me, this was not particularly helpful information. And I had no equipment that would enable me to do the off-loading myself. There were 150 boxes weighing 42 pounds each (coffee book tables aren't lightweights, my friend). Not only did they need to get *in* the studio, they also needed to get *up* the small elevator to my second-floor space.

Desperation mounting inside me, I called Clark to see if he could help or send any of his employees to help. Nothing. Busy day at his office too. I peeked into my framer's office, adjacent to my own, and asked if Joe—a faithful friend, not just my framer—could spare a minute to help. "Well, this might take more than a minute, Joe," I tried to explain.

We went to work and began unloading the truck, box by box. After a few boxes I felt pretty discouraged. I was already feeling the strain and had no clue how Joe and I would be able to complete this massive undertaking. I threw up the prayer equivalent to a Hail Mary pass in football, asking God to help.

God answered in the form of a guy named Calvin.

"Excuse me, ma'am," this stranger began. "Could you spare just a few dollars? I'm strugglin'. Homeless. Trying to get back on my feet."

Calvin saved me from a massive setback that day, unloading *Angels in Our Midst* and neatly stacking all 150 boxes in my second-floor studio

on Kingston Avenue. I was overjoyed to pay Calvin a lot more than a few dollars, and off he walked, a small backpack slung over his shoulder. I never saw him again. I'm not saying Calvin *was* an angel, but his help was a gift from God. So was my faithful friend Joe's.

Clark arrived at my studio later that day, after his own busy day at work. He took one look at the stacks and stacks of boxes, then said what might be the worst possible thing you can say to someone who had just self-published an art book.

"Wow! How in the world are you going to get rid of all these books?"

He didn't intend it meanly. And I didn't get angry. I honestly had total faith that God would, one book at a time, get *Angels in Our Midst* into the right people's hands. Three weeks later every single book was gone and another five thousand copies were on their way.

"We're gonna need a bigger truck," I imagined Delivery Dan saying.

In the blink of an eye, those five thousand copies were gone, then another five thousand, and, well, you get the picture.

I had no idea that what had started out as sketches of angels would become a veritable heavenly host. Emails started flooding in, messages from people who wanted to share how much the book meant to them. I found that readers were eager to share their own stories of inspiration after journeying with me through the stories of inspiration told in the book.

The whole experience was beyond incredible. It was phenomenal to sit back and watch God at work. I also had to do a whole lot of work to keep up with what He was doing. I shipped and painted, painted and shipped. I also did some marketing and found that I was quite good at it. I missed my chance to get an A in a college class—Marketing 101. I feel like I could have killed that coursework. Heck, I might have been able to teach that class!

My detailed nature and attention to particulars helped in the marketing of *Angels in Our Midst*. My willingness to take some risks did as well. Okay, maybe it wasn't super risky to ship a book to Kathie Lee

Gifford, one of the celebrities I most admired, but I might have sent the book and never heard a word back. That is *not* what happened, however. Quite the contrary. God used that one little risk to grant me a hugely rewarding relationship with a sister in Christ who I count as one of my all-time best friends.

eighteen

Sharpening

As iron sharpens iron,
so one person sharpens another.

Proverbs 27:17

A few weeks after I sent Kathie Lee a copy of *Angels in Our Midst*, I received an email from her. I had to pinch myself. Had I actually gotten an email from the host of the *Today* show? I had watched or listened to Kathie Lee and Regis Philbin for years as I worked on pottery pieces back in the day. I loved her heart and knew she had a vibrant faith in God. God had made it clear that He wanted me to send her a copy of the book, so I did.

Her return email was so kind, so real.

"Oh my gosh, I have just received a copy of *Angels in Our Midst*. I'm going to be late to start my show—first time ever! I cannot put it down. It is so anointed by the Holy Spirit. We have to meet this side of heaven. How? When?"[1]

I emailed her back. Immediately! I happened to have a trip to New York City scheduled with my girls for the very next day. I waited for her

reply and felt a little sting of disappointment when Kathie Lee told me that she was headed to California. My initial distress faded when I read her closing sentences, though. "Please let me know how we can meet. I want an angel!"

Kathie Lee and I traded emails for almost two months before finding a date that worked for us to meet. I had been asked to exhibit my original works at a gallery in Essex, Connecticut, about an hour and a half from her home. I was honored that Kathie Lee wanted to meet, even if it meant a lengthy drive for her. As the date approached I made the arrangements to transport my artwork—and myself, my husband, Catherine, and Taylor—to Essex.

I was excited about the art show but, to be completely honest, I was even more excited to meet Kathie Lee. That's why I was so discouraged to get an "I'm so sorry; I can't make it" email from her. A family member of one of her assistants had just passed away, and Kathie Lee planned to attend the funeral. I could hardly be upset about that. I had always loved that Kathie Lee was so caring and compassionate. *Of course* she would support her assistant in this time of need.

I was sad, but I was also determined to make the best of the situation. Doing that just turned out to be more difficult than I imagined it would be. I had never been to Connecticut before and had no idea that March is still full-on winter that far north. I'm sure Essex is normally a charming little town, but my family and I arrived to dreary rain and patches of lingering snow. I anticipated cute little boats dotting the Connecticut River, on which Essex sits, but every boat was buttoned up and my girls wouldn't stop moaning, "There's *nothing* to do, Mom. Why did you bring us here?"

I was wondering the same, truth be told.

At one point, when we piled in our rental car, Catherine and Taylor started in again. They were just being teenagers, complaining and whining like bored teens do, but I had had it. Whipping around with a stern

look on my face, I told the girls in no uncertain terms, "We are *not* going to complain no matter who shows up at the art gallery. We are going to go, be blessed, and be a blessing." I might as well have ended that speech with "so help us God."

The girls gaped at me but remained totally unconvinced. They begged to stay back at the hotel, and I agreed. *Maybe it's better that they don't come*, I thought. I needed to get my head on straight for that evening's event, and my encouragement meter was dipping dangerously low. Later on Clark and I left them at the hotel and walked through the tiny town of Essex to the art gallery.

Just after 5 p.m. Clark and I strolled through the doors, genuinely unsure if anyone would come. I wasn't the only artist represented that evening, so Clark and I took the opportunity to enjoy some of the other exhibits. We strolled up and down the aisles and were beginning to make our way back toward the front when the gallery manager hurried toward us.

"Kathie Lee Gifford is here to see you."

We followed her to the reception area, where Kathie Lee immediately gave me the sweetest, warmest hug.

"I guess you're wondering why I'm here," she laughed.

I was, actually, but didn't have to ask.

"The Lord woke me up early and said, 'Go; she needs to be encouraged,' so here I am."

God sent Kathie Lee Gifford to encourage me? I could hardly believe it! She had made time for her assistant's grieving family *and* for me. I was so impressed with her kindness and faith.

Kathie Lee and I spent some time touring the gallery together, and I signed a lot of books for her. For every person she bought a copy of *Angels in Our Midst* for, Kathie Lee had a story. She shared how she was praying for that person or how God had moved in this other person's life. I was a little starstruck; not only was Kathie Lee my new friend but she was

buying my book for other famous people, asking me to sign copies for them. *How in the world is this happening?* I wondered.

Kathie Lee didn't give me any identifying details (that girl is a good friend who keeps her confidences). So even though I didn't know the situations that prompted Kathie Lee to buy a book or pray for her celebrity friends, I said little prayers while I signed each book, asking God to bless whoever received that copy.

I also made a quick call to Catherine and Taylor, telling them to grab some lipstick for me and get to the gallery . . . stat! "Kathie Lee came, and I want a family picture," I told them in a rush. We got that picture. And I got the encouragement God sent Kathie Lee to give me. That night went from super dreary to downright spectacular.

Right before she left, Kathie Lee grabbed me—in the middle of the gallery—wrapped her arms around me and said a prayer. She's affectionate and Spirit-filled like that. In Jesus' name, Kathie Lee blessed me, my family, and the talent God had given me. After she said, "amen," my new friend looked me in the eye and said, "On Monday I'm going to hold this [a copy of *Angels in Our Midst*] up in my 'favorite things' segment. Are you ready?"

I honestly wasn't sure if I was. But I knew that God was ready. He would equip me for whatever lay ahead.

True to her word, Kathie Lee displayed *Angels in Our Midst* on the *Today* show that Monday morning. Almost instantaneously my website blew up with orders. God showed up and showed off over the next few months; as He expanded the reach of the angels, He gave me more and more—far beyond what I ever could have done on my own.

About a week after Kathie Lee identified my book as one of her favorite things, a woman from one of the *O* states called me. I honestly can't remember if it was Ohio or Oklahoma, but I know she was from an *O* state. She shared the most heartbreaking yet encouraging story I had heard about *Angels in Our Midst* to date.

Her four-year-old granddaughter, she told me, had passed away two years before. There had been a block inside this woman, something that had made it impossible for her to grieve the terrible loss of her beloved grandchild. After seeing *Angels in Our Midst* on the *Today* show, she ordered the book and read it cover to cover.

"The moment I closed the book after reading the last page," she told me, "the floodgates of heaven opened. The healing process began. Thank you."

I was overcome with emotions—sorrow for her loss, gratitude that God had allowed me to be part of her healing, amazement at what God had done. He had turned my paintings into a ministry. When I painted those first few angels, I had no idea what impact God had created them to have. It was a humbling privilege to be part of what He was doing.

Brushstroke Moment

Have you ever been caught up in something far bigger than you? What does it mean to be a part of something that transcends yourself? What cause or ministry would you like to be a part of— is it a social justice or human rights issue? Perhaps it's a personal struggle with mental health or addiction that you'd like to help other people navigate? God is ready and willing to use your gifts to change lives. How wonderful is that?

I would never have connected with that grandmother if Kathie Lee hadn't shown *Angels in Our Midst* on national TV. I'm so grateful that God brought Kathie Lee into my life, and not just because she's promoted my work. In the many years since, she has been like iron to me, sharpening me to become a better wife, a better mom, a better woman.

The warmth and strength of her spirit does that; she makes people better, bringing them closer to God. I was so very glad that we stayed in touch via frequent phone calls after that first meeting in Essex.

Getting an invitation to her birthday party was a special blessing. I knew that we were really, truly friends. But more than that, she embraced my entire family. I'll never forget showing up at her home for the party—a shared birthday event with her husband, Frank—and being welcomed like we were *her* family. It must have felt a bit awkward for my girls, in their late teens at that time, to be at a party where they knew absolutely no one. They smiled and met people and ate the delicious food but eventually started to ask how long we planned to stay. I'll never forget what happened next. The band had just started to play, and Kathie Lee swooped down on our table, grabbed my girls, and pulled them on to the dance floor. Her light and energy—always contagious, in the best possible sense of that word—won my girls over. I couldn't have been more grateful for my new friend.

Especially since parenting teenagers was anything but an easy journey for me.

nineteen

Less than Perfect, More than Enough

Life is not meant to be easy, my child; but take courage: it can be delightful.

GEORGE BERNARD SHAW, ART CRITIC, PLAYWRIGHT, NOBEL
PEACE PRIZE RECIPIENT, FROM *BACK TO METHUSELAH*

God blessed Clark and me with four of the most amazing, beautiful, talented children to parent. I love being Mom to Blakely, Catherine, Taylor, and Ford. Being a parent is also the hardest job on the planet. (Can I get an amen from all you parents?) My kids are wonderful; they are also less than perfect. And I am far from being a perfect mom.

For me one of the greatest struggles of parenting has been letting go. My now-adult children, if they were writing this chapter, might describe me as a helicopter mom, hovering over their lives, sometimes a little too closely. I had the best of intentions—at least I think I did. I wanted them to grow and thrive, to know and love God, to walk in His ways, to live fulfilling lives. For those times I held on to control, or tried to—more

than was healthy for them or for me—I pray my kids do and will forgive me. God has progressively invited me to let go of my expectations, let go of my control, let go of my fears about my kids' behavior and safety, the security of their futures.

Raising teenagers was particularly challenging for me. I'll be perfectly honest: I had my head in the sand on more than one occasion. I wanted to believe that my kids wouldn't struggle, that they wouldn't do some of the foolish or even dangerous things that adolescents are renowned, the world over, for doing. Looking back I guess I wanted them to be perfect and wanted to believe that they actually were perfect. Like the long-ago days when I used to doll my daughters up in matching smocked dresses with oversized bows, I wanted to present to the world a picture of a beautiful, put-together family.

I remember one especially hard situation, a time when I had to pull my head out of the sand and face some difficult truths about my parenting and my kids. Clark and I were taking one of our older teens to college orientation. We had left the other teenagers at home.

Clark and I asked a gal to come and stay at the house with our kids. I'll never forget her response.

"I don't know, Mrs. Neilson. What if they have a party?"

What? My children? *No way.*

Clark and I went away, came back, and everything seemed fine. Until I started noticing odd things around the house.

"Did y'all move this table?" I asked.

Insert mumbling, vague denials, and "Maybe so-and-so did it" statements here.

Several other things were out of place as well. Nothing major, but certainly noticeable to me.

Then I got a phone call from our next-door neighbor.

"Hey, Anne, I don't quite know how to say this, but your kids had a raging party at your house on Tuesday night."

There were a whole lot of problems with this revelation:

1. I really, truly did not believe that my kids would throw a "rager."
2. We had hired someone to watch over our children and our house. What in the world had happened to her?
3. It was the end of summer vacation for my kids but a night-before-work weekday for others in our neighborhood. How could my children have been so disrespectful?
4. And perhaps most distressing for me personally, what did this say about our family?

I dialed the house sitter immediately. Wouldn't you know it? She had gone to Hawaii. *She probably needed a break after the raging party on Tuesday*, I fumed. She eventually returned my call and apologized profusely.

"The kids wanted a few friends over and, I am so sorry, but it just got completely out of hand."

Do you want to know one of the greatest ironies of this situation?

The previous year one of our daughters had gone on a trip similar to the Outward Bound one I'd attended as a twentysomething. She had written herself a letter on that trip, a "bucket list" sort of letter, which the outdoor school staff held on to and mailed back to her a year later. On that list, I kid you not, was this line item:

"Throw a huge party."

I marched myself straight into her room and said, "Well, I think you can cross that one off your bucket list."

Keeping up appearances is a bit difficult when your entire neighborhood watches your children throw a midweek rager while you're out of town. But, in a way, it was really good for me to face the fact that I had wanted my kids to be perfect.

I learned a great deal from that situation, but there was more for me to learn.

Another time I had the amazing opportunity to be an artist-in-residence at Blackberry Farm, a stunning place that I insist you visit if ever you have the chance. The staff there rolled out the red carpet for me and my family, with spa treatments and champagne. I was so glad to have some super positive time with my teenagers.

This trip happened right before one of my kids' senior year in high school. I was urging this child—who will remain nameless to protect the innocent—to play tennis during that last year in school. Clark and I had become concerned about the choices this kid's friend group had started making. Suggesting a return to tennis, which this child had played and was quite good at, was my way of trying to tighten the reins, to exercise control in a circumstance that felt perilously close to spinning out of control.

There wasn't much time to convince this kid. We were driving home on a Sunday night, and tennis tryouts were the next day. On the car ride home, we talked about tennis, but the answer was no, so I dropped it. Later, while Clark and I were getting settled back at home, our child came in and asked permission to go to a Mexican restaurant in Charlotte.

"Okay," I replied, not thinking anything of it.

Not too long afterward, I got some ominous news.

A group of one of my other teen's friends were sitting around my kitchen table, eating blueberry pie while saying their goodbyes. Unsurprisingly they had their phones out and were checking social media frequently.

"You know why they chose that Mexican place, right?" one of them commented.

I really had no idea.

"You can get tequila there even if you're not twenty-one."

I was horrified when, moments later, I saw a post that looked like it

could have been featured on "Teens Gone Wild" pop up on one of their social media feeds.

"What? That's totally illegal! How can teens be doing shots of hard liquor in a public place?"

Livid would be an understatement describing my mood at that moment. Furious, mad at my kid and mad at myself, plus feeling a whole lot of shame, I hauled myself down to that restaurant, picked this child up, and got home, where things went from bad to worse. I'm talking throw-up-in-the-bed worse.

Is this the kid I raised? I thought in desperation.

Not sure what to do and absolutely convinced I needed God to guide me, I turned to Him in prayer. He gave me a best next step. I went downstairs, printed out all the forms for tennis tryouts, and filled them out. I made an appointment at MinuteClinic for a sports physical the next day and called our local tennis club.

"Can you get my teen in for a refresher lesson tomorrow afternoon?" I asked the tennis pro. That appointment secured, I got in bed. I didn't know how this would all turn out, but I had to move forward. Wallowing in "What did I do wrong?" wasn't going to help anyone.

The next day was not easy, my friend. This kid did *not* want to get out of bed and go to tennis tryouts. But this was the deal: make the tennis team or be grounded until you're thirty-five. Okay, that wasn't the exact deal, but you get the picture.

I'm super thankful that this story has a happy ending. My child made the team and, in the process, reunited with a much healthier group of friends. Playing tennis transformed that kid's senior year of high school, and I am *so* grateful God gave me that "best next step" to take.

No parent wants to get calls like the ones I described in this chapter. It's so humbling and hard to face the truth that *our kids are less than perfect.* Remember my multiple confessions that control issues and letting go have been ongoing challenges for me? These parenting experiences were

watershed moments for me, times when God invited me to surrender—more and more fully—my expectations and fears. He continually pressed on my heart to trust Him, not myself.

I honestly don't know how things would have gone if my kid hadn't made the tennis team. I hope I still would have chosen to trust God and let go. From my present vantage point, I see that the issue was far less about my kids' behavior—throwing parties, drinking tequila, making or not making a sports team—and far more about God's grace. Because of grace, my children are *more than enough*. I am more than enough. What joyous relief I found in this truth!

Our children don't have to be perfect. They can be—all at once—*less than perfect* and *more than enough*. Parenting isn't usually an either-or endeavor. There's a whole lot of "and" involved. Of course we don't want our children to experiment with things like rager parties and alcohol. I'm not condoning those choices. I'm only saying that, as parents, we are invited by God to parent the children we actually have, not the ones in our imaginations.

Thank God, He is more than capable of finishing the good work He started in our kids (Philippians 1:6). He alone is the perfect parent. My kids need their heavenly Father far more than they need a helicopter mom, trying to be perfect and make them perfect. Raising teens really brought this truth to the forefront of my mind, and—though it was sometimes excruciatingly hard during those adolescent years—I'm so thankful God showed me that He is more than enough for our less-than-perfect family.

Because my artwork has made my family's life somewhat public, the temptation to "put on a front" has increased over the years. I'm grateful that I can be an imperfect-but-choosing-to-follow-God parent for my kids and also an example to other parents out there, especially those raising kids during these challenging modern times.

I think of the words of Jesus as I close this chapter. In John 16:33

He made an astounding declaration: "In this world you will have trouble." Ugh. Really? Yes. "But," He continued—and this "but" changes everything—"take heart! I have overcome the world." We are living in troubled times. No one gets through life unscathed. But Jesus died to overcome every sin and the weight of the world with it. I'm grateful that we don't have to face trials on our own. What about you?

Brushstroke Moment

Take a moment to turn back to the front cover or
title page of this book. Notice the subtitle.
In my experience, the brushstrokes of the Master Artist appear,
sometimes most beautifully, during trials and tribulations.
How have your trials and tribulations affected your perceptions
of God? How might the words of John 16:33, taken to heart,
influence your perceptions of your trials and tribulations?

The Art of Overcoming
Disappointment

Don't let today's disappointments cast a shadow on tomorrow's dreams.

UNKNOWN

I love that the very teens who gave me a serious run for my money back then now sit at my kitchen counter as beautiful, maturing young adults, talking about their lives and faith in deep and meaningful ways. If you're in the midst of raising teens, hear me loud and clear: there is hope. God redeems all things! Keep on, dear friend, keep on. Parenting wayward children—young or adult—can feel like an agonizingly long journey. Sometimes it *is* an agonizingly long journey. That's why it's so essential that we encourage one another's flagging faith as we run the parenting marathon. Whether your child's struggles last for a month or many, many years, God never stops working. He is faithful to finish the good work He starts in each of our kids, whether that takes a week or a lifetime.[1]

"We really gave you hell," one of my children's sweet friends reflected recently. "That's true," I laughed, "but God did amazing things in all of us through those tough times." I've learned more through parenting than any other area of life. It's a challenge to own a business, to create and sell my own artwork, but it's small potatoes compared to raising children.

To all my friends in challenging seasons: hang on to Jesus; He won't let you down. As you persevere, you'll see Him move in powerful ways!

As I persisted through the refining and rewarding years of parenting teens and young adults, I also saw God move powerfully in my artwork and business. *Angels in Our Midst* continued to sell well, commissions continued to flow in, and I painted and shipped to keep up. I cannot express how thankful I was when a dynamic gal waltzed into my life one day, ready to help take my business to the next level. Wendy Wilson had received an angel painting from her husband as a birthday gift. She was ready and willing to help me out, whatever that might look like, and she jumped right in, helping me with shipping first. That task was below the level of her gifts and abilities, though, and I knew that she could help me on a bigger scale. I wanted to get my work into a broader market, and Wendy was just the gal to help me do that.

I knew quite a bit about the gift market, having sold my pottery at the Atlanta Market back in the day. But that had been a few (as in thirty!) years before. Would I be able to break back in? Stores were interested in carrying *Angels in Our Midst*, so I thought it would be worth a try to expand my reach. I knew it would require persistence and patience, but I was excited to see what God might do.

Wendy and I secured a prime location at the Georgia gift market—an eight-foot wall right next to the bathrooms. Seriously! Everyone has to go at some point, and we'd be right in their line of sight. We contracted one of the stores in Hilton Head that carried my artwork, a store whose employees had a knack for design, to build a display that would make the book pop. They had created the most charming display for me when I

did a book signing at their store; I was confident they'd make something fantastic.

I was not disappointed.

Picture this: Wooden pallets. The simple ones on which mass goods arrive. You've probably seen them at a warehouse store or, if you've worked in retail, in a back storeroom. The designer from Hilton Head crafted bookshelves out of these pallets, staining them a deep, rich mocha brown. The cover of *Angels in Our Midst*, displayed on these handmade, rustic-looking shelves—it was just perfect! I wanted to use these for years to come, not just at one market in Atlanta.

"Are these for sale?" I asked. After a bit of negotiating, they were mine. I may have paid more than it would have cost me to make them, but what did that ultimately matter? They really were perfect. And the display definitely grabbed people's attention. Wendy and I watched as we went from three retail stores to three hundred in the space of a weekend. We sold books and shared stories and started making plans for the next gift market, this one in New York City.

We secured a booth, a step up from the single wall we'd had in Atlanta. I envisioned setting up the gorgeous pallet bookshelves and was assured that—if I packed them in a careful and particular way—they would arrive safe and sound for the big weekend. On the day and time I had been assigned to receive my goods and set up my booth, we opened the crates and discovered that the bookshelves I had paid a hefty price to secure were now nothing more than splinters.

I stared in disbelief. What now?

I wandered up and down the aisles, fighting back tears, looking forlornly at all the sleek booths around me. When I got back to my place, I saw that my neighbors had set up their wares: fake flowers and garden gnomes. I have nothing against artificial greenery and garden décor as a rule, but the gnomes next door made my artwork look positionally out of place. The tears really started to flow then.

Because going to God is not just the right answer but also the best answer, I turned to Him in prayer. *Lord, I feel like this weekend is going to be like those splintered bookshelves: useless. I don't understand why this is happening. I've tried to honor You with the angels. What am I supposed to do now?*

God is so, so good to have given me Wendy that weekend. Her positive, can-do attitude went into beast mode and we rallied, coming up with a plan B. We quickly gathered a small, round table and placed a simple white tablecloth over it, placing it in the center of the booth. We hung six floating bookshelves—also white—on the back wall. It wasn't what I had envisioned, but it was beautiful. And that weekend at the New York NOW Gift + Home Show was fruitful. God provided, and I was so thankful.

Things were going really well with my art career, but I needed to learn how to overcome disappointments. Maturing in this area on a small scale (dealing with splintered bookshelves) enabled me to prepare for more significant disappointments later on (in running my own business and in close relationships). God taught me a lot about both persistence and wisdom in the wake of those gift markets. We'll explore those lessons in greater detail in the chapters to come. Both back then and in the years since, He's taught me—in a very personal way—the truths recorded in James 1:2–5.

> Consider it pure joy, my brothers and sisters, whenever you face trials of many kinds, because you know that the testing of your faith produces perseverance. Let perseverance finish its work so that you may be mature and complete, not lacking anything. If any of you lacks wisdom, you should ask God, who gives generously to all without finding fault, and it will be given to you.

When we face trials and troubles, we have a choice. We can run and hide, but escaping to things like TV, food, drinks, relationships, or the

internet will help only temporarily. Grumbling and complaining won't get us anywhere. And making choices that set us back in our walk with God is just plain foolish. He has taught me the art of overcoming disappointment, and I invite you to press on when difficult things happen in your own life.

In the grand scheme of eternity, the disappointment I faced at the gift market was a blip. The broken bookshelves were an inconvenience but ultimately something that I could overcome in a day. You and I both know that many of life's disappointments hit a lot harder, a lot deeper, a lot longer. Chronic illness, family dysfunction, financial strains amid raging diseases and soaring inflation—these aren't simply "disappointments." They can and often do feel like crushing weights we're asked to carry up Everest-sized mountains.

Dear friend, if you find yourself in a situation like this, please allow me to stop right now and offer a prayer for you:

Father, Your beloved children are facing trials and pain. There's so much hurt, Lord. We can turn to You in faith and hope only because You are who You say You are—good, merciful, true, gracious, and loving. We need You, Jesus. Please be with each reader facing disappointment and discouragement. For anyone who feels completely overwhelmed, please provide strength and hope. We can't manufacture our own faith, Lord. Even that is a gift from You, so I pray for the gift of increased faith for each of the dear ones reading these words. We love You and place our trust in You because You are faithful. Amen.

When I think about pressing in to the presence of God during disappointment—whether it's a little thing or a massive problem—I imagine myself like a little girl running to her perfect Father. That's who God our heavenly Father is. You may not have had an earthly dad

you could run to for protection or help; I'm so sorry if that is what you experienced. It doesn't immediately erase the wounds of our childhoods, but it *can* transform our present to know that our heavenly Father will never disappoint us. He equips us to overcome. It requires some practice (just like all of discipleship), but God does empower us to press past disappointments. That's why the passage from James you just read promises that trials produce perseverance in us.

We practice the art of overcoming disappointment when we make time with God a priority, when we read His Word, listen to His truth through praise music or podcasts, journal our thoughts and prayers.

We can also ask God to help us understand the *why* behind our heartaches. When something disappoints us deeply, we can ask our heavenly Father to reveal if there's a root of unbelief or fear left in us. The input of godly friends can help in this too. And through all of these practices, the amazing and added benefit of turning to Him is that He also gives us wisdom.

Brushstroke Moment

When you read the word *disappointment*, what do you think?
How have you learned the art of overcoming disappointment?
I made the claim that, to be persistent, I have to *practice* persistence.
I have to push forward when things get tough.
What do you think about this?
Take a moment and look back,
tracing the brushstrokes of persistence through pain in your life.

I don't know where today finds you. You may be in a fierce storm right this moment. Or things may be going well. Wherever you are right now, you and I both know that trials come into every life. We should be

prepared, deciding ahead of time that we will turn to God, who promises to give us wisdom.

I needed His wisdom at so many different points in my career, not just breaking into the gift market but also as I embarked on another great adventure with God—opening a gallery.

twenty-one

Open Hands, Open Hearts

My happiness grows in direct proportion to my acceptance,
and in inverse proportion to my expectations.

MICHAEL J. FOX, ACTOR, AUTHOR, AND
PARKINSON'S DISEASE ADVOCATE

The Red Dot Art Fair in Miami, Florida, is a curated, gallery-only contemporary art fair that showcases seventy-five of the top galleries from around the world. It's a prestigious event, and I was thrilled to secure a booth representing my works and the works of a few other artists.

One day when I was at Red Dot, I took a break from my booth and strolled through another art show, Art Basel. I remember seeing a newspaper framed behind glass. Some squiggly markings in what looked like tempera paint, though it might have been acrylic, covered parts of the newsprint. I turned to read the description and saw a red dot, an international sign used to mark a painting as sold. This one to the tune of $350,000.

I strolled around, viewing other exhibitions. The pricing simply

shocked me. The art—much of it along the lines of the newspaper with random paint splatters—was selling for hundreds of thousands, in some cases millions, of dollars. My heart sank.

I was in Florida to sell the angels along with other artists' work. (Andy Braitman, from whom I had learned so many techniques early in my painting journey; brilliant sculptor Paul Day; and the incredibly talented Ken Auster all had pieces on display at the booth I manned.) We had agreed to give a portion of the proceeds back to charity. With my colleagues and friends, I wanted to make a difference in our world. But I couldn't compete with what I was seeing. And I didn't want to. I wanted to create and represent art that inspired people, not simply work that would sell to the highest bidder. What I saw at these fancy art shows frustrated me, but it also motivated me.

As I walked back to my booth at Red Dot, I felt the Holy Spirit's nudge: *Be a light, Anne. And shine My light on others.*

The Master Artist had already shown me how He wanted to use—and already was using—the art He inspired me to create as a light reflecting His glory and drawing others to Him. Now I sensed God directing me to use the influence I had gained in order to be a light in the greater art world. I didn't quite know what that meant yet, but I came home from Miami's Red Dot Art Fair praying about it earnestly.

Please, Lord, show me what it means to be a light in the art world.

In the weeks to come, it became clear that I felt led to—and I very much wanted to—shine the Master Artist's light on other talented creators from around the world. I presented my desire to open an art gallery to Clark and, after a lot of praying, we both sensed the nod to open Anne Neilson Fine Art. In 2014, I became a gallery owner-operator!

Since its inception, Anne Neilson Fine Art (ANFA), located in the heart of Charlotte's South Park neighborhood, has represented regional, national, and international artists of all styles and media. The vision God gave me—to create a space that would be a lighthouse in the Charlotte

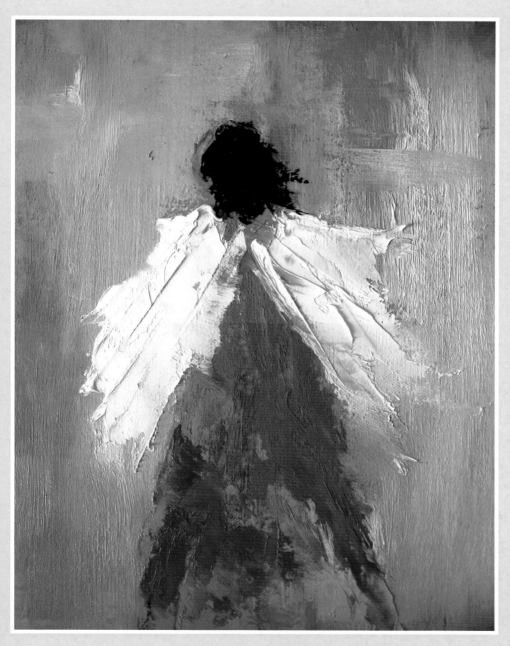

I sent this image to my sister, and her response
was, "You have found your voice."

Sketching the composition usually starts out laying down the foundation, sketching out the angels, and then sculpting them out of oil paint.

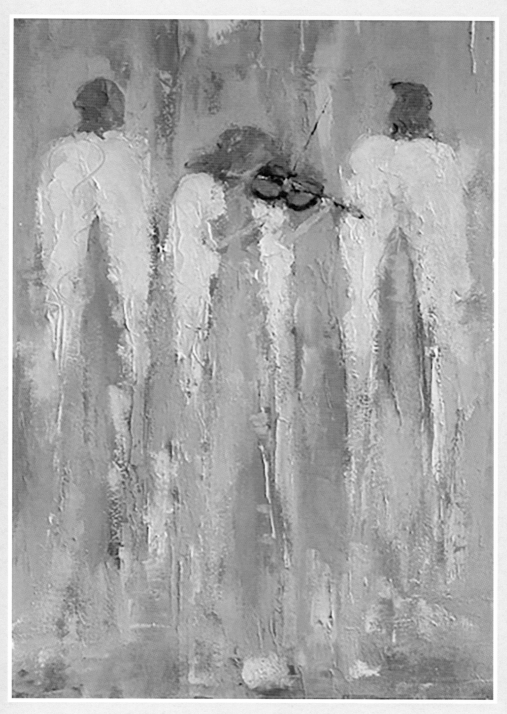

This painting partnered with the Charlotte Symphony in
2004. It was the marketing piece for their Gala.

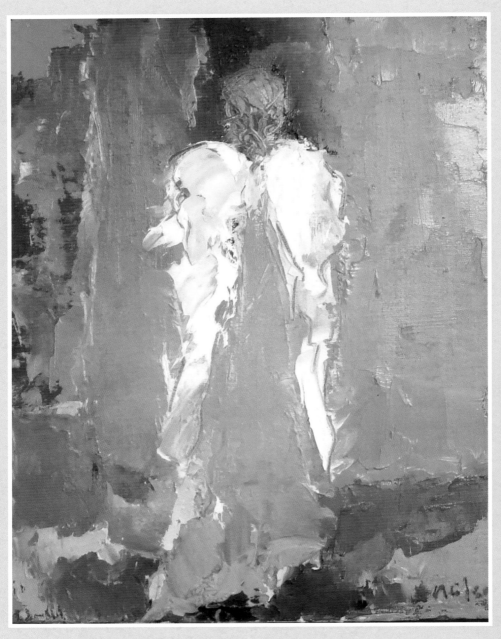

Early Angel. Experimenting with color, texture, and form.

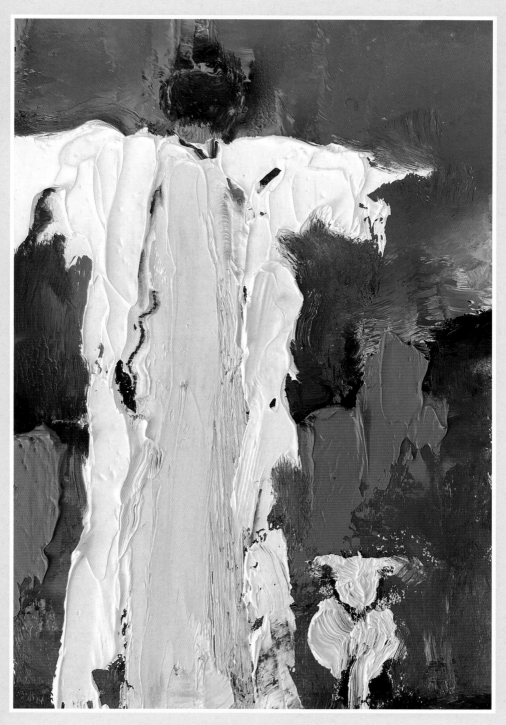

The Lord Is My Shepherd. 2022 Original Painting.

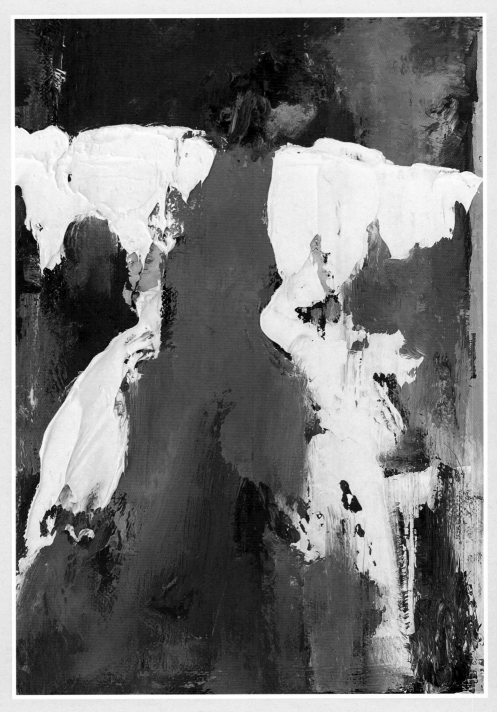

The Glory of God. 2022 Original Painting.
Creating texture, I use a palette knife, and often in my paintings
you will find a hidden heart, dove, or symbol of hope.

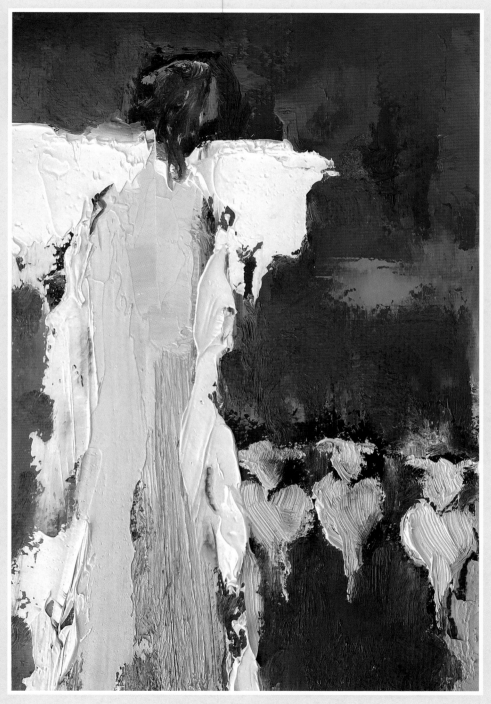

The Shepherd of My Soul. 2022 Original Painting.
Experimenting with texture and color, I love to use my
palette knife to sculpt these angels on to the canvas.

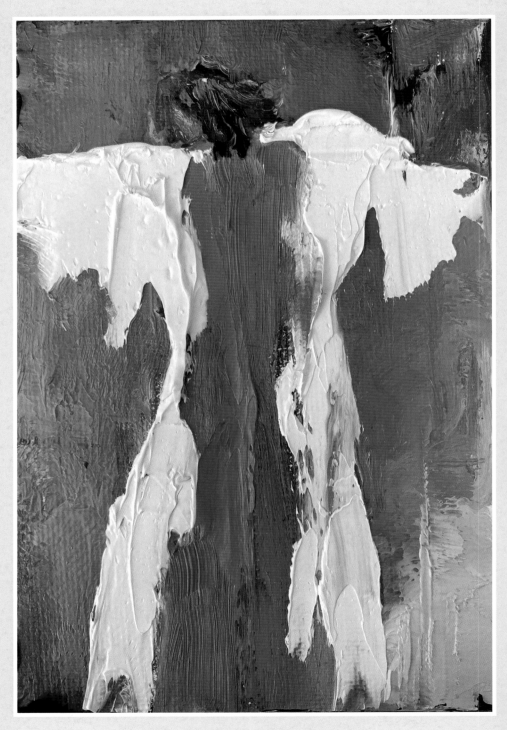

Radiant Love. 2022 Original Painting.

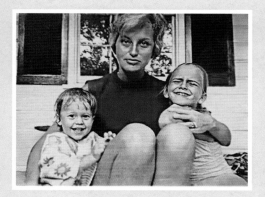

A captured moment with my mom and baby sister. Despite the rough patches of divorced parents, God had a plan for my family. He redeems all things and my favorite scripture is Joel 2:25: "God will restore all the years of locusts eaten."

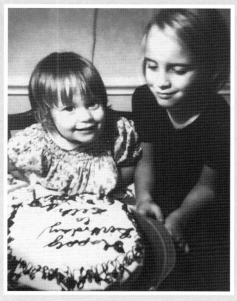

My baby sister Beth's second birthday party. Despite some meanness in my bones, I would like to think I had a lot more kindness in my spirit.

Celebrating my birthday with my baby sister. Grateful for God's grace and mercy throughout the years.

Grateful that my sister forgave me. When you forgive, you heal. When you let go, you grow. She brings a spark of joy to all of our families.

Pensive, shy, and pondering what
I wanted to be when I grew up.

In the third grade I had to write a paper
about what I wanted to be when I grew
up. Highlighted were three sentences
stating that I wanted to be an artist.

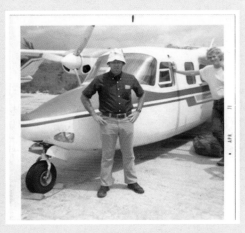

My dad was a fighter pilot for the Navy
and was away on reserves during my early
years. I talk about him being the coolest,
most adventurous, most handsome dad.

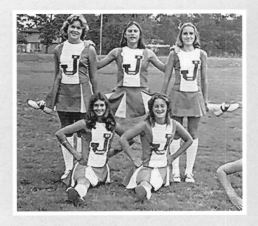

After ditching the funky ID bracelet,
I finally made the cheerleading team.

This says it all. I was not a happy student and carried a teenage attitude.

My best friend Jane, who giggled her way through life, and I know now is laughing with Jesus in eternity. She passed away too early in life, and I think about her every single day.

A few days into the Outward Bound experience we had to climb this steep mountain. Pensive and unsure, but determined to overcome any challenges.

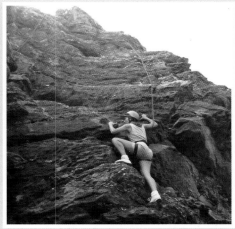

My dear friend Kathie Lee always says the harder the climb, the greater the blessing is on the mountaintop.

My view for my solo during Outward Bound. This image captures the beauty of God's masterpiece.

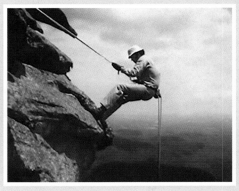

Like father, like daughter. I love this picture as it mirrors my adventurous climb. My dad has always been my biggest cheerleader for all that I do.

Circa 1990, when the Herring Company (Herring Designs) was formed.

I was hooked on fish, no pun intended, as my last name was Herring. Each platter and plate were hand-carved by me.

My mom and stepfather ill
after food poisoning. All ten of
us stayed in bed for a few days
recovering before the wedding.

A very hungover groom,
but we tied the knot.

Moved the reception to the
Turnberry, Scotland. A glorious
venue for a fairytale wedding.

Being a wife and a mom is the greatest
gift and such a blessing. We had
three girls in less than three years.

When Clark asked me to marry him, he asked how many children I wanted, I said four, he said that's a good number. After struggling with two miscarriages after the girls, we finally got our fourth, an amazing son.

Family is everything to me. The number one lesson I have had to learn is to let go and let God be the parent to these wonderful adults. It's been an adventure being a parent to these four beautiful children.

Building a house God's way. The cross showed up on our tree two weeks before we moved in to our new home, where I built a little studio to get back into the creative dream.

Painting with praise music, allowing the Holy Spirit to flow out of my heart and onto a blank canvas.

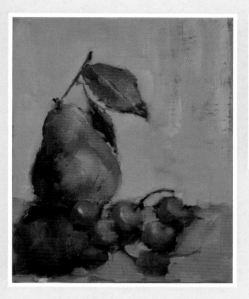

This was my first studio outside of my home in 2005. My paintings were getting bigger and I needed more space.

In 2003 I picked up a paintbrush and started painting with oils. My first painting with oils was a still life of a pear.

Wendy was my first employee. We had no idea that this hobby would grow into a thriving business.

My first book and my first market in New York City. The design was supposed to be a lot different, but when the display shows up as splinters, you have to regroup and let God take over the disappointment. It turned out to be a pretty great show.

From disappointment to divine appointments, God has brought many people along this journey to support and bring encouragement along the way. Left Jimmy Wayne, Right Kathie Lee Gifford.

Shining a light through art, in 2014 I opened Anne Neilson Fine Art representing over sixty artists throughout the country. Our mission is to give back through art by partnering with charitable organizations.

God's faithfulness. Early in the journey of inner healing, Norma Dearing led me in prayer and visualization of meeting Jesus. My place where I met Jesus was a field of yellow flowers. Several decades later, I stepped off of a bus in Israel to a field of yellow flowers.

Grateful for my husband who stands by me all these thirty plus years.

Grateful for my dad who taught me to be adventurous in every area of life.

Grateful for my mom who taught me the power of prayer.

area and beyond—came to life. And the gallery's mission, giving back through art and spotlighting organizations dedicated to serving our community, has brought me and everyone involved such great joy. Each month the team at ANFA selects a meaningful organization as the recipient of a portion of our monthly profits. Using our gallery as a platform for philanthropy is our highest priority and honor.

At ANFA, our artists and collectors are like family. We foster creative relationships through our work, allowing us to introduce our clients to artwork that enhances their collections and inspires them in their daily lives. Because we strive to connect people and art, ANFA is a warm, inviting, and uplifting space where all are welcomed and appreciated. I love walking into the gallery and seeing the fulfillment of the vision God gave me after the Red Dot experience. There has been great joy, great celebration, great anticipation, and great art in ANFA every single year.

There has also been great sadness and great doubt.

Just because something is God's will and your heart's desire does not mean it will be easy. It's not that I expected zero obstacles—after all, Jesus didn't exempt anyone or anything from His promise of troubles in John 16:33. I just didn't anticipate how many details I'd have to navigate as a small business owner or how they would spill over to disrupt my creative energy. Running the day-to-day operations of a gallery and all of the HR needs that go with it—these aren't my primary gifts; creating art is! I needed help, a team of people I could trust. Looking back, I guess I expected that all the people I worked with would share the vision God had given me. I expected that we'd work together as a team. But personnel issues became a major source of stress in my life, rattling my mood in the studio, at home, and with my family.

I have been through five gallery managers, trying to find a trustworthy, long-term employee who shares my vision to serve God and give back through creating, representing, and selling fine art. Several fantastic employees went on to become moms, which of course I celebrated and

encouraged them to do; there's no role as wonderful as being a mama, and you have only a handful of years with each child. The departures of the moms-to-be were difficult in a logistical sense, but other departures cast a shadow of sadness and doubt.

One manager up and quit moments before our scheduled move to a newly renovated gallery space. I had always told people that she was the angel who dropped out of heaven to move ANFA and all of the artists represented there to the next level. I had invested a *great deal* in this "dream employee" over a two-and-a-half-year span. Indeed, I had all but handed over ANFA's reins to her. I trusted this employee that much.

But she wanted more. More compensation, especially.

I have always made it my express aim to care for the people God brings into my business. I'm a giver at heart and felt I'd been more than generous with her financially. After a very awkward conversation about money, however, she simply quit. No two weeks' notice, no "I'll help you get through the gallery move." Just "I quit."

The shock and betrayal I felt hurt on a soul level. I thought of this employee more like a sister in Christ who shared the vision the Great Artist had given me. Seeing that it was only a job—not even a calling— was extremely painful. But God used this situation powerfully. He showed me that I need to guard what He's deposited in my soul; the vision He gives me is for me primarily, not to be given away to someone else. He also helped me see that, in the midst of trials and tribulations, something far bigger is going on.

Brushstroke Moment

In what ways is your life a light for God? What opportunities has God given you to shine His light on others for His sake?
Maybe your expectations of what it means to shine God's

light are different from what He has in mind for you. If
it seems like God is slow to make your dreams a reality,
why not invite Him to reveal His dreams for you?

While ANFA had lost a key employee, we still had the best guide—
God the Holy Spirit. He had given me the idea to move the employees
of Anne Neilson Home, the business that sold décor based on my fine
art, to a design and fulfillment center. This allowed ANFA to downsize
gallery space and focus on creating the kind of energy and ambience that
we wanted and hoped would most glorify God.

So much prayer had gone into the gallery move. And in a just-like-
that sequence, a space had become available just twenty steps from my
previous gallery. It was an empty shell, yes, but it had great potential.
My creative brain fired into overdrive while Clark and I worked with
a builder who affirmed he could do the renovations for the amount, or
close to the amount, that the building owners approved.

"Are you certain?" I must have asked a hundred times. I was lim-
ited on money and did not want a slew of out-of-pocket cash expenses.
Assured that it would work, we developed plans with an architect who
translated our vision to blueprints.

Now, you may have skipped over the description "empty shell" that I
gave two paragraphs ago, but that's exactly what this space was—empty.
No air, no plumbing, almost no electrical. This was a *ground up* over-
haul. And two words in the architect's plans—*catering kitchen*—cost me
countless nights of sleep, floods of tears, and the addition of an extra
bathroom.

When the builder called and told me that his price had doubled—
yes, *doubled*—I pleaded with God. *I thought this is what You wanted,
Lord. What do I do now?*

God gave Clark some amazing ideas, and my husband came through

for me in a huge way. He helped me think creatively rather than dissolve into panic and doubt. Together we went back into negotiations with the landlord and building owners. We discussed a variety of ways to make things work and ultimately landed on an agreeable option: a ten-year lease.

That would have worked perfectly if I'd had the team leader that I thought I had—the ideal manager to lead ANFA through the next decade. But here I was, signing a contract for ten years and moving into a new space without the employee I believed was perfect. I had to step out in faith alone, trusting God to come through because He had given me the vision to shine His light for and on others.

And, oh, how He came through, my friend! Many years previously, when I served as a Bible study leader, I was taught that sometimes you have to step down so that someone else can rise. I saw this principle proved true in an incredible way over the next few months. A junior employee stepped up in *huge* ways, working harder than anyone I've ever known. I joyfully promoted her for her efforts. Ignited with the vision to make ANFA a lighthouse through art, this employee made a massive difference in the transition and beyond! A new builder also stepped onto the jobsite with an amazing can-do attitude. Together, the team established ANFA in its new space. It was different from what I had envisioned. Indeed, with God, it was *better*.

Brushstroke Moment

Through challenges in my journey as a gallery owner-operator, God wanted to teach me to rely on Him, to trust Him. I learned that He might not always provide in the way I expect, but He always provides in the way that is best. I can accept that and live in His peace and joy, or I can fight it and struggle. It's my choice.

You have a similar choice in your own life.
Look back at the words of actor, author, and advocate
Michael J. Fox at the beginning of this chapter.
Have you experienced what Fox describes?
In what area of life might God be inviting
you to accept rather than expect?

I recently looked at a collection of photos cataloguing the first eight years of Anne Neilson Fine Art. I was astonished at all God accomplished during that time. He called me and equipped me to shine His light on other artists and bring His light to every person who walked into the gallery. In those moments of sadness or doubt, especially when I felt betrayed or baffled, God faithfully brought me through.

The Great Artist wasn't angry or disappointed when I looked at the canvas and prayed, *What am I going to do? This is a complete mess!* He simply placed His hand on my heart, reminding me that He was in control and He had a plan. He added the brushstrokes during this time in careful, perfect ways. Where I saw a mess, He was creating a message.

"I am the light of the world," His message proclaims, "let your light shine before others, that they may see your good deeds and glorify your Father in heaven" (John 8:12; Matthew 5:16). Art that shines light and does good. That's what Anne Neilson Fine Art is all about.

twenty-two

Painting with Purpose

Whether you turn to the right or to the left, your ears will hear a voice behind you, saying, "This is the way; walk in it."

Isaiah 30:21

lark once asked me, "How long are you going to paint angels?"

My response rose from a place deep within: "As long as God calls me to paint them."

For me, painting is and has always been about following God. It's such a privilege that the work I do is the work I love and also a work that enables me to give back and bless others with Jesus' love. I thoroughly enjoy the times of worship in my studio, playing praise music, mixing colors, and creating the ethereal beings who make up my Angels series. I don't *just* paint with purpose; I also love it. But purpose increases both my delight in painting and my love for God. When my work furthers His purposes, that's when I stand in awe and bow in humility.

Whenever God nudges my heart, I want to listen and obey. A few times, however, I've doubted and delayed. On one such occasion, God

prompted me to paint an angel for the Chapman family. Steven Curtis Chapman, a Christian recording artist I admired, and his wife, Mary Beth, had suffered the terrible loss of their precious five-year-old daughter Maria Sue in a tragic accident. I sensed God guiding me to paint, and I did so through tears, listening to Steven Curtis's music every day for weeks.

Tears flowing from my heart to the canvas, I saw a small angel appear, a red ponytail holder fastened around a tousled head of radiant, dark hair. The colors in the painting—pale yellows, greens, and pinks—were not ones I frequently used. Somehow, though, I knew that I needed those on my palette.

While allowing the painting to dry in my studio, I read an article about the Chapmans. The journalist gave a few details about their house, and this opened a flood of doubt in my mind. The description of the Chapmans' home did not match—in fact, it seemed in opposition to—the colors with which I had painted. For weeks I debated whether to send the painting. I wondered if I had actually sensed God's leading to paint or if I simply empathized with the Chapmans and wanted to do something, anything.

The restlessness inside me would not subside, though. I had to send the painting. I contacted a dear friend, whose son knew the Chapmans through the Nashville recording industry, and asked if he would deliver the angel to the family. I didn't expect to hear from Steven Curtis or Mary Beth; I was a stranger to them. I just wanted to follow what God had asked me to do.

I did hear from the Chapmans, however, in an email that confirmed that I should always follow God's lead—without delay. Mary Beth told my friend, "We about dropped it [the painting] when we opened it . . . the colors were the same colors as our home and our little Maria Sue always wore her hair tousled in a ponytail." The Master Artist's purposes are always greater than mine.

Indeed, over the course of my career, His purpose connected me with

amazing ministries and individuals, including Oprah Winfrey. I had always loved Oprah's generous heart—she gives back in a way I respect so much—and wanted her to have an angel painting. While watching her Angel Network every Christmas, I declared, "One day I'm going to paint something for Oprah."

But I didn't have a clear vision, so I continued to paint other angels and images. I never sensed that a painting I had created was for Oprah. Then, one day, a painting emerged on my canvas—a grouping of three angels, the center angel slightly taller than the other two. Both angels flanking the central figure had the same cropped hairdo. *Hmm,* I thought, *that's interesting.* I stepped back to review the painting and sensed a nudge: *This one. This one is for Oprah.*

I stood there pondering the composition and the three angels, not quite sure who or what they represented. Once again I ignored the nudge, and this painting hung in my studio *for more than a year.* With it was a letter I had typed out, telling Oprah who I was, why I painted, and how I shared her heart's desire to give back, especially to those who are under-resourced or struggling. I pressed Save on the letter's file, but neither it nor the three angels went anywhere.

Over the next year, many people who visited my gallery offered to buy that painting, but I would tell them, "I think one day I am going to give that to Oprah Winfrey, but I'm not sure who all the angels represent." I'm also not sure how many people took me seriously when I said this.

Cooking spaghetti one evening—I recall this distinctly because the noodles were boiling and the sauce simmering—I listened as the news droned in the background. A feature story came on about none other than Oprah Winfrey, who had discovered a half sister she never knew. Oprah's other half siblings, a sister and a brother, had both died years ago. Her remaining half sister, Patricia, did everything she could to get in touch with Oprah, but no one believed her story. Finally, through many twists and turns, Patricia and Oprah met.[1] Watching video footage, I

noticed right away that Patricia was shorter than Oprah. When the sisters hugged, Patricia measured right at Oprah's shoulder. Photographs of their other half sister (also named Patricia!) showed that she, too, came to the height of Oprah's shoulder; and she looked almost like the other Patricia's twin.

Instantly I started crying, finally understanding the meaning of the painting. The two angel figures flanking a taller figure represented Oprah and her half sisters. I dug up the archived letter I had written more than a year before, printed it out, and carefully folded it, fitting it within the canvas's rear supports. I also grabbed some stationery and scribbled a small note, something to this effect: "Oprah, I have always thought you were supposed to have an angel painting. After learning about your family, however, I believe this painting might be for your half sister Patricia. Do with it as you will."

I shipped the painting to the assistant Oprah had frequently referred to on her show. Done. Oprah's painting was finally sent. It had meaning; it had purpose. And I was overwhelmed with joy that God had given me direction for that painting.

A few weeks later, on a Tuesday night at 8:20 (to be exact), my cell phone rang. My family had just finished up dinner, and the kids were washing the dishes. I looked at the number on my phone and noticed a 312 area code. No caller ID, though. I answered, no idea who might be on the other end of the line.

When a familiar voice asked, "Hello, is Anne Neilson there?" I tried to remain calm, cool, and collected.

"This is Anne," I replied, my voice trembling ever so slightly with excitement.

"Well, this is Oprah Winfrey."

"Oh, Oprah, wow. I just want to take you to coffee," I blurted out.

Right then my daughter brushed by me and whispered, "Mom, you sound so lame."

Nothing like being a mom to keep you humble!

Oprah was so gracious. It felt like we talked forever, but really it was more like seven minutes. It was a super jam-packed seven minutes, though! I got to tell her about my work and the ways God nudged me to paint with purpose. I also told Oprah how much I admired her giving heart and sought to give from the depths of my own heart in the same way she did.

The next day I wrote a note to thank Oprah for calling me. She could have had any aide or assistant dial my number to express gratitude for the painting, but she picked up the phone. It was such an honor. I mailed the letter that day and, two days later, I got an email from her assistant, informing me that the office had received my letter and would make sure she got it when she returned from traveling.

While chatting, Oprah's assistant and I discovered we would both be in New York a week later. We set a date, and I met her at the Red Dot Art Fair in New York City. She was every bit as gracious as I had imagined, and a friendship formed. A few weeks later, I received a phone call from her. Oprah wanted to offer two tickets to Clark and me, she explained. Would we like to be her guests at a show in May? I don't know anyone who would say no to that invitation!

Over the next several weeks, I emailed back and forth with the assistant I had met in NYC. There were quite a few details to arrange. When I was told that a car and driver would pick up Clark and me and take us to the Charlotte airport, I responded, "Thank you so much; that's so generous, but it's definitely not necessary. We live only fifteen minutes from the airport, and it's a straight shot."

"Thank you, Anne, but Ms. Winfrey wants to bless you with white-glove service. She won't have it any other way."

Wow! I thought, simultaneously humbled and delighted. *I can't believe this is real!*

Overwhelmed with gratitude, I asked the names of every individual

working in Oprah's office on our extensive travel arrangements and hatched a plan to send five framed angel prints to thank those helping make this opportunity a reality for me. I also painted a small six-by-six-inch angel study as a thank-you to Oprah for extending the invitation to Clark and me. I loved that little painting and titled it *Amazing Grace*. Tuck that name in your memory because the best is yet to come with this story.

Clark and I arrived in Chicago that May, and celebrities of all kinds celebrated Oprah the evening of the show. Tyler Perry came to the main stage and talked about the ultimate gift of education and how it empowers Black families. Video footage of testimonies from the men of Morehouse College played as students and graduates lined up behind Oprah. Kristin Chenoweth sang as more than four hundred of the men Ms. Winfrey helped put through college filed onstage one by one. The power of education and the power of giving back were on profound display.

I thought back to all the times God had pressed on my own heart to give back. I remembered my first day at Harvest Center and my desire to make a difference for those experiencing homelessness in Charlotte. It was so affirming to see—on a scale far bigger than my own life—what giving back can do.

There was not a dry eye in the United Center that night. Honestly, it was a very good thing that Kleenex was one of the sponsors of that evening's festivities. A box of tissues could be found under each of the seventeen thousand seats that night; most of them were well used.

Toward the end of the evening, Stedman Graham, Oprah's long-term partner, walked onstage. He proceeded to tell Oprah how much he loved her, then enumerated many of her remarkable accomplishments, including her tireless work to help others. He ended with the words, "It's only by God's amazing grace that you are here." Right then Aretha Franklin walked gracefully onstage and sang the beloved hymn, "Amazing Grace."

I could not stop crying. I flashed back to the preceding days in my

studio, creating the tiny angel study I titled *Amazing Grace*, which I had given Oprah almost as a token thank-you gift. As He always does, God had a much bigger purpose in mind!

The last guest on that evening's schedule, Usher, swooped onstage, honored Oprah, then broke out in song: "Oh Happy Day." It was an unforgettable night. Seventeen thousand people gathered because of the unique impact of one woman. And God revealed Himself powerfully as Usher praised Jesus, many thousands singing along with him.

Wow, Lord, I thought. *How can I ever doubt Your purposes? Please help me listen and obey, always.* Imagine if I had been too nervous to send that painting to Oprah. Or the Chapmans. I would have missed so much! *Thank You for letting me be a part of Your amazing adventure, Lord. May I always paint with Your purpose.*

His adventures truly are amazing. They don't always include celebrities and thousands of people, though. Sometimes they include washing dirty feet. I found this to be true as I partnered with the humanitarian organization Samaritan's Feet. Taking shoes to underresourced countries and people, Samaritan's Feet changes people's lives, one foot at a time. It's been an honor for me to partner with this amazing ministry.

Many of those who receive help from Samaritan's Feet have never owned a pair of shoes. I had heard the story of founders Manny and Tracie Ohonme at an event that I almost missed (you've likely spotted the repeating pattern here). That season was a particularly busy one for me, and I contemplated backing out of my commitment to attend the fundraiser. I am so, so glad I didn't. Manny's story inspired me and, later that year, my family and I joined Samaritan's Feet on a mission trip to Peru.

I was elated. My missionary heart was on fire, and I was ready to serve. Not so much my children, however. One of my kids in particular complained *a lot*.

"Why? Why do we have to go wash feet? I *hate* feet!"

I did not think it wise, at this juncture, to tell my child that I also hated touching feet.

"When you are called, you're called," I responded. "I'm called, and that's that!"

For weeks before the trip, my kid would send me digital images of the most diseased, corroded feet you can imagine with accompanying texts: "I will NOT be touching any feet resembling these images!"

"Honestly, the trip will be great," I promised, trusting that it would be. "You'll see. We're all going to be together and we're going to have fun!"

It was immediately *not* fun for my kid when the entire group was asked to wear bright orange T-shirts with "Samaritan's Feet" plastered on the front and back through the airport on departure day. Stomping and complaining, this child told me—yet again—that other people could do the whole foot-washing thing.

The trip was amazing. A bit like controlled chaos, but amazing nonetheless. We traveled to the poorest of poor towns in Peru and set up shop, filling buckets of soapy water to wash these precious children's (and sometimes adults') feet. At another station, Samaritan's Feet staff or volunteers sized their feet for new running shoes and focused on getting the perfect shoe for each person.

It was so humbling to sit down in front of a little one who you know has dreams and pray for them, telling them that they are a child of God and that with Him nothing is impossible. "Dream and believe, trusting the One who created you; you are fearfully and wonderfully made," we would remind each child. Washing their feet, clothing them with a clean pair of socks, then slipping on a brand-new pair of shoes—it was incredible.

At one point I looked over at the kid who had complained the entire time leading up to the trip. Truly, with God nothing is impossible. This child of mine was caring for a little girl, maybe five or six years old, gently washing her feet and speaking a few Spanish words. My face broke

out in a huge smile; actually, my entire heart smiled in that precious moment. I was hooked on this organization and made a pact to partner with them any way I could, to bring awareness to this ministry and give back through my artwork and resources.

God inspired Manny and Tracie to start Samaritan's Feet and change lives through footwear. As you know, God worked differently in my life. He put a paintbrush in my hand and a grand vision to paint with purpose. Through me, He opened a gallery to be a lighthouse. My impact is unique. And guess what? *So is yours.*

We have all been given something and called to something. God doesn't direct all of us to run ministries or galleries. But please don't underestimate your impact because of its size. God wants to use whatever we have to give back to others. Whether He asks you to "turn to the right or to the left," like the verse from Isaiah that opened this chapter describes, I urge you to listen and follow; the results are up to Him. If you pursue Him with purpose and passion, God *will* fulfill His plans for you, whatever the size, on whatever scale.

I've served alongside Samaritan's Feet on several occasions and invited many others to join me. One weekend a whole group of us rejoiced as two hundred underresourced children in California received new shoes. That weekend, Manny Ohonme asked us to reflect on our purpose in life. He asked whether we had a "community calling card," a clear sign to others that we are zealous to give back. Giving back moves us from success to significance, Manny explained.

Dear friend, are you focused on success or significance? Our world screams that success is supreme, but I've discovered that *purpose is paramount*. In order to move from a success-oriented perspective to a significance-oriented one, we need to take risks and get out of our comfort zones. Not unlike my child who learned that washing feet can change two lives—the life of the servant as much as the one being served—each of us can take risks that change us forever. It's all because of God. When

we honor and serve Him with everything, we find a purposeful life is the most fulfilling life.

It's true: taking risks with God often disrupts our equilibrium. He takes us to the edge of what is comfortable, then invites us to take one step more. That can be tough. But allowing God-moments to pass us by dulls our joy and limits our vision. I don't want to live that way and I don't believe that you do either. John 10:10 tells us that Jesus came that we might have life and life *more abundant*. C'mon! Doesn't that sound good? What's holding you back from a life of greater purpose?

Brushstroke Moment

I once heard that we are to gaze at God but glance at life.
What do you think this means?
Do you currently use what God has given you—however much
or little—for a purpose greater than your own comfort?
If so, what is that like for you?
If not, why not? What is your purpose?
Take some time to journal about this, talk it over with
a trusted friend, and listen for God's direction.

twenty-three

Devotions and Distractions

Art work is a representation of our devotion to life. . . . The enormous pitfall is devotion to oneself instead of to life. All works that are self-devoted are absolutely ineffective.

AGNES MARTIN, ABSTRACT EXPRESSIONIST

People often ask me, "Do you see angels?"

No, I personally have never seen an angel. I have heard and collected so many stories of angelic encounters, however, that I wrote a devotional titled *Entertaining Angels*. This phrase comes from a Bible verse urging all of us, "Don't forget to show hospitality to strangers, for some who have done this have entertained angels without realizing it!" (Hebrews 13:2 NLT).

In *Entertaining Angels*, I give readers a glimpse into the lives of those who have, in fact, seen angels. God created the heavenly beings I paint for specific roles. When angels come to earth, they bring the messages of God. They are protectors, defenders, worshipers, and warriors. In biblical narrative the beauty and glory of angels caused humans to fall down in

awe or terror. We are *never* called to worship angels, however. All worship belongs to God, who created the angels.

That's why, as I wrote *Entertaining Angels*, I always pointed people back to God. The book isn't simply a collection of stories. It's a devotional, a book with a purpose. I trace the brushstrokes of God in every angelic encounter because, in every story, God reveals something about Himself and/or His purpose. I loved crafting a devotional around this subject, just as I loved writing my other devotionals.

In my life devotion and art have always gone hand in hand. Canadian-American painter Agnes Martin once observed that "art work is a representation of our devotion to life."[1] My artwork has been and will continue to be a representation of my devotion to Life Himself. In John 14:6 Jesus revealed that He is the way, the truth, and the life. I follow Him as the Way, trust Him as the Truth, and live my life—whether I'm painting, writing, or praying—in devotion to Him.

Setting aside quiet time for God each day has been important to me for many years. With the busyness of my life, I can't afford to skip that centering time alone with God. I may read my Bible and pray or read a devotional that helps me reflect on a Bible passage or topic. Sometimes I do all of the above. Devotionals have figured prominently in my own spiritual journey.

After I published *Angels in Our Midst*, one reader told me that she used it as her devotional. *Wow*, I thought. *A coffee table art book is kind of big and heavy for a devotional.* Right then a thought struck me: *I wonder what it would be like to pair devotional thoughts with my angel paintings?*

The art book already had a devotional nature; it invited readers to reflect on God's work and His character. It included scriptures and pointed to Jesus on every page. But *Angels in Our Midst* seemed, at least to me, vastly oversized for holding during a quiet time with God. I tucked away the idea of writing a devotional with art and got on with the wonderful work God already had placed on my plate and palette. I

prayed God would open the doors for me to publish a little devotional art book, but I needed someone to help me. I had all the proverbial tools in my toolbox; still, I needed a publishing "general contractor" to help with construction.

Fast-forward to an art show and book signing Kathie Lee and I did, celebrating the release of her wonderful book, *The Rock, the Road, and the Rabbi*. You must stop immediately and purchase this book if you have not yet read it. Wow! I love my friend's heart for Jesus and her way with words.

During this sold-out event at my gallery, people lined up to see Kathie Lee. One woman had flown in from Dallas, along with her mom, who was a huge fan of Kathie Lee's. We chatted for a bit, and the daughter told me she was a book agent. Never having met a literary agent, I was impressed and sent her and her mom home with signed copies of my bulky coffee table books (by this point, my second art book, *Strokes of Compassion*, had also been published). "It's my way of thanking you for flying all the way from Texas!" I affirmed.

That was that, and I really didn't give the encounter a second thought until I attended a birthday party for a sister-in-Christ who used one of my paintings in her memoir, *Box of Butterflies* (also a book you *must* buy and read). Actress and author Roma Downey, famed for portraying the kindhearted angel, Monica, for nine seasons on television's *Touched by an Angel*, had invited me to celebrate her birthday with her and some other friends. Of course I said yes to *that* invite!

As a friend and I drove to the party, I explained how I had been praying about writing a devotional. I just needed the right person by my side and was trusting God to bring him or her. Not two hours later, I saw the very literary agent I had met at Kathie Lee's book-signing event. She looked me right in the eye and said, "Your ears must've been burning."

Turns out this fantastic woman, Shannon Marven, was the vice president of Dupree Miller & Associates, one of the finest literary agencies in

the United States. Right beside Shannon was the agency's founder, Jan Miller. This divine appointment started me on another amazing journey, bringing to life the devotionals God had laid on my heart. Had I not traveled across the country to attend a party, I may never have re-met my now-beloved agent. Shannon has walked every step with me, taking my dream of publishing *one* devotional and making it a reality beyond what I could have asked for or imagined (Ephesians 3:20). Indeed, you would not be reading this book if it weren't for God's higher purpose in connecting me with Shannon, Dupree Miller & Associates, and the phenomenal publishing team at Thomas Nelson.

Thomas Nelson hoped that my first devotional would sell approximately fifty thousand copies in one year. Never—never!—in my wildest dreams could I have imagined that the little devotional that went from God's heart to mine, from a file on my computer to a gorgeous, four-color devotional book, would touch fifty thousand lives in three months. To say that I was honored and humbled is a vast understatement. You could have blown me away with a single breath! In fact, that's a great picture of what God did.

Perhaps, like me, you've noticed that every "that blows me away" work of God is also opposed in some way or another. Before I even wanted to write devotionals, God taught me to approach life with a devotional mindset—which meant looking for, acknowledging, and trusting Him moment by moment, day by day. In wanting to live devotionally, however, I discovered that God's enemy wanted to distract me. Sometimes these distractions came through nagging doubts in my mind. *What if* this, or *If only* that. Other times distractions came through my closest relationships.

On one such occasion, tensions with one of my children almost distracted me from what God wanted to do through a trip to Israel.

Before we get to that, let me give you the backstory: Clark and I had been invited by Kathie Lee to join her on a tour of the Holy Land. We

were ecstatic and invited one of our children, who could take the time off, to travel with us. We passed along what Kathie Lee had told us: "This will be an incredible opportunity to see the Bible come to life. You will walk where Jesus walked! But this is not an easy trip. We hike . . . sometimes several miles a day. This will be more like an Indiana Jones adventure—boots and hat on at 7 a.m.—than a Holiday Inn vacation."

"Yes, please," I answered my friend. I assumed my kid would feel the same.

A few weeks before the trip, however, long after flights had been booked, accommodations secured, and passports renewed, I sent a text message with a picture of hiking boots and the words, "I'll treat you to some boots!"

When I got the response, "I'm not going," from my adult child, I felt kicked in the stomach.

Our series of back-and-forth texts got a little testier as my kid outlined the following "foolproof" plan to get out of the trip: "I can get everything refunded with a doctor's excuse because my anxiety about traveling to Israel is just 'too much,'" this child stated.

After a bunch of texts, I finally snapped. "This commitment was a costly one, and backing out means paying your dad back," I explained.

I put my phone down, frustration mounting. I went from being thrilled about visiting the Holy Land to being beyond aggravated with my adult child. The texts we'd exchanged threatened to cast a dark cloud over the entire trip.

When Kathie Lee heard that our kid planned to back out, she called me immediately. She told me that she was going to follow up, and she did. Well, guess who agreed to set anxiety aside and go on the trip? Yep. Our kid. I swung from frustrated to excited again.

Then, the night before the trip, I got a call from this child, who had had a dream about dying in Israel. I went completely silent on the line. The immediate thought that came to me was, *This trip will be a death*

to self. I wasn't entirely sure what that meant, but I sensed it was from the Holy Spirit. I knew I couldn't control whether my child was afraid. I didn't have control over the repercussions of my kid's decisions or emotions. If I wasn't careful, though, I could let my own fear and desire to be in control rule me. All I could do was pray, wait, and watch. *Please work through this, Jesus*, I pleaded.

Despite having deep reservations and fear, our kid went with us. The Holy Spirit had told me that the trip would be a "death to self," which could mean all sorts of things, so I chose to surrender expectations. God gave me peace to let go of how things should look and on what timeline they should unfold. Seeds had been planted and I could trust Him in faith.

It turned out that the fruit of that trip wasn't immediate in my child's life. It wasn't the instantly life-changing experience I'd hoped for my kid.

I could have allowed all of this to distract me from what God wanted to do and what He *was doing*, even if I couldn't see it. I had to take a lot of deep breaths and trust, not in my child's good attitude (which was often less than cheerful) but in the hope that God *had* planted seeds that would eventually bloom into beautiful fruit for His glory. Trusting more and worrying less were important ways I learned to live devotionally. That trip was only one part of the journey, but it was a significant one for me.

The Enemy wanted to steal my joy on that trip—as he's tried to steal my joy on many occasions throughout life. As only He could, though, God did something so miraculous in Israel that I couldn't help but turn from the distractions to delighted devotion. My devotional mindset expanded and matured while we walked where Jesus walked. More than two decades after the vision of my father in a stream with Jesus, Clark and I spent time at the Jordan River, where many of us were baptized in Jesus' name. Only a short time later that day, I hopped off the bus in Caesarea. To my left was the largest field of bright yellow flowers I had ever seen. It looked exactly like the prayer vision God had given me more than twenty years before.

That day God reminded me that His promises are always "Yes, and amen!" No matter what the people around us do or think or say, we can choose devotion to God. We don't have to be distracted by the Enemy's obstacles. This truth has become absolutely essential to me. And it became a lifeline as Clark and I did major renovations on our house, just as God started major renovations on our marriage.

Brushstroke Moment

How have you seen devotion and distraction play out in your life?

When is it easiest for you to be distracted from a mindset of worship?

What helps you to resist distraction and reclaim
a posture of devotion toward God?

What is one change you want to make today to
move from distraction to devotion?

twenty-four

The Art of Renovation

Our lives and how we find the world now and in the future are, almost totally, a simple result of what we have become in the depths of our being—in our spirits, will, or hearts. From there we see our world and interpret reality. From there we make our choices, break forth into action, try to change our world. . . . The greatest need of collective humanity—is renovation of our hearts.

DALLAS WILLARD, PROFESSOR OF PHILOSOPHY AND
BESTSELLING AUTHOR, FROM *RENOVATION OF THE HEART*

When I travel for speaking engagements, I usually share the highlights of my story. God has done so many incredible things—and allowed me to be part of them—that it's a joy to focus on the triumphs. I've never wanted to give the impression that my life is all glitz and glamour, though. That's part of why I wanted to write this book. God doesn't just work in our triumphs; He paints beautiful brushstrokes through our trials and tragedies as well.

Many of you are married or have been married. Whether you're

currently married or not, I'm certain there will be quite a few internal *amen*s when you read this: marriage is anything but easy. I'm married to a truly wonderful man, and it's still not easy. I'm married to a guy who loves God with all his heart, and it's *still* not easy. We have a great family and a strong marriage, and—you guessed it—it's *still not easy*. Partly it's because my amazing husband isn't perfect. But the reality is that a big part of why my marriage isn't perfect is because *I'm not perfect*.

And I don't mean this in an "I'm only human" sort of way. I mean to touch on a deeper, more painful truth: Clark and I have hurt each other, sometimes unintentionally but other times deliberately. We haven't just made mistakes; we've sinned against each other. Clark and I both carried some heavy baggage into our marriage. Yes, we had a lot going for us way back when we said I do. We also are tremendously fortunate to have a whole lot going for us these thirty years later. But the secret of our success is not having the right solutions or being in the right situations. It's Jesus, dear friend. Jesus, *and only Jesus*, has held us together.

Years ago I remember checking out at some store, not paying much attention because I had taken an important call. The gal at the register looked at my wedding ring and said, "What a beautiful ring! How long have you been married?" At that point it had been twenty-four years since Clark and I had tied the knot in Scotland, and I told the checkout girl we would celebrate twenty-five years next anniversary.

Apparently oblivious to the fact that I was on the phone, the gal asked, "What do you think is the secret of marriage?"

My phone call momentarily forgotten, I answered her immediately: "Jesus! If He's not the center of your marriage, I'm not sure how you can make it."

I don't even know if she was taken aback or intrigued. I just rolled forward because (1) she had asked and (2) I felt super passionate about the answer!

"Jesus is the thread that weaves your marriage together and makes

you stronger in the midst of storms, disappointments, and hardships. You need Jesus!"

Responding from the depth of my heart when the clerk asked me about marriage moved her to tears; she had only recently moved to Charlotte after picking up the pieces of her life in the wake of a broken marriage. To think I could have missed this opportunity to share about God because of a business call!

I think at that point, after wiping a stray tear away, the clerk told me that I owed $42.38. (Too bad amazing conversations don't pay the bills!) The customers behind me looked eager for me to move on, so I ran my credit card and left the store.

That encounter really impacted me, giving me a desire to pass along what I've learned through my own ups and downs.

Some of you may be just starting out in marriage, perhaps for the first time or after a broken relationship. I want you to know that you can make it through really tough stuff if both of you make Jesus the center of your marriage.

Some of you may be facing a particularly difficult season with your spouse of many years. Wherever you're at, you can deal with the baggage that both of you brought to the wedding ceremony and have dragged through life. I know that you can because the same God who brought Clark and me through is strong enough to deliver you. He wants to renovate *every* heart and every relationship.

That said, some people will resist God's invitation to grow and change. There are marriages in which one or both partners wound so deeply—through infidelity, abuse, or abandonment—that the covenant of marriage is broken. As you read this chapter, please understand that I am not advocating that anyone tolerate or excuse affairs or abuse with a simplistic "Christian couples should work things out" attitude. God wants to renovate every heart, but not every heart welcomes His renovation.

If you believe that you're in a situation like this, please speak with at

least two trusted, Jesus-loving people who can advise you how to proceed. I specify two or more because, sadly, we can get bad counsel even from someone in the church or with spiritual authority. Hold up whatever counsel you receive against the truth of God's Word, asking Jesus to make clear what your best next steps might be. Isaiah 9:6 affirms that He is our "Wonderful Counselor" and Jeremiah 17:10 declares that He knows the content of every heart. Dear friend, He's had to do a whole lot of renovation in mine.

I recall getting in a fight with Clark once, pretty early in our marriage. I wanted to pack my bags and get out, but I went down to the basement instead. At least down there I could have a good cry by myself. *This is not what I expected, God*, I sobbed in prayer. It was dark and cold, and I was all alone, but I heard His whispered response: *Clark is My gift to you, Anne. Forgive him just as I have forgiven you. Love him unconditionally, as I love you.*

God's peace flooded my heart once again. His peace didn't make everything easy, but I knew that my call was to stay, trust, and love. With Jesus' power and grace, I could do that. On my own, not so much. I don't always *want* to forgive. I don't always *want* to love unconditionally. But I do have a choice of whether I will surrender to God. I've learned (sometimes the hard way) that resisting God's love in any way hurts me and everyone around me, so I've chosen to ask forgiveness when I'm wrong, forgive when I've been wounded, and love as unconditionally as I can, each and every day.

I look back on my basement time with Jesus as an essential step in my soul's renovation. It would be nice if the changes in my heart could have happened in an instant, but—as I'm quite sure you have experienced—heart change is a process.

When Clark and I renovated our home, God gave me an incredibly clear picture of what He's done and is still doing in our marriage. The kids were grown, and Clark and I were empty nesters, our youngest

having recently gone to college. We decided to fix up some of the indoor spaces that had begun to wear down. Having four children and staying in the same house through their teenage years is apparently rather hard on a kitchen in particular!

For months the inside of my home was a complete disaster. Dust and construction supplies and who knows what else took over my interior. It was a mess, and the process sometimes felt like madness. But we knew those renovations would eventually be done.

I think renovation shows are popular with television viewers because almost everyone enjoys a before-and-after story. People also like to see a mess turn into a miracle. No one wants to live in their own messy middle, though. Clark and I had to go *through* a significant renovation of our marriage so that we could enjoy a beautiful before and after.

It struck me through this process that there's a whole lot of messy middle in every marriage. At the same time as our home underwent serious renovations, things bubbled to the surface for Clark and me. Perhaps we had pushed some hurts to the back burner in the midst of raising kids and running our own businesses. Maybe we didn't realize that unforgiveness or bitterness had crept in. Perhaps God knew this was the right timing. Most likely it was a combination of all those factors. Whatever the root cause, weeds had begun to twist around the baggage we'd carried into marriage. Those darn weeds tried to twist around our hearts too.

I'll never forget a January afternoon when Clark and I sat on our back porch. It was freezing cold that day; pouring rain made us shiver, and I was sobbing. Clark and I had processed a lot. Our marriage seemed messy and torn up, a lot like our house.

But we could see the sun through the rain. Really, I should say that we could see the Son—Jesus—through the downpour. I had a vision of God's glory shining down on us. He gave me a picture of what our "after" would be.

Like my experience in the basement early in marriage, that January

day was another watershed moment in my soul's transformation. Clark and I couldn't solve everything in one conversation; we simply acknowledged that we wanted to be changed. We prayed that God would work in us to act and to will according to His purpose and decided together not to resist the renovation of our hearts. It was a commitment to the process and—more importantly—the One superintending our transformation.

By that point Clark and I had been people of faith for many years. We always said that Jesus was and needed to be the center of our marriage. And He was. We also needed some major remodeling in order to grow more and more into His likeness. We can say we have faith, but if we're not in daily, close communication with God, are we really faithful? We can say our marriage is founded on Christ, but if we're not communicating and listening in God-honoring ways, are we really building a Christian marriage?

Clark and I wanted to embrace more fully God's design for marriage—intimacy on every level: body, mind, and spirit. The Lord created us for connection and community; that's why communication is so key to any fellowship and most especially in close relationships like marriage and family. Clark and I learned that when you shut down communication, when you stop listening, talking, and forgiving, the Enemy can wreak havoc. For many months after that watershed January conversation, we kept returning to confession and repentance, key components of heart renovation.

I came to think of it as God doing heart surgery on us. To renovate our hearts, God had to peel back the layers that had built up over many years. As for me, I had learned lessons about letting go, surrender, and trust—but I still had a long way to go. I had held grudges and formed harsh judgments. God needed to soften my hardened heart in a number of ways. I began to see how easily provoked I was, how reactionary I had become. I had to relearn how to act with compassion rather than react

with contempt. God taught me to trade my tendency to focus on minutiae for mercy. I prayed earnestly, asking the Holy Spirit to change the ways I communicated with Clark.

I also had to shift some mental patterns. I had gotten in the habit of focusing on how my needs weren't being met, rehearsing my frustrations over and over again. I needed to shift the focus of my thoughts back to Jesus whenever I felt hurt and misunderstood. God helped me see the truth that I needed to stop trying to change Clark, entrusting my husband to the transforming work of the Holy Spirit instead. Applying all of these truths to my life felt like having and recovering from a massive surgery, but I wouldn't trade what I've learned and how I've been transformed for anything.

During the intense season when God worked on our marriage, I reached out to Kathie Lee and asked her to pray for Clark and me. She joined me in praying that God would leave no stone unturned in my heart. She also told me that she was going to start praying that God would move in Clark, that Jesus would "wake, break, and make" my husband into the man God created Him to be.

I kid you not, Clark started waking up earlier than ever. He would read his Bible or pray for long stretches before work. Jesus broke off hurtful patterns in my husband *without* my assistance (nagging). And I watched as the Lord made Clark's heart more and more amazing. God used Kathie's "wake, break, and make" prayer not just to renovate Clark but also to change me; I saw that I didn't have to be the one to point out what Clark needed to change or nag him about my needs. When Jesus is in charge, every renovation is infinitely better.

There's no quick fix when it comes to the hurts of marriage. But healing comes through right relationship, with God and with each other, and that requires continued effort, patience, and humility. So Clark and I kept on talking and forgiving and asking for grace—over and over. Like most of life, the renovation of our house was a *process* that took time. Even

more so the renovation of our marriage. But oh, dear friend, it was and *is* so good to walk with Jesus through the messy middle.

Jesus once told a woman who had a slew of marriage problems (she'd been married five times) something completely astonishing: ". . .whoever drinks of the water that I will give [them] will never be thirsty again. The water that I will give [them] will become in [them] a spring of water welling up to eternal life" (John 4:14 ESV). Jesus' living water has filled our marriage. We're not perfect, and some days are, well, *those kind of days*, but we have grown so much through the years.

If you're thirsty, my friend, go straight to the source of living water. Don't waste your time on anything else.

I thank God that we didn't have to overhaul our entire house just to renovate the kitchen and other spaces. The bones of our house—its foundation and structure—were sound. But things that hadn't been tended to over the years had begun to fall apart. This was a lot like our marriage. Maybe it's like a close relationship you're in too.

Whether or not you're married or ever will be, I imagine that you can relate to the messy middle in some part of your life. The things we hide, the pain we bury, the relationships that we don't tend to, the ugliness we ignore—all of these can rear their ugly heads in our physical health, our emotional stability, our spiritual strength. You may or may not need renovation in your marriage, but all of us need a renovation of the heart.

That's why Dallas Willard said the renovation of the heart is "*the greatest need* of collective humanity."[1] And, if you ask me, with all of the division, pain, and anger in our modern society, it's clear he was right. We can't just educate or legislate people. We can't white-knuckle ourselves to change. We need to be renovated internally.

It may be messy, but it's going to be worth it, dear one. The "after" will be glorious. So let's embrace the art of renovation together. What do you say?

Brushstroke Moment

Do you agree or disagree that the process of renovating the
heart is ultimately worth the effort and difficulty?
What experiences or opinions form your answer to that question?
What role do you think forgiveness plays in the renovation of a heart?
How ready do you feel to ask God to renovate your life?

twenty-five

Remembering Redemptively

Redemptive remembering keeps a clear picture of the past,
but it adds a new setting and shifts its focus. . . .
Redemptive remembering drives us to a better
future; it does not nail us to a worse past.[1]

LEWIS B. SMEDES, AUTHOR AND THEOLOGIAN

Over time it has become clear to me that there arises, in every life, a season for reflection, a time to remember, and an opportunity to restart. We all need to restore and refresh. Writing this book has been part of my reflection and remembering. Moving to Charlotte, marrying Clark, bringing each of my babies into the world, painting my first angel, my first child leaving for college, releasing my books, opening a gallery—these are milestones in my life, markers on the incredible journey only God could have orchestrated for me.

Between the milestones, however, there was a whole lot of daily living. Balancing the life of a wife, mom, and business owner. Cooking, cleaning, attending meetings, speaking, and traveling (with all its accompanying

packing and unpacking). There's no way I could remember every meal I've made for my family, every meeting I've had. More often than not it's the "majors" we recall; the "minors" blur into a collected memory that fades with time.

Traveling back into my memories while penning this account has given me the opportunity to explore all the peaks and pits of my life. Looking back I see how easy it would be to focus on the difficult parts of my past. That's what author Lewis Smedes calls "destructive remembering."[2] I've chosen to remember redemptively instead, to trace the brushstrokes of God throughout my life.

This book is my story, yes, but it's part of a far grander narrative—*His story*. Seeing my life in the context of God's story provides a framework from which I've been better able to evaluate what's happened to me, what I've done, and what the future might hold. It's so fascinating how writing the story of my past seems to be shaping my future at the same time. Who knows what will come as this chapter of my story—writing *The Brushstrokes of Life*—comes to a close?

My husband, Clark, is a gifted apologist. I've always been a story-teller. He speaks with others about God in a way I'm not able to do. I tell the story of my life and the stories of my paintings as a testimony to the faithfulness of God. I have committed myself to excellence and diligence in my work and home life, but it's God's grace that has kept me going all of these busy years.

I wasn't prepared for a lot of what life threw my way. I sometimes came home from my studio or a speaking engagement weary and wanting to quit what God had set before me. But then I would recharge, sitting before the Lord, emptying out all my woes. I came away from those times knowing that He had equipped me and would keep equipping me to do everything He'd called me to do.

Many years ago during one of those recharging times with God, I highlighted a passage in my Bible, words from the book of Deuteronomy.

As I was reading them, I felt strongly that I was supposed to write a trade book. It was a clear-as-day call. I didn't know how or when, but I knew that God had laid it on my heart to write down what He had done in my life.

After Clark and I built our family home, I got very excited about writing a book that I titled *Building a House God's Way*. It was exhilarating to sift through the memories of building our home, remembering all that God had done. My fingers danced on the keyboard as I wrote about the time that I visited our homesite, eager to see the progress. The framing was going well, but I was dismayed to see that the beams that were supposed to uphold my home were covered in ugly knots. I assumed this was second-quality wood and made a beeline for our builder.

"Anne," he replied, "the more knots there are, the stronger the wood is."

I didn't realize until twenty years later that my builder had told me a fib. After I published this anecdote in a devotional, a reader in the construction industry emailed me to bring this to my attention. I was grateful to be able to correct the misinformation I had previously included.

Because God works in mysterious and marvelous ways, He let me learn an essential life principle through false information from my builder. Knots may make wood weaker, but our lives can become stronger through every knotty situation. "That is why, for Christ's sake, I delight in weaknesses, in insults, in hardships, in persecutions, in difficulties. For when I am weak, then I am strong" (2 Corinthians 12:10).

Do you see this truth operating in your own life? It's there, just like it is for all of us. As we look back on the trials, battles, and failures of our lives, we can either remember destructively or remember redemptively. We can look at the knots in our lives and wish for clean, clear timber instead. But if we listen to the voice of the Master Creator, we can see the strength and beauty that have come from every knotty season we've endured.

I was so excited about sharing ideas and stories like this. And I believed that God had called me to write. So I crafted a proposal for *Building a House God's Way* and signed up for Lysa TerKeurst's writers'

conference, She Speaks. I'd be able to develop my content, practice my pitch, and meet with editors from major publishing houses there. I was pumped and ready. At least I thought I was ready.

In focus groups and breakout sessions, I learned so much. I shared my passion and vision. I told every person I met about the book I wanted to write. I told them about the oak trees on our property, the grouping of three trees I nicknamed the Holy Spirit trees. They had been damaged when city workers dug the water pipes necessary for our home. The company who came to assess the damage told me that we would most likely lose one of these majestic oaks. I didn't know exactly why I was so committed to keeping that one tree alive, but I placed a silver cross in a hole in its trunk and prayed. Days later I noticed something astonishing. Emblazoned across that tree was a new marking—a gigantic dark cross. People at the She Speaks Conference seemed encouraged as I told stories like this, and I loved sharing with them the ways God had moved.

Who wouldn't want to publish this book? I thought.

Well, it turned out that no one wanted to publish *Building a House God's Way*, at least no agent, editor, or publisher at She Speaks.

I was confused and disheartened. I truly believed God wanted me to write a book. I returned home deflated, unsure what was next. I began painting the angels shortly after that conference.

If I had focused only on my disappointment and confusion, I could have missed so much of the adventure God had for me. Yes, I felt the sting of rejection from the publishing world, but I didn't let it define me. I poured myself into another creative expression, leaving writing for a time and investing in painting. The rejection I faced for a moment was God's protection over an important calling He'd placed on my life—the calling to shine His light through my art and eventually the art of others represented in the gallery He prepared for me.

Years later when I published *Angels in Our Midst*, *Strokes of Compassion*, and three devotionals, I marveled at how God had brought the call to

write back into my life. It looked different than I originally believed it would. I've told a few scattered stories about building our home over the years, but I didn't return to that proposal I wrote for *Building a House God's Way* for more than a decade.

Even though I had published several books, I still felt God wanted to say more through me. That's when an opportunity to write *The Brushstrokes of Life* presented itself. This book is the one I believe God birthed in me all those years ago. It's His story and my story, brought together through redemptive remembering.

If you and I look primarily at the stings, the rejections, and the pain of our lives, we will see devastation more than anything else. If we remember redemptively, though, we will see Him in everything.

Brushstroke Moment

What do you see as the primary calling of your life?
Are you currently living in that?
If not, why not? If so, what does that mean for you?
I discovered one of my primary callings after
a rejection that genuinely hurt.
Do you think it's possible that a painful experience in your
life ultimately might help you experience a better future?
What do you think about remembering redemptively?
How can you choose to do that with your life story?

As you have journeyed with me through my process of redemptive remembering, I pray that you've been able to see your own life through a new lens. Remembering redemptively doesn't erase the pain of the past, but it does add a new setting and shifts our focus.

You read the beautiful words of Lewis Smedes at the beginning of

this chapter: "Redemptive remembering drives us to a better future; it does not nail us to a worse past."[3] Tracing the Master Artist's brushstrokes in our lives drives us to a better future. I pray you'll continue the journey of redemptive remembering long after you close this book. I will be doing the same.

Epilogue

Painting is just another way of keeping a diary.

PABLO PICASSO, MASTER OF MODERN ART

I've always loved those words of Picasso's.[1] Maybe that's because my artwork really is like a diary. With each painting there's a story. And I love that so very much. Thank you for allowing me to share my life with you.

If you and I had the opportunity to sit down and drink a cup of coffee together, I'd share even more stories with you. And if we had that coffee date, I'd also want to impress this on your heart: God made you to shine. It's a light only you can shine. You don't have to create the light; you're prewired to shine *His* glorious, spectacular light in everything you do, to every person you meet, through every word you speak.

Many years ago I left Bible study early to meet with an electrician. We needed to make some decisions about where light fixtures would go and where the electrical wiring would be placed. I felt the Holy Spirit's nudge to pray with the electrician, so I did. I thought the prayer was for him, but after our meeting, I realized that it was for me. God wanted to prepare my heart to hear something extremely important.

After praying, the electrician and I walked into the kitchen and dining room. He asked if I wanted sconces, and I really didn't know. I expressed my uncertainty and he responded, "If we prewire for possibility, you'll be able to do pretty much anything. If you don't prewire, you'll have to tear everything out and start over."

The truth struck me so powerfully: God prewired us for possibility and power. In Him we can do all things, endure all things, triumph through the trials we face.[2]

You are prewired for all good things, my friend. The Bible makes this absolutely clear: "His divine power has given us everything we need for a godly life through our knowledge of him who called us by his own glory and goodness" (2 Peter 1:3). You already have everything you need, dear one. You lack *nothing* (Psalm 23:1). You were made on purpose, for a purpose.

If you're in my stage of life, you may be facing questions about your purpose; lots of people my age are. Maybe your kids are raised and your home is empty. If you and I were having that cup of coffee, I'd encourage you to dream again. In fact, I'm encouraging you to do that right now, as you read.

What did you want to do when you were a child? Is there a dream to which God might want you to return? Maybe that means signing up for a ballet class, starting a blog, or finishing your degree. I encourage you to find freedom in expressing yourself in new ways.

If you're a young married person or in the thick of raising kids, I'd drink that cup of coffee with you and listen. Listen to how challenging being "on" 24-7 is, how much it requires to give yourself—day after day—in marriage and parenting. I hope you've come away from this book encouraged; I didn't even begin painting the angels until my kids were all in school. Be patient and gracious with yourself. Perhaps as you sow into your family's life, you can enjoy creating something beautiful in a garden; your kids may be able to help in that!

Maybe you're single, busy building your career, or a student who

doesn't yet know what adult life holds. Imagine we're having coffee together; I'm expressing excitement for what God is doing in and through you. I'm reminding you to trust the One who holds your future, my friend. He will complete the good work He started in you, and He won't stop until the day He returns.

Our purposes and giftings are beautifully unique, but every single one of us is invited to bring beauty into the world through our prayers. Becoming a prayer warrior can happen between changing diapers, driving carpool, attending business meetings, or writing term papers. God is near you in those tasks as much as He is near me in the studio, where I worship while painting.

Dear friend, whatever your stage of life, resist the temptation to copy or compare. I think all of us do well to keep in mind the words of Ray Cummings: the "thief of joy is comparison." I keep having to learn this, and every time I do, God reveals Himself powerfully.

I recently had the opportunity to visit the remarkable Museum of the Bible. I gave a talk there, along with Trudy Cathy White, daughter of the founders of Chick-fil-A and cofounder of Lifeshape and Impact 360 Institute. With us was the former CEO and co-owner of Keller Williams Realty International, Mo Anderson, who delivered a powerful message. All three of us had been asked to share thoughts about legacy.

I'll be honest—I felt a bit intimidated by the accomplishments of these highly successful women. Then God reminded me that I don't have to be anyone else or copy their achievements. I'm prewired to shine His light in my own way, Trudy and Mo in their own ways. *You* are prewired to shine His light in a way no one else on earth can.

Out of that speaking engagement came another remarkable opportunity. Clark and I were invited to visit the Italian villa of world-renowned singer Andrea Bocelli. I know that sounds super glamorous, but my point in sharing this is that I could have missed something phenomenal if I'd been too intimidated to speak at the Museum of the Bible. Instead I got to paint an angel for Signor Bocelli, on the back of which I placed

a braille description of the Angel series. Andrea Bocelli is blind, but he can see with the eyes of his heart and sing beauty into the world with the magnificent voice God gave him. Can you imagine if Bocelli focused only on his blindness and refused to step out in faith, expressing the gift of music God gave him? The world would be darker without his light!

What is the song of your heart, dear friend? Are you presently singing it? Are you shining in the way you've been prewired to shine? Scottish Olympian Eric Liddell, subject of the film *Chariots of Fire*, was a man of great faith and incredible athletic ability. In one of the movie's most gripping moments, Eric Liddell observes, "I believe that God made me for a purpose. But He also made me fast, and when I run, I feel His pleasure."[3]

When I paint, I feel God's pleasure. In what do *you* feel God's great joy? Chase that, my friend, and don't stop until you experience the light of Christ radiating so brightly through you that everyone around you takes notice. For this you were made, dear one. Settle for nothing less.

I'd like to close our time together with a prayer, a benediction of blessing. With it I send you my love and God's love.

Precious Father, I lift up each and every person who is reading this prayer. I pray that You would touch their hearts. I pray for those who need healing, forgiveness, and redeeming love. Lord, let them cling to You. I thank You that You will meet all their needs according to the riches of Your glory.

I pray that each person would see Your masterful touch in the brushstrokes, color, and texture on the canvas of their lives. As they commit their ways to You, trusting in You for all things, I know that You will go before them, making their paths straight. I pray that as the journey of this book comes to a close, that You, oh Lord, would equip each reader to go forth and shine Your light in this world, a light that brings peace, grace, forgiveness, mercy, and love to all.

In Jesus' name I pray, amen.

Notes

Introduction

1. "The Making of an Artist: Training and Practice," Italian Renaissance Learning Resources, 2022, http://www.italianrenaissanceresources.com/units/unit-3/essays/training-and-practice/.
2. M. J. Wilkins, "Disciples," *Dictionary of Jesus and the Gospels*, ed. Joel B. Green, Scot McKnight, and I. Howard Marshall (Downers Grove, IL: InterVarsity Press, 1992), 176.

Chapter 4

1. "Christa McAuliffe Biography," Biography.com, last updated September 16, 2020, https://www.biography.com/astronaut/christa-mcauliffe.

Chapter 6

1. "Mission and Vision," Outward Bound, accessed September 29, 2022, https://www.outwardbound.org/our-difference/mission-and-vision.
2. From Outward Bound's handbook, July 1987, which we read as a group the first night at "Dangle Rock." Transcribed in my journal, one sentence modified for the purposes of this book.

Chapter 8

1. Frederick Hartt and David G. Wilkins (2007), "Michelangelo 1505–1516," *History of Italian Renaissance Art* (7th ed.) (Pearson Education, Inc.), 496–512.
2. "About Us," Poiema Masterpiece, accessed September 29, 2022, https://www.poiemamasterpiece.com.

Chapter 9

1. "About Us," R. B. Pharr & Associates, accessed September 29, 2022, https://www.rbpharr.com/about-us.

Chapter 14

1. Mark Batterson, "Day 2: Established by God," in *Draw the Circle: The 40 Day Prayer Challenge* (Grand Rapids, MI: Zondervan, 2012), section titled "Choreography."
2. "Mission and History," Allegro Foundation, accessed August 31, 2022, https://allegrofoundation.net/mission-%26-history.

Chapter 15

1. Dan Baker and Cameron Stauth, *What Happy People Know: How the New Science of Happiness Can Change Your Life for the Better* (New York: St. Martin's Press, 2003), 81.

Chapter 16

1. U.S. Copyright Office, "Copyrightable Authorship: What Can Be Registered," in Compendium of U.S. Copyright Office Practices, 3rd ed., January 2021; see 308: The Originality Requirement, https://copyright.gov/comp3/chap300/ch300-copyrightable-authorship.pdf.

Chapter 18

1. Kathie Lee Gifford, email message to author.

Chapter 20

1. Reread Philippians 1:6 for a great reminder of this.

Chapter 22

1. Emily Friedman, "Talk-Show Queen Oprah Winfrey Reveals a Half-Sister She Didn't Know She Had," ABC News, January 24, 2011, https://abcnews.go.com/Entertainment/oprah-winfrey-reveals-half-sister-patricia/story?id=12747830.

Chapter 23

1. Michael Cavna, "Agnes Martin: To Celebrate the Great Painter, Google Doodle Offers Meditative Muted Beauty," *Washington Post*, March 22,

2014, https://www.washingtonpost.com/news/comic-riffs/wp/2014
/03/22/agnes-martin-to-celebrate-the-great-painter-google-doodle-offers
-meditative-muted-beauty/.

Chapter 24

1. Dallas Willard, *Renovation of the Heart: Putting on the Character of Christ*, 20th anniversary ed. (Colorado Springs, CO: NavPress, 2021), 5–6, emphasis added.

Chapter 25

1. Lewis B. Smedes, "Forgiveness: The Power to Change the Past," *Christianity Today*, January 7, 1983, https://www.christianitytoday.com /ct/1983/january-7/forgiveness-power-to-change-past.html.
2. David Neff, "Hurt, Hate, and Healing: A 1985 interview with Lewis Smedes," *Christianity Today*, December 1, 2002, https://www .christianitytoday.com/ct/2002/decemberweb-only/12-16-54.0.html.
3. Smedes, "Forgiveness."

Epilogue

1. Pablo Picasso, interview in *L'Intransigeant*, June 15, 1932, quoted in J. Richardson *A Life of Picasso: The Triumphant Years, 1917–1932*, vol. 3 (New York: Knopf, 2007), ch. 39. Picasso originally said, "One's work is a way of keeping a diary." This statement is widely translated and quoted as, "Painting is just another way of keeping a diary." See Susan Ratcliffe, ed., *Oxford Essential Quotations*, 5th ed. (Oxford University Press, 2017), https://www.oxfordreference.com/view/10.1093/acref/9780191843730 .001.0001/q-oro-ed5-00008311.
2. If you'd like to know more, start with Bible verses like Philippians 4:13; 1 Corinthians 13:7; and Psalm 34:19.
3. Dr. R. Albert Mohler Jr., "'God Made Me for China': Eric Liddell, Beyond Olympic Glory," *Washington Times*, November 29, 2017, https:// www.washingtontimes.com/news/2017/nov/29/god-made-me-for-china -eric-liddell-beyond-olympic-/.

Acknowledgments

I cannot believe we have arrived here, to the pages where I get to pour out my gratitude for everyone who has surrounded me on this journey. First and foremost, I give God all the glory. This is *His* story, and the fingerprints of His love, mercy, and grace are all over my story. He has taken my mess and created a beautiful message.

Years ago I had a powerful experience with a prayer group; I envisioned giving birth to a book. In the years since I have written several books, but I believe that this book—*The Brushstrokes of Life*—is the fulfillment of the vision God gave me in prayer. Through the broken and beautiful parts, He redeems all and He gets all the glory.

Writing this memoir has been such an amazing process, and I could not have done it without some incredibly talented people who stood by my side at every moment.

First, my agent, Shannon Marven, who has cheered me on since day one. Shannon, you dream big and make big things happen. Thank you for introducing me to Jerusha Clark.

When I first turned in my manuscript, I knew that it needed a little help. In came Jerusha. For weeks on end, with endless Zoom calls, she dug deeper with me. She is beautiful and talented and oh, what a way she has with word structure! I called her my midwife for this book. She has done a beautiful job sculpting the words onto these pages, much like I sculpt angels out of oil paint.

ACKNOWLEDGMENTS

To my outstanding team at Thomas Nelson—Carrie Marrs, Stephanie Newton, Lauren Bridges, Ashley Reed, Allison Carter, and freelance editor Erin Healy. Thank you for believing in this book and wanting more and better for every reader. Your questions, suggestions, and encouragement along the way created a strong dialogue that strengthened this book and its reach in every way.

Kathie Lee, you have been by my side for almost a decade now. Thank you for being a constant rock in my life and for all your support along the way. Thank you for always saying yes and encouraging me to do the things God has created me to do, to paint and share my stories. I know that God will continue to do "immeasurably more" in our lives. As you always say, "If we have a pulse, we have a purpose." Amen! I am so grateful for your email more than ten years ago, for all our divine appointments since, and more to come!

To my parents: Thank you for your unconditional love for me. Each of you has been by my side, encouraging me in all my endeavors through affirmation, support, and prayer. You have been amazing parents, and I am grateful.

To my beloved sister, Beth: Thank you for forgiving me so many years ago. I am so grateful that we have each other on this journey of life.

And, finally, to my family:

To each of my incredible adult children—Blakely, Catherine, Taylor, and Ford. Thank you for allowing me to make mistakes as a helicopter mom, for loving me unconditionally and forgiving me through it all. You are my life, and I have watched you grow into beautiful young adults. I pray that as you navigate through your own journeys, you will see God's brushstrokes over every area of your lives.

Clark, thank you for sitting and reading this book in its raw stages. Sitting by the pool, listening to you laugh, and watching you make notes

in the margins melted my soul. You are my rock and my forever. I hope that our kids can see God's mighty power of forgiveness, mercy, and grace woven in our lives and our marriage. I pray that gives them hope—hope for their future and their families that are to come.

About the Author

A lifelong artist, Anne Neilson began painting with oils in 2003 and quickly became nationally known for her ethereal Angel series, which are inspiring reflections of her faith.

Neilson has published several books, including three coffee table books, *Angels in Our Midst*, *Strokes of Compassion*, and *Angels: The Collector's Edition*. Her latest books, published through Thomas Nelson, include Anne Neilson's *Angels: Devotions and Art to Encourage, Refresh and Inspire*, *Entertaining Angels: True Stories and Art Inspired by Divine Encounters*, and *The Brushstrokes of Life: Discovering How God Brings Beauty and Purpose to Your Story*.

Because of the high demand for her original oils, Anne Neilson Home launched in 2013, which is a collection of luxury home products complementing the Angel series and providing one-of-a-kind beauty and quality.

In 2014, Neilson opened Anne Neilson Fine Art (ANFA), a gallery located in Charlotte, North Carolina, representing over sixty artists throughout the country. ANFA showcases masterpieces from the finest artists and shines a light on charitable organizations by donating a portion of art proceeds each month.

With a passion to make a difference in the world, Neilson continues to paint, write, and share her journey through speaking engagements. She is also a wife of twenty-nine years to Clark and a mother of four adult children.

ABOUT THE AUTHOR

Learn more about Anne Neilson Home, her luxury home product line, at www.anneneilsonhome.com | @anneneilsonhome.

Learn more about Anne Neilson Fine Art at www.anneneilsonfineart.com | @anneneilsonfineart.